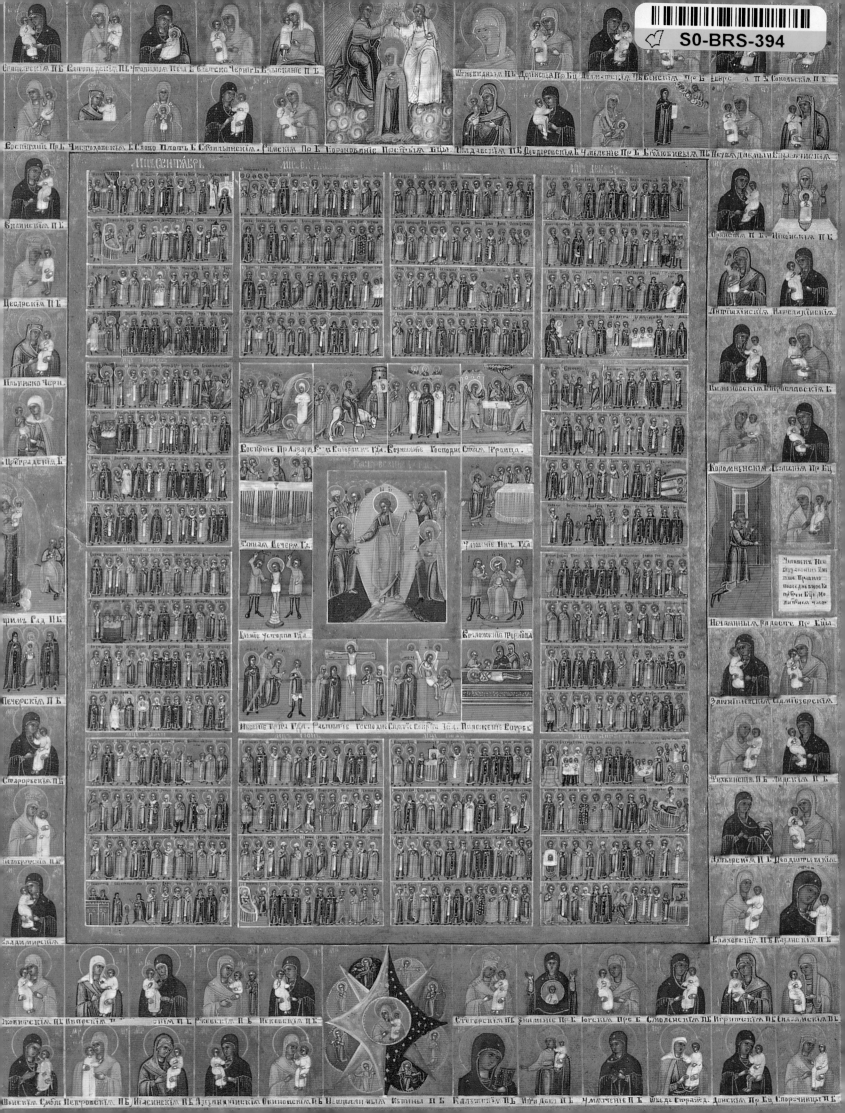

# The Mother of God: Art Celebrates Mary

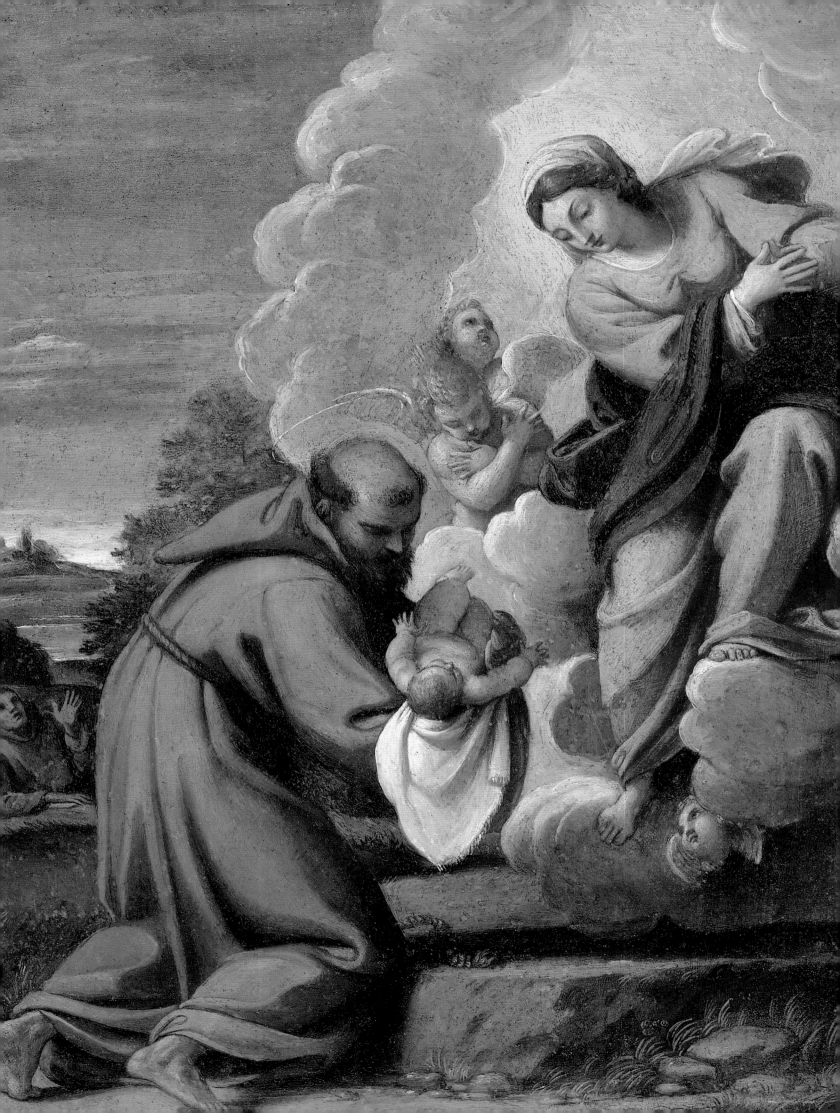

# The Mother of God: Art Celebrates Mary

MONUMENTI, MUSEI E GALLERIE PONTIFICIE

POPE JOHN PAUL II CULTURAL CENTER

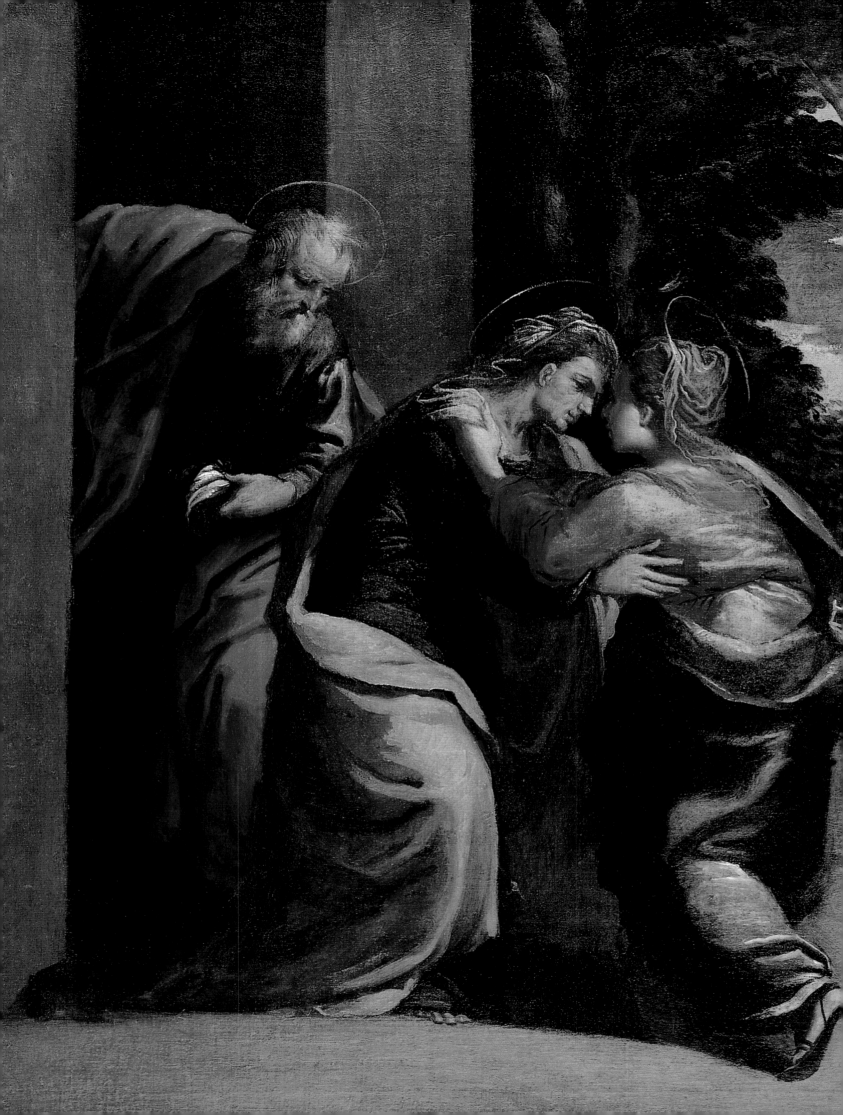

# ·CONTENTS·

Pope John Paul II Cultural Center
Washington, DC
*The Mother of God: Art Celebrates Mary*
March 22, 2001–June 17, 2002

*The Mother of God: Art Celebrates Mary*
is organized by the Vatican Museums and
the Pope John Paul II Cultural Center.

Rebecca Phillips Abbott,
*Direcor of Exhibitions, Programs, and Technology,*
*Pope John Paul II Cultural Center*
Ulrike Mills, *Editor*
Kathleen Samiy, *Art Director*
Patty Inglis, *Designer*

Calligraphy by Julian Waters

Composed in Adobe Jenson
by Duke & Company, Devon, Pennsylvania
The typeface was designed by Robert Slimbach based
on the Italian Renaissance designs of Nicolas Jenson
and Ludovico degli Arrighi, including the ligatures
and swashes. The ornamental initial letters on pages 15
and 38 were drawn by Martha Vaughan and are derived
from fifteenth-century Venetian lettering.

*Illustrations*

COVER: Giovanni Battista Salvi, called Sassoferrato,
*Madonna and Child,* c. 1650, Vatican Museums (cat. 1)

ENDSHEETS: Russian (Kholuj, near Vladimir),
*Annual Religious Calendar,* mid – late 19th century, Vatican
Museums (cat. 18)

HALF TITLE: Master of Sant'Ivo, *Madonna and Child
(Madonna Queen of Heaven),* 1390–1395, Vatican Museums
(cat. 4)

FRONTISPIECE: School of Carracci (Antonio Carracci?),
*The Virgin Offers the Child to Saint Francis (or to a Franciscan
Saint)* (detail), late 16th – early 17th century, Vatican
Museums (cat. 22)

BACK OF TITLE PAGE: Ippolito Scarsella, called
Scarsellino, *The Visitation* (detail), late 16th century,
Vatican Museums (cat. 7)

Photograph on page 76 by Lee Stallsworth

Library of Congress Control Number
2001093257

ISBN 0-9712981-0-6

Authors: Pietro Amato, Adele Breda, Guido Cornini,
Maria Antonietta De Angelis, Anna Maria De Strobel,
Daniela Derini, Micol Forti, Giandomenico Spinola,
Umberto Utro, Roberto Zagnoli

Printed in Italy by Mondadori Printing S.p.A.

# · CONTRIBUTORS · VATICAN MUSEUMS ·

EXECUTIVE COMMITTEE

PRESIDENT
Francesco Buranelli, Acting Director General

SECRETARY
Edith Cicerchia

ADMINISTRATOR
Francesco Riccardi

CURATORS
Pietro Amato
Roberto Zagnoli

EXHIBITION OFFICE OF THE VATICAN MUSEUMS
Andrea Carignani
Marta Monopoli
Diego Ortuso

PHOTOGRAPHIC ARCHIVES
Guido Cornini
Rosanna Di Pinto
Filipo Petrignani
Daniela Valci
Mario Vitaletti

PHOTOGRAPHS
Alessandro Bracchetti
Luigi Giordano
Pietro Zigrossi

CATALOG AUTHORS

Adele Breda
Guido Cornini
Maria Antonietta De Angelis

Anna Maria De Strobel
Daniela Derini
Micol Forti
Giandomenico Spinola
Umberto Utro
Roberto Zagnoli

CATALOG EDITOR
Cristina Pantella

CONSULTATION FOR SCIENTIFIC RESEARCH
Nazzareno Gabrielli
Fabio Morresi

RESTORATION LABORATORY

PAINTINGS
Maestro Maurizio De Luca
Gianni Cecchini
Maria Vittoria Cimino
Claudio Rossi De Gasperis
Eugenio Ercadi
Bruno Mattei

WOOD
Marcello Mattarocci
Massimo Alesi

STONE
Luciano Ermo

METALS AND CERAMICS
Sante Guido
Angelica Mazzuccato
Henriette Schokking

*Praised be Jesus Christ!*

As we officially open the Pope John Paul II Cultural Center, it is in every way fitting and appropriate that we inaugurate at the same time our first special exhibition, *The Mother of God: Art Celebrates Mary*. I am deeply grateful to our Holy Father, Pope John Paul II, for his personal commitment to the development of this Cultural Center and the gift he has promised of ongoing exhibitions of art from the Vatican Museums. What better way to study the continual dialogue between faith and culture than through the lens of Christian art, especially Christian art as depicted in the story of faith lived out by the Blessed Virgin Mary, Mother of the Lord and Mother of the Church!

From the very beginning of his own pontificate, Pope John Paul II has looked to the Mother of God as a point of reference and consolation. As he has written and proclaimed on numerous occasions, the Blessed Virgin Mary continues to go before the people of God, and her exceptional pilgrimage of faith is a constant reference point for individuals and communities, for people of every time and culture.

Through the generous cooperation of the staff of the Vatican Museums, the exhibition, *The Mother of God: Art Celebrates Mary*, allows us to enjoy thirty-eight noteworthy and historic artistic renderings that spell out for us the Church's understanding of Mary in various cultures and throughout salvation history, right up to the beginning of the contemporary period at the dawning of the third millennium of Christianity. This exhibition represents a unique expression of what our Holy Father, Pope John Paul II, has called "the new evangelization"—a way of coming to a renewed appreciation of the mystery of faith and our call to an ever-deeper communion with the Lord Jesus and His Body the Church.

While Christians will find their own faith life deepened through this exhibition, people of all backgrounds and experiences will be able to enjoy these works of classic and contemporary historic and artistic value, a living and enduring expression of faith and culture brought together in a beautiful and powerful harmony.

Wishing you a joyful and enriching visit to the exhibition, and with gratitude to our Holy Father and the Vatican Museums, I pray that the Mother of the Lord and our Mother, Mary, will give us all hope, consolation, and new strength for the joys and sorrows of our own journey of faith.

ADAM CARDINAL MAIDA
*Archbishop of Detroit*
*President, Pope John Paul II Cultural Center*

ON OCTOBER 21, 1997, an agreement was signed between the Pontifical Commission for Vatican City State and the Pope John Paul II Cultural Center in Washington, DC, which at the time was not yet built. The agreement made possible a unique collaboration between the Vatican Museums and the Cultural Center, whose purpose it is to preserve the legacy of Pope John Paul II. This agreement has resulted in the presentation of the exhibition, *The Mother of God: Art Celebrates Mary*, organized by the Vatican Museums. An exhibition focusing on Mary should not be viewed as an arbitrary choice among the many that could have been considered. The bond between this Pope and the Mother of God is indelible and his filial devotion to Our Lady so evident that an exhibition celebrating the opening of the Center could only have had the Mother of God as its theme.

The Vatican Museums have lent a number of significant works, all of which have Mary as the subject—the one who, together with her Son, is present in an exalted role in the art of two thousand years of Christian history, from its beginning to the present. Styles change, the sensibilities of individual artists change, and various cultures change, but explicitly or not, the notion that Mary's motherhood exemplifies the idea of maternity itself endures. Psychology helps us understand how very deep and significant the call of the mother is in every human soul. The exhibition is therefore an invitation to everyone to participate in a dialogue. In Mary, the archetype of maternity, every person of good will can find the very source of his or her relationships with others.

John Paul II affirms this in his *Letter to Women* (2): "Thank you, women who are mothers! You have sheltered human beings within yourselves in a unique experience of joy and travail. This experience makes you become God's own smile upon the newborn child, the one who guides your child's first steps, who helps it grow, and who is the anchor as the child makes its way along the journey of life. . . . Thank you, every woman, for the simple fact of being a woman! Through the insight that is so much a part of your womanhood, you enrich the world's understanding and help to make human relations more honest and authentic."

All these sentiments are enhanced by the fact that a woman became the Mother of God: "Once more, echoing the words of Jesus himself (John 19:26) and giving voice to the filial affection of the whole Church, I say to her: 'Woman, behold your children'" (*Novo Millennio Ineunte*, 59). Mary may be considered the icon that, above all others, expresses Pope John Paul II's true thoughts.

The Son of God made man "is the foundation and center of history, he is its meaning and ultimate goal" (*Novo Millennio Ineunte*, 5). But this Son was given by Mary. Mankind, seeing in Him its fulfillment and the sense of its own hope, will find in Mary the one whom the Pope himself describes as "the radiant dawn and sure guide for our steps" (*Novo Millennio Ineunte*, 58).

"By the light of the star, we continue to look at Christ, mercy and Light of the World, and to show him, as did the Virgin Mother, to all creatures" (Pope's Admonition at the Sealing of Saint Peter's Holy Door).

But there is more!

The Pope, from the beginning of his pontificate, has addressed all those who are anxiously preparing for the challenges of the third millennium with a forceful, almost shouted invitation: "Do not be afraid!" At the origin of that powerful exhortation is the knowledge that "the unassuming Young Woman of Nazareth . . . two thousand years ago offered to the world the Incarnate Word." It is she who leads "the men and women of the new millennium toward the One who is 'the true light that enlightens every man'" (John 1:9) (*Tertio Millennio Adveniente*, 59).

This inaugural exhibition certainly features works of art, but it also opens a dialogue on the subject of faith, implicitly manifested by these works. Those who are more interested in art may think this interpretation is perhaps too limiting, or even strays from the classical approach to works of art. However, art—the instrument of the manifestation of beauty—is itself a privileged path to the intuition of absolute goodness and beauty.

Pope John Paul II writes in his *Letter to Artists* (6), "Every genuine art form in its own way is a path to the inmost reality of man and of the world. It is therefore a wholly valid approach to the realm of faith which gives human experience its ultimate meaning."

EDMUND CARDINAL SZOKA
*President of the Pontifical Commission for Vatican City State*

# · ACKNOWLEDGMENTS ·

ALL EXHIBITIONS ARE THE PRODUCT of the imagination, inspiration, time, and attention of countless contributors. *The Mother of God: Art Celebrates Mary* is no exception, for many individuals and organizations have participated in its development and presentation.

It is, however, to the Holy Father, Pope John Paul II, that we owe our deepest gratitude. We are immeasurably honored by his beneficent support, which has made the Cultural Center's art exhibition program possible and which inspires and encourages our efforts daily. We are deeply grateful to Edmund Cardinal Szoka, President of the Pontifical Commission for Vatican City State, for entrusting the treasures of the Monumenti, Musei e Gallerie Pontificie to our care and for his presence as the Holy Father's personal delegate and *latore* at the Center's grand opening, which included the inauguration of the art exhibition. Our appreciation is also extended to Rosalio Cardinal Castillo Lara, President Emeritus of the Pontifical Commission for Vatican City State, whose visionary leadership, together with that of Adam Cardinal Maida, led to the idea of a collaborative exhibition program between the Vatican Museums and the Pope John Paul II Cultural Center.

The exhibition became a reality under the watchful eye of the Reverend Monsignor Walter A. Hurley, who served as Cardinal Maida's personal delegate during the design and construction phase of the project. Our debt to Dr. Francesco Buranelli, Acting Director General of the Vatican Museums, is tremendous for it was he who gave the exhibition its form, personally steering its course from the initial concept to the selection and preparation of the works of art, all the while marshaling the talents and expertise of the Vatican's curators and conservators.

Our sincere gratitude is extended to the Knights of Columbus for the generous support of the Cultural Center's art programs. Their steadfast belief in our objectives has enabled us to bring these artistic treasures to the United States for the first time—for the enrichment and enjoyment of all.

We are also extremely grateful to the Executive Committee for the exhibition, whose members include Dr. Buranelli; Edith Cicerchia, Secretary; and Francesco Riccardi, Administrator. Also serving on the Executive Committee are curators Reverend Monsignor Pietro Amato and Roberto Zagnoli, whose scholarly contributions are especially acknowledged. Catalog entries by Adele Breda, Guido Cornini, Maria Antonietta De Angelis, Anna Maria De Strobel, Daniela Derini, Micol Forti, Giandomenico Spinola, Umberto Utro, and Roberto Zagnoli will enlighten the readers of this volume. We would also like to acknowledge the efforts of the staff in the Restoration Laboratory, in particular Marcello Mattarocci and Giovanni Cecchini, under whose guidance the exhibition was installed.

The invaluable contributions of Edwin Schlossberg of the design firm Edwin Schlossberg Incor-

porated are gratefully acknowledged. His early assistance in organizing the exhibition and in providing the installation design is much appreciated.

A final note of gratitude is extended to all members of the staff of the Pope John Paul II Cultural Center who contributed directly or indirectly to the planning and realization of *The Mother of God: Art Celebrates Mary,* especially to Penelope Fletcher, Deputy Director; Rebecca Phillips Abbott, Director of Exhibitions, Programs, and Technology; Catherine Tuggle, Curator of Education; and Annie Kuniholm, Curatorial Assistant. Their contributions made this exhibition a reality.

REVEREND G. MICHAEL BUGARIN
*Director and CEO*
*Pope John Paul II Cultural Center*

# ·  I N T R O D U C T I O N  ·

THE EXHIBITION, *The Mother of God: Art Celebrates Mary,* inaugurates a close collaboration between the newly founded Pope John Paul II Cultural Center in Washington, DC, and the Vatican Museums, which celebrate their five-hundredth anniversary in 2006. The mission of the new Cultural Center, dedicated to Pope John Paul II, will be not only to honor the Holy Father but also to examine faith in the new millennium—through exhibitions for visitors and scholarly research. Although our "age" difference and geographical distance are considerable, the Cultural Center will reflect the same aims as the Vatican Museums, whose holdings include masterpieces dating from the first pontiffs of Rome to recent acquisitions made by Pope John Paul II.

It was the president of the Cultural Center, the Archbishop of Detroit, His Eminence Adam Joseph Cardinal Maida, who sought our cooperation by inviting us to participate in an exhibition worthy of the grand opening of the Center. In so doing, Cardinal Maida engaged one of the most eminent cultural institutions of the Roman Church in a series of educational initiatives designed to promote Christian culture and the pontiff's foremost position in societies of the past, present, and future. The nature and uniqueness of the collections in the Vatican Museums make available an infinite number of works of art of inestimable religious, historical, and artistic value. These works address the primary themes of Catholic doctrine and document not only the enduring attention the Church of Rome has bestowed on humankind, but also the highest artistic expression of all ages and cultures.

The grand opening exhibition centers on the Virgin Mary who, together with her Son, Jesus, is central to the entire history of salvation. It is known that the Pope has a special affinity for the Mother of God. The exhibition, then, has as its starting point an inseparable pair: Pope John Paul II on one side, and Mary, the Mother of God, on the other. The objective is to introduce a theoretical dialogue between them. Instrumental to this dialogue are the Pope's writings, linking his thoughts to Mary, who walks before the entire Church on the path of faith, charity, and the perfect union with Christ (Second Vatican Council, *Lumen Gentium,* 63), and to art, inspired by the Mother of God.

Although small in number, the works featured in *The Mother of God: Art Celebrates Mary* are significant for the interest that art and culture have shown in Mary. The six sections comprising the exhibition are introduced by excerpts from important pontifical documents. In order to present both the art and the Pope's writings as a coherent whole, the two essays in the catalog concentrate, respectively, on Pope John Paul II's thoughts on Our Lady and on the images and contextual history of Marian art. The thirty-eight works on display represent Christian art from its inception to contemporary times. They emphasize not only the abiding image of Mary, the Mother of God, but also Our Lady as an exemplary reference for the entire history of Christianity.

The exhibition and catalog present the themes of Marian faith throughout the entire history of salvation, beginning with Eve, the mother of all living creatures, and ending with Mary who, through her Son, becomes the new Mother of Humanity. The deliberately didactic aspects of the exhibition will not disappoint art historians. Despite the limited number of works, they will find noteworthy artists as well as iconography pertinent to Marian art in all ages.

From early Christian art with expressive ancient icons to art from the Renaissance to contemporary works, each period reflects seminal artists and points in time. The names alone arouse interest: Carracci, Claudio Ridolfi, Daniel Seghers, Scarsellino, all the way to contemporary artists such as Adamo Kamte, Francesco Messina, and Mario Bardi—all are represented with works dedicated to Mary. Many of these works, although known and studied by scholars, are kept at the Vatican in areas not accessible to the public. The exhibition is therefore also uncommon from this perspective and may generate interest for that reason as well.

The unusual concept of this exhibition is heightened by the works in the fifth section, which is devoted to images of Mary in the world's cultures. Encountering the sensitivities of people from diverse traditions and cultures offers a further reason to look to Mary who, in her role as the Mother of Christ, encompasses all humanity. The exhibition concludes with a section dedicated to Mary and the Church in the third millennium. Works by modern artists emphasize the continual and current relevance of Mary to all humanity. Contemporary art occasionally refers to a type of visual expression with early Christian origins, called the *Biblia Pauperum* (Poor Man's Bible). In ancient churches, mosaics or frescoes had a didactic, educational function in addition to their artistic merit, by serving as a true Bible to those who did not know how to read. The immediacy of the image conveyed the tenets of faith when cultural circumstances did not provide the tools for other means of comprehension.

This particular characteristic of religious art or art with religious content is typical not only for antiquity, but also for the Middle Ages, the cinquecento, and the seicento. Both art and the Church, which has always supported it, had an obvious role in delivering explanatory commentary to the faithful and thus, in a broad sense, to serve as *Biblia Pauperum*. Pope John Paul II states in his *Letter to Artists*: "In the history of human culture, this (art) is a rich chapter of faith and beauty. Believers above all have gained from it in their experience of prayer and Christian living. Indeed for many of them, in times when few could read or write, representations of the Bible were a concrete mode of catechesis. But for everyone, believers or not, the works of art inspired by Scripture remain a reflection of the unfathomable mystery which engulfs and inhabits the earth."

A great number of writings exist on this subject by the Church Fathers and pontiffs. The words of Pope John Paul II on the occasion of the opening of the Vatican exhibition *Evangelization and Art* apply to all: "Art—yes, even our anguished, fragmented, often powerful contemporary art—is an incomparably effective means of 'evangelizing,' that is, to spread among humankind the image and the idea of Jesus Christ. Like music, visual art can offer a means of utmost importance to this end, especially for those peoples of our time who have better access to the language of the senses, above all to the visual sense rather than an intellectual approach." The exhibition and its catalog may be justly considered an anthology of the value the Church has attributed to art and artists, as a small *Biblia Pauperum* dedicated to the theme of Mary, Mother of God.

FRANCESCO BURANELLI
*Acting Director General of the Vatican Museums*

Pietro Amato

# THE REPRESENTATION OF MARY IN THE HISTORY OF ART

I T IS IMPOSSIBLE TO REVIEW the entire history of the iconography of Mary, that is, the history of the representation of Mary, in a brief summary such as this one. This catalog has a more modest goal. It will examine a few of the many considerations regarding the cultural, theological, and spiritual context within which the pictorial image of the Mother of God developed. The works in this exhibition represent but a small nucleus of Christian subject matter. The catalog will include brief historic and artistic interpretations of these works suggested by the general contextual history that is the theme of this exhibition.

### WE DO NOT KNOW THE FACE OF MARY
*Utrum autem illa facies Mariae fuerit . . . nec novimus omnino, nec credimus*
(Saint Augustine, *De Trinitate* 8:5, 7)

Among Christians there is one certainty: the exact features and external appearance of Mary are unknown. The face of the Virgin thus belongs to the history of spirituality. Through the centuries, believers have created a wealth of iconography that describes Mary in response to the concerns of theology, ecclesiastic thought, prayer, and devotion. An observation by Saint Augustine of Hippo, expressed in the eighth chapter of his treatise on the Trinity, *De Trinitate*, suggests the significance of Mary: "We believe," he writes, "that the Lord Jesus Christ was born of a Virgin named Mary. What a virgin is, a birth, and a proper name, we do not need to believe: we know."

We imagine the face of the Virgin when we contemplate these matters. It is consistent with our faith to say, perhaps the Virgin looked like this or like that. However, no one can question whether Christ was born of a virgin without offending the Christian faith.[1] In the history of religious art the image of Mary, just as that of Christ, is central to pictorial representation. "The mere name *Theotókos*, the Mother of God, contains the entire mystery of salvation" ( John of Damascus, *The Orthodox Faith* 3:12).

Portrayals of Mary are also related to the Church's understanding of Christ, of whom "we saw His glory, the glory as of the Father's only Son" ( John 1:14). The way in which we interpret Mary is innately Christological. The Church intimately unites Mother and Son through prayer: "We thank you, oh God, for your favorite child Jesus Christ, whom you have sent to us in our time as Savior, Redeemer, and Messenger of your will. He is your inseparable Word, through whom you have created all things. In your mercy you have sent Him from the heavens into the bosom of a Virgin. Having been conceived through the Holy Spirit, He was incarnated as your Son, and born from the Virgin."[2]

1. Mellet and Camelot 1955.

2. Botte 1966, 11 and following.

3. Cignelli 1966.

In early Christian art Christ is frequently represented as a small Child in the arms of the Virgin. As Christian theology developed, new ideas took form, linking Christ as the new Adam with Mary, the new Eve.[3] The iconographic inventions of the first centuries of Christianity are the foundation for the representational ideas that evolved into Christian imagery, from the Middle Ages to the Renaissance, from the Catholic Reformation to the baroque, and from the nineteenth century to our own time.

## Mary Is the Mother of the Light of the World
*Maria inluminatrix, sive stella maris. Genuit enim lux mundi*
(Isidore of Seville, *Etymologiarum* 8:10.1a)

During the first half of the seventh century, Saint Isidore, Bishop of Seville, unwittingly abridged the concept of the *Theotókos*. His intention was to define the meaning of the word "Mary." But, taking into consideration that for the Church Fathers iconography and liturgy constitute two separate aspects of one faith and tradition, he bequeathed to posterity a theological interpretation derived from the history of imagining Mary.

"Mary," he writes in his encyclopedic work, "means she who illuminates, or the Star of the Sea, because she generated the Light of the World." He adds, "Moreover, in the Syrian language Mary means Lady; this is appropriate and beautiful because she brought Christ into existence" (*Etymologiarum* 8:10.1).

Saint Isidore suggests that in late antiquity the iconography of Mary developed in two different ways. The first, beginning in the second century, showed her as the Mother of the Light of the World; the second, beginning in the fourth century, as the queenly Mother of a kingly Christ. These images frequently coincided, particularly in mosaics, resulting in a more complex visual message.

The theme of light takes on importance after the coming of Christ. Saint John the Apostle, called "the Theologist" by the Eastern Church, was aware of this. To appease humanity's fear of death, he writes the good news in his gospel. In his prologue, before narrating the events he has witnessed, he describes Christ the Savior, the Anointed of the Lord, as the Light of the World (*lux mundi*). The Light is the Word (*verbum*) of the Father; the Word was incarnated (*caro factum est*) and is living among men (John 1). The Light, incarnated in the womb of a Virgin called Mary, is the answer to the *brevis lux* of Catullus and the horror of the hereafter where, illuminated only by the moon, eternal darkness reigns. Jesus Christ is the Light that destroys the Kingdom of Hades; He is *lux aeterna*. Perpetual darkness ends after His resurrection. His Light brings victory over death.

4. Paris 1964, nos. 24, 144.

Two ancient Egyptian paintings in the Musée du Louvre in Paris illustrate this cultural revolution.[4] One, an encaustic painting, represents the solemn god Anubis introducing a soul into the underworld. The other, equally hieratic, is a painting on wood that shows Christ introducing Abbot Mena to the Kingdom of Light. Anubis and Christ are depicted with identical gestures as they accompany the dead to the hereafter. The circumstances, however, are different. In the first image, Anubis leads a soul to the Kingdom of Darkness, lit only by the moon, whereas in the second Christ is shown with a golden book of life decorated with pearls and precious stones, leading Mena to the Kingdom of the Sun in a scene flooded with sunlight.

Two epigraphs from the first half of the fourth century refer to similar themes of the afterworld. One of these is on the covering slab of a burial niche (cat. 2). Its inscription reads: *Vibas Pontiana in Aeterno* (May you, Pontiana, live in eternity). The other is on a sarcophagus, showing Severa accompanied by a scene of the Epiphany (cat. 3). This epigraph reads *Severa in Deo Vivas* (May you live in God, Severa). Both convey the concept that life is eternal in God. On the sarcophagus depicting Severa, the Child *Logos* (the Word) is on the knees of His mother, who is identified by a star.

To us, the Magi were the first followers of the star. Curiously, in Roman writing the asterisk, placed where it is necessary to have light, is transcribed in the shape of a star (the Latin *astrum* means star). Guided by a star, the Magi find a Mother and Child. The asterisk symbolizes the fact that the Magi understood they were before the *Logos* generated by the Virgin. Thus they presented their allegorical gifts to the God of Light (cats. 3, 9).

Widely known in early Christian art, the subject of the Adoration of the Magi was widespread among early Christians because of their pagan past. For early Christians, this event signified the identification of the Church of the Gentiles with the New Kingdom initiated by "the fruit of your womb" (Luke 1:42). In antiquity, the virginal womb was the prerequisite symbol of divine motherhood.

One of the oldest known, rare images of Mary and Child survives in the catacomb of Priscilla in Rome. Painted around AD 230–240, the figures are described in accordance with the canons of late Roman Severian art. A woman dressed in a tunic is seated, nursing her son, her head covered with a veil. The large, luminous eyes of the Child, reminiscent of Egyptian art and the style of late Roman mystical portraits, turn toward the spectator. A male onlooker, dressed in a tunic and cloak, participates in the scene by pointing with his right hand to a star high in the sky between the two figures. Among scholars of iconography, his identity is in dispute. For some he is Isaiah (Isaiah 7:14), for others Baalam (Numbers 24:17), and for yet others Micah (Micah 5:14). Some have suggested that the event refers to a Psalm of David: "In holy splendor before the daystar, like the dew I begot you" (Psalm 110:3).

A question arises: does the image really represent Mary, the chaste wife of Joseph, and the *Logos*? Or is it possible that the scene, including the onlooker, indicates a general messianic announcement? The latter would suggest that the idea expressed here was introduced into Christian art with a specific content, as, for example, the image of Severa accompanied by the scene of the Epiphany.

### MARY MEANS LADY, SHE WHO ENGENDERED THE LORD
*Sermone autem Syro Maria domina nuncupatur; et pulcre, quia Dominum genuit*
(Isidore of Seville, *Etymologiarum* 8:10.1b)

The concept of representing Mary in royal garments did not seem unusual to Christians in the early centuries. They considered this a natural consequence of the words spoken by Gabriel to the Virgin Mary, in her house at Nazareth: "Behold, you will conceive in your womb and bear a son, and you shall name Him Jesus. He will be great and will be called Son of the Most High, and the Lord God will give Him the throne of David his father, and He will rule over the house of Jacob forever, and of His kingdom there will be no end" (Luke 1:31–33). The regality of the Child, born to sit on the throne of His father David, makes Mary the mother of Christ the King, the Prince of Peace (Isaiah 9:6). The episode of the Magi (Matthew 2:1–12) reflects the question, "Where is the newborn king of the Jews?" King Herod was worried. The iconography of the Adoration of the Magi, always Christological, implies that Mary is a queen. How could it be otherwise—the mother of a king would naturally be a queen.

In the art of the Christian East, especially that of Antioch, which inspired the iconography of Byzantine art, Mary was depicted as the one who presents the Victor (*Madonna Nicopéia*). The image of the *Nicopéia* came to be fundamental to Christian art.[5] Here Christ is the Victor; He is victorious over death and He has destroyed Hades. Mary is the one who presents Him, and she does so in a regal manner. The *Nicopéia* image is the visual synthesis that Christians created of the Virgin and the Son. It is the culmination of the Annunciation to the Virgin. The announced King is now shown in the glory of eternal light and regality, and the Virgin Mother is the one who accomplishes this, from the earliest moment of His life

5. Amato 1996a.

to His victorious appearance on earth. Mary holds the Son standing on her knees, in the same position that a general would hold his shield. Thus the image suggests a new emperor who has defeated the enemy: one hand raised, the other down. At the sight of such an image, His subjects prostrated themselves in acknowledgment of His presence.

The interpretation of Mary as *Nicopéia* (symbolizing victory) existed not only in the East but also in Rome. This is evident in a sixth-century votive fresco painted for the widow Turtura in the catacomb of Commodilla, a *Madonna and Child between Saints Felix and Adauctus*. The painting can be more precisely defined as *Nicopéia* between Saints Felix and Adauctus.

6. Amato 1996a,
108–112.

The same applies to an exquisite icon showing the *Madonna and Child Enthroned between Saints George and Theodore* in the convent of Saint Catherine in Sinai, in which the Virgin is a *Nicopéia*.[6] Here the queenliness of Mary assumes stronger, more defined features. This type would be used for the interpretation of Mary up to the thirteenth century. The scene is spectacular, taking place in an unearthly, eternal, luminous realm. The domain is imperial, and so is the protocol. Two angels take the role of guards behind the *Nicopéia*, who holds the *Logos* on her knees, dressed in the himation or imperial garb and carrying the scroll of the law. The throne is magnificent; it is covered with pearls. Two warrior saints look on from the sides, and they too participate in the victory of Christ the Light. With their left hands they hold the golden cross, the victorious emblem of Constantine and the symbol of the Lord of Light, whose second coming is awaited

7. Amato 1997, 36–38.

by Christians.[7] Their garments, embroidered in gold, are regal. The earthly protagonists face the spectator with a hypnotic gaze, while the angels lift their heads as though called from above. There the hand of God the Father consecrates the Victor, who is seated on His Mother's knees and flanked by the two military saints—the young George who has freed the city from the dragon and Theodore the soldier-martyr.

## MARY, IMAGE OF THE CHURCH
*Maria figuram in se sanctae Ecclesiae demonstrat* (Saint Ambrose, *In Luc.* 1)

The Church Fathers soon established a parallel between Mary, Virgin and Mother, and the Church caring for its children. Mary's titles and those of the Church are very similar: *Sicut Maria ita et Ecclesia*.

Rome also had a reason to present itself through the image of Mary, for it was the queen of the empire's cities. The emperor was centered there; his authority ruled the world, ensuring justice for its citizens and peace on earth. The *pax romana* was considered the will of God by the Church Fathers, for through it the earth was at peace when it prepared for the arrival of the Son. By eternal and universal mandate,

8. Amato 1990, 35–38.

Rome proclaimed itself to the world as the regal city: *Roma christiana, sed aduc Roma*.[8] Therefore the Church of Rome is portrayed in the image of Mary, with attributes that are exclusively those of a queen.

The mosaic of the triumphal arch in the church of Santa Maria Maggiore in Rome (fig. 1) is the most eloquent document signaling the history of the Church of Rome's iconography in comparison to that of the East. Here the Virgin Mother appears in all her regal splendor. Nothing reminds the spectator of the humble girl from Nazareth; quite the contrary. On the occasion of her coronation, Mary is dressed in sumptuous imperial vestments. She wears fine earrings and moves in accordance with court protocol. Her image, together with that of Christ, is inserted in a sphere. She points to the flanking figures of Saints Peter and Paul who, through their mission of peace, founded the new Rome. Constructed by Pope Sixtus III (432–440), the apsidal arch of Santa Maria Maggiore celebrates the newly found peace between the Church of Alexandria and that of Antioch. A breach between the two had developed at the Council of Ephesus, which took place in 431. It was largely through the Bishop of Rome, the *Cathedra Petri*, that peace was re-

9. Amato 1980.

stored between the leaders of these Churches following the Council.[9]

Figure 1. Triumphal arch with mosaics, AD 432–440, Santa Maria Maggiore, Rome

An inscription, *Sixtus episcopus plebi Dei,* conveys the ecclesiastical content of the arch. In this inscription, Bishop Sixtus dedicates the figurative manifest to the people of God. The mosaics record the accomplishments of Sixtus for the Roman Church. The *Etimasia,* that is, the (empty) throne of the lamb, the sign of the second coming of the Lord, is centered in the keystone, flanked by Saints Peter and Paul. Their images are repeated in the decoration of the throne. The lower panels are devoted to a series of episodes relating to the infancy of the *Logos.*

The order of the stories about the infancy of Christ is not always chronological. Its aim is instead to develop doctrine and thought, exalting, with the *Logos,* the roles of Mary and Joseph. Mary is the image of the Church as described by the Church Fathers, while Joseph, as the bishop, is the virginal witness of Mary and the defender of her virginal motherhood before the law, as explained by Saint Jerome. The *Logos* derives from the results of the Council of Ephesus, which proclaimed His dual nature as both true God and true Man. Sixtus' reconciliation of the Churches of Antioch and Alexandria is suggested in the *Adoration of the Magi,* in which the figures appear to be from Antioch (fig. 2), and the Arrival in Egypt, where the Holy Family is received by Afrodisio and the people of Sotine (fig. 3). Together these scenes suggest the newly achieved unification of the Roman Church as a model of harmony and peace. This ingenious iconographic formula is the work of Sixtus' closest collaborator, the future Pope Leo I "the Great" (440–461).[10]

10. Amato 1990, 4–47.

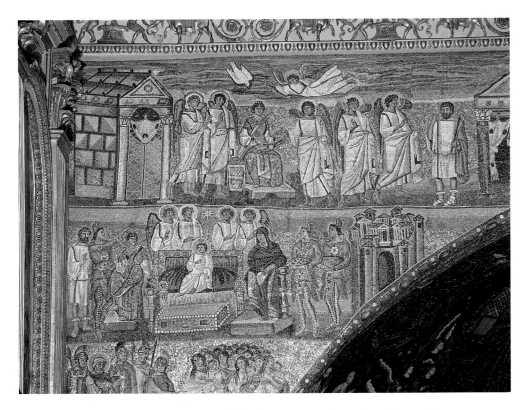

Figure 2. *Adoration of the Magi,* mosaic on triumphal arch, AD 432–440, Santa Maria Maggiore, Rome

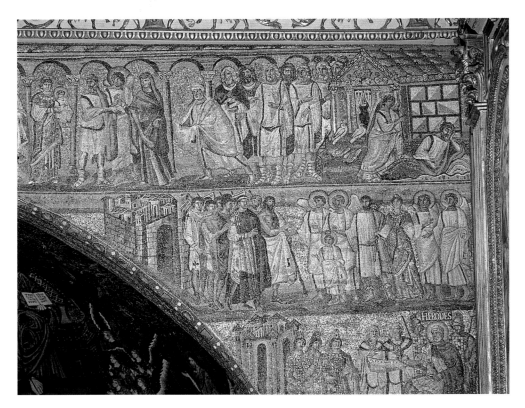

Figure 3. *The Adoration of Afrodisio and the People of Sotine,* mosaic on triumphal arch, AD 432–440, Santa Maria Maggiore, Rome

The apse of the basilica of Santa Maria Maggiore originally contained a mosaic of Mary as Queen surrounded by angels that was intended as a radiant symbol of growing faith and power. A sixth- or seventh-century encaustic painting, *Mary as Queen and the Child between Two Angels with a Kneeling Pontiff*, also known as the *Madonna of Clemency* and now in the basilica of Santa Maria in Trastevere, is thought to reproduce the lost mosaic.[11] Here, seated on a crimson cushion, on a throne adorned with pearls, the Virgin holds the *Logos* on her knees. In her right hand she displays a jeweled staff in the shape of a cross, a symbol of victory. The royal couple is flanked by two angels. As a personification of Clemency (clemency is an imperial act), the Virgin wears a spectacular crown. She and her Son, represented as an eternal icon, cast a mesmerizing gaze at the viewer. Together they are the Church and the Word of God, tending to the misery of humanity. The idea of depicting Mary as a queen would spread throughout Western Europe in the Middle Ages. After being adopted by the Benedictines, the use of the image in the Roman Church continued until about the fourteenth century.

However, things were different in the East. Antioch and Constantinople produced an abundance of liturgical texts and written prayers of intense emotion about Mary as queen. They created a vast body of literature about the Queen of Heaven and Earth. Yet artists in the East were forbidden to represent a visual image of Mary as empress; rules imposed on pictorial imagery did not permit it.

The depiction of Mary with imperial attributes is a concept that belongs to the Roman Church. An example is the *Virgin Queen* that survives in the chapel of San Vincenzo al Volturno, part of an extensive Benedictine complex of the eighth and ninth centuries that was known as one of the largest in Christian Europe. Here, Mary is the image and expression of Rome as the universal and glorious Church.

### We Take Refuge under the Shadow of Your Wings, Oh Holy Mother of God
*Sub tuum praesidium confugimus, Sancta Dei Genitrix*

The *sub tuum praesidium* is the oldest known prayer dedicated to Mary. Its text, surviving on a papyrus dating between the third and fourth century, was found in Egypt in the early twentieth century.[12] The prayer directly addresses the Mother of God. It asks for help, salvation, and shelter under the mantle of her mercy.

Underlying this private prayer was a long-standing religious tenet. The Virgin who gave birth was a Mother. Because she gave birth to God, she is the Mother of God. As Virgin and as Mother of God, she is the most appropriate person to intercede with the Son, the Divine Light. To turn to the Mother of God is a natural human impulse: it is, essentially, the request of a divine gift. The first Christian iconography, based on the *sub tuum praesidium*, shows the composition of a royal group, the Mother of God with the *Logos* who is seated on her lap. This formula is both ideological and figurative. When Mary is presented as the Mother of God (*Theotókos*), she takes on the role of intercessor. According to Saint Irenaeus, she has the function of advocate before God (*Against the Heresies* 5:17; P.G. 7: col. 1176).

Originating in Egypt, this figurative and sculptural concept was dispersed throughout the entire Mediterranean. It is reflected in the depiction of the *Dêesis*, which is first seen on the apsidal basins and later on the gates of the Sancta Sanctorum.[13]

What is the *Dêesis*? When it originally appeared during the first millennium, it was the liturgical prayer of the Church for obtaining eternal life. This prayer invoked three images: the Lord Christ in the center, enthroned; to His right, the Mother, standing; and to His left John the Baptist, also standing. Speaking of John the Baptist, Jesus said that among all those who have been born no one is greater than John the Baptist (Luke 7:24–35). The Mother of God and John the Baptist flank the image of Christ as Judge (*Pantocrator*). As friends of humankind they are the intercessors par excellence for all humanity.

11. Amato 1988a, 26–32.

12. Roberts 1938, 46–47.

13. Amato 1982, 601–606.

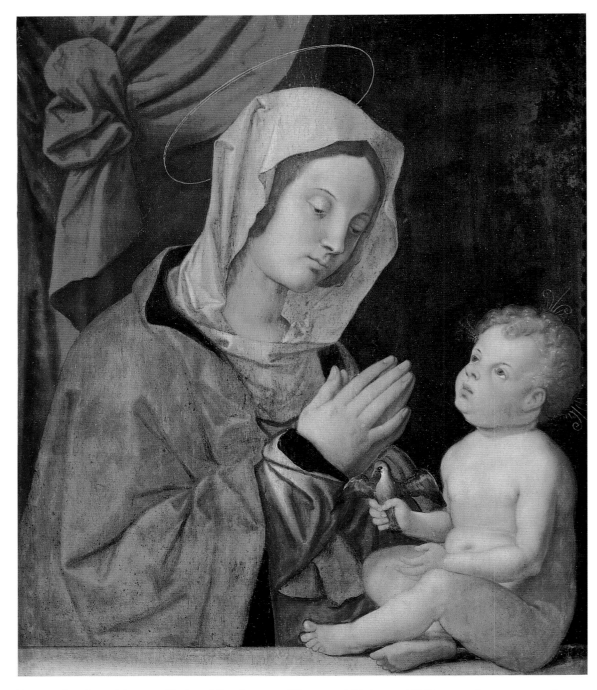

Figure 4. Bartolomeo Montagna (Orzinuovi, Brescia, c. 1450 – Vicenza 1523), *Madonna and Child*, c. 1503, oil on canvas, 74 x 60 cm (29⅛ x 23⅝ in.), Vatican Museums, Vatican Pinacoteca, Inv. 40378

Although the iconography of this triad has a pagan origin (a tradition in which the king was shown between two intercessors), the visual idiom of Christianity assigned a new meaning to these figures: they act out a prayer that is a petition for obtaining eternal life. In accordance with the new demands of Christianity and the spiritual needs of the third to the sixth century, the *Dêesis*, or invocation, suggests eternal light. The image, placed on the basin (which was considered the luminous cave in which life is given birth) in the presbytery of a church, appears to have had eschatological meaning, perhaps referring to the Resurrection.

In the first millennium the Mother of God and the Baptist ask for imperial mercy and seek eternal light. An image of the *Madonna Nicopéia between Saints Elizabeth and Anne* is of interest in this regard. Dating from the early eighth century, the picture in Santa Maria Antiqua in Rome contains three mothers, each holding her respective child and thereby creating a double triad.

Later, in the second millennium, Mary's virginity is emphasized when the *Dêesis* takes on the characteristics of a devotional image. The prayer is now directed to the Virgin Mary and John the Evangelist, who was present with the Virgin at the Crucifixion. Monks in the cloisters now sing the *O Intemerata* (Oh Unstained One). The state of Mary's virginity comes to be more prominent and is regarded with greater tenderness and love than the divine motherhood. The virginal circumstance established by God becomes more important than the theological fact of the divine motherhood, and the *Genitrix Dei* (Mother of God) is replaced by the *Mater Misericordiae* (Madonna of Mercy). The iconography of Mary does not remain regal and imperial, but instead becomes earthly and deeply human over time. Faith in the divinity of Christ is intensified by meditation on His suffering and humanity. The iconography of the Nativity develops a new role for Mary—foreseeing the suffering and death of the Son.

As this iconography develops, we observe Mary spreading out her mantle so that all Christians can find shelter beneath it: popes and kings, monks and ecclesiastics, nobles and landowners, friends and enemies, poor men and women. One example is the *Madonna della Misericordia* in the Museo della Cattedrale, Pienza. In this fourteenth-century image, different social classes are united in prayer under the protective mantle of the Virgin Mother.

In 1437 Parri Spinello (1387–1444) painted the *Madonna della Misericordia with Episodes from the Lives of Saints Lorentino and Pergentino,* now in the Museo Statale di Arte Medioevale e Moderna, Arezzo. Here people pray while the Child, supported by the Virgin on one arm, holds in His hand a little bird— the symbol of death. Afraid, the Child draws back, lovingly watched over by the Mother. There is sadness in their faces, as though they anticipate Christ's martyrdom on the cross, an event in which Mary will participate. From their sacrificial suffering is born a sense of redemption.[14]

Several paintings in the Vatican address this context of the theology of suffering. The *Madonna and Child,* painted about 1503 by Bartolomeo Montagna, is an example (fig. 4). It shows the Child with a bird in His hand. More sophisticated subjects of the Madonna and Child suggest the drama of life in the faces of the protagonists. Among them are works by Stefano di Giovanni, called Sassetta, such as figure 5 and the *Madonna and Child (Madonna Queen of Heaven)* (cat.4), which is included in the exhibition. The Virgin engages the spectator, and through her maternal suffering she invites the faithful to contemplate the sacrificial mystery that is the Son.

A famous *Madonna della Misericordia* of 1452 by Enguenand Quarton, at the Musée Condé, Chantilly, France, has an ecclesiastical flavor. Here the Virgin is the image of the Church. With her hands she spreads her mantle over the kneeling supplicants. The Pope and the emperor are first, and the ecclesiastical and civil authorities follow, a direct reference to Roman tradition. Also present are two praying intercessors, Saints John the Baptist and John the Evangelist.

A variation on the idea that humanity is united in prayer is demonstrated by the so-called *Madonna*

14. Rome 1988a, cat. 58.

15. Rome 1988, cat. 62.

*of the Angels* of about 1457 by Benozzo Gozzoli (1420–1503), in the church of Santa Maria Assunta in Sermoneta. On her knees, the Virgin supports a scale model of the city of Lazio, signifying her protection of that city.[15] Similarly, in a painting of the *Madonna of the Mountain,* signed and dated 1491, Lorenzo d'Alessandro da San Severino (active 1462 to 1503) places Caldarola, a village of the Marches region of Italy, on a table offered to Mary. The Virgin winds a ribbon around the donors and their gifts and sets her wedding ring (which, according to tradition, was thought to be preserved in the Cathedral of Perugia) in a basket of gold offerings. This painting refers to the *Ave Maris Stella,* a hymn that originated during the reign of Pope Sixtus IV.[16]

16. Amato 1991.

## Mary Belongs between Christ and the Church
*Maria inter Christum et Ecclesiam constituta* (Saint Bernard, *Homily for the First Sunday after the Assumption, 5*)

Perhaps the cathedrals of the Middle Ages would not have been so splendid had it not been for the extraordinary devotion to Mary in late medieval times. She is the protagonist in Christian sentiment and search for love. Christians invoked and praised her in works of architecture, sculpture, and painting; the metallic arts, tapestry, and folk art. In Europe, most of the great churches are dedicated to Mary, especially to events in her life—such as the Dormition or the Assumption—that were celebrated through her "transformation," the redemption of all humanity.

It is the Virgin Mother who is responsible for the joy of redemption, as suggested by the liturgy of the Visitation of Mary and Saint Elizabeth. The writings, based on the Gospel of Saint Luke, hail the meeting of unborn babies, the Savior and Saint John the Baptist, as a joyous moment (Luke 1:44). In the two paintings shown here, which closely follow the liturgical source, the mothers greet each other and embrace in accordance with Roman ritual (cats. 6, 7).

In France the Virgin was honored as Notre Dame, the name given to many cathedrals; for example Notre Dame of Laon, Notre Dame of Amiens, Notre Dame of Paris, and Notre Dame of Chartres. In the choir of the cathedral in Chartres is a stained glass window that has a special blue background, a shade of blue not found before the thirteenth century, within which is placed the Queen of Heaven, *Nicopéia*-style. This window survived a great fire in 1294; its Virgin is known by the romantic name "Notre Dame de la Belle Verrière" (Our Lady of the Beautiful Stained Glass Window). In Notre Dame of Senlis, the history of Mary occupies the main portal; in that of Rheims, her image dominates the stone pillar that divides the main entrance; in Notre Dame of Paris, two portals are dedicated to events from her life. The Cistercians at Cîteaux, in eastern France, placed their churches under the special protection of the Virgin.

A competition of names for the Mother of God began to ensue among Christians in the eleventh and twelfth centuries. Some of these names derive from cities, suggesting that the Virgin is considered the bastion of the community. Frequently her icon was zealously guarded in a building that served to protect a given city. A Russian icon from the second half of the nineteenth century (cat. 18) brings together eighty-four famous icons of Mary in miniature format that take their names from cities. Examples include The Blessed Mother of Rome, The Blessed Mother of Moldavia, The Blessed Mother of Antioch, The Blessed Mother of Cyprus, The Blessed Mother of the King, and The Blessed Mother of Pecersk, illustrating a veritable account of the geography of Mary.

Other names derive from Genesis, the Song of Songs, and the Gospels as well as the Apocalypse. They also come from the Fathers of the Latin and Greek churches. Others have their sources in exegesis or in medieval mysticism. Full of tenderness, they take the form of invocations recited after the contemplation

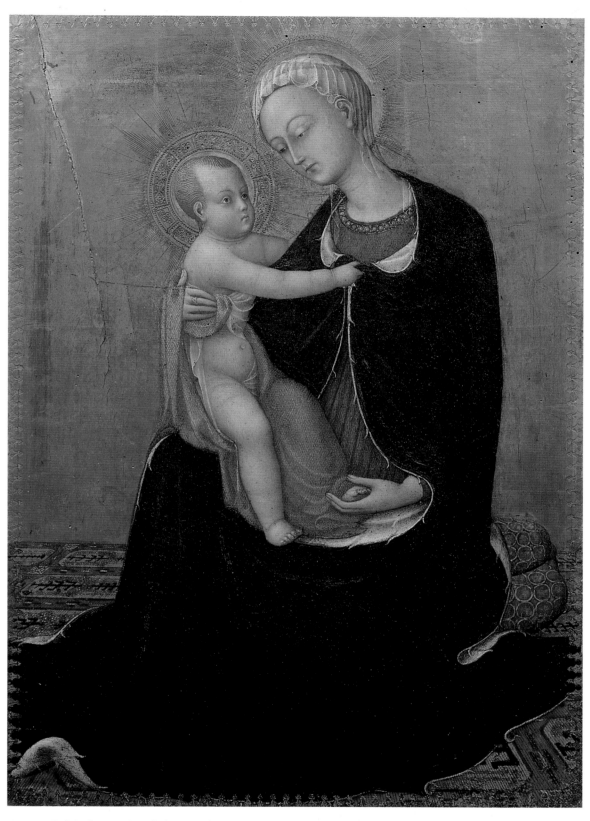

Figure 5. Stefano di Giovanni, called Sassetta (Siena c. 1400–Siena 1450), *Madonna and Child*, c. 1435, oil on canvas, 73 x 54.5 cm (28¾ x 21⁷⁄₁₆ in.), Vatican Museums, Vatican Pinacoteca, Inv. 42139

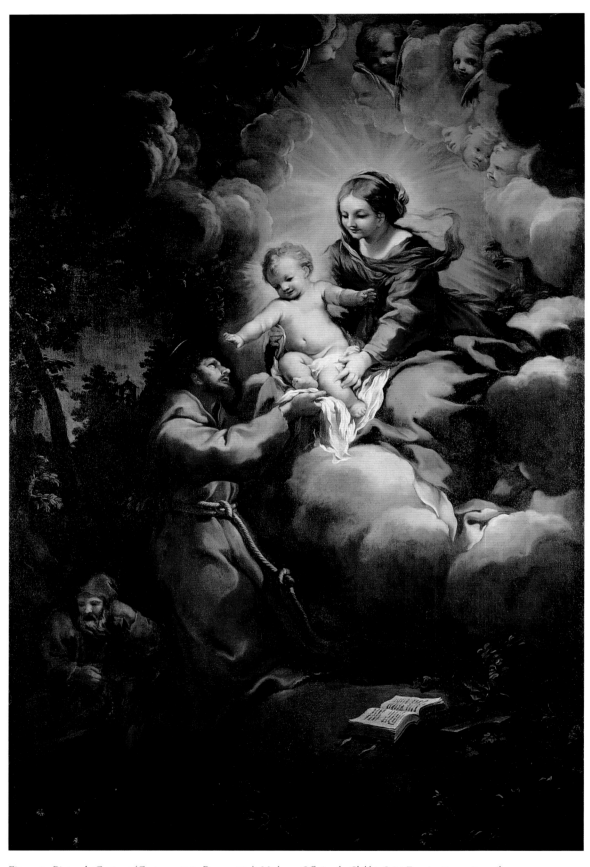

Figure 6. Pietro da Cortona (Cortona 1596–Rome 1669), *Madonna Offering the Child to Saint Francis*, 1640–1641, oil on canvas, 227 x 151 cm (89⅜ x 59⁷⁄₁₆ in.), Vatican Museums, Vatican Pinacoteca, Inv. 40405

of the Mysteries of the Rosary (cat. 19) and are remembered in such paintings as the *Madonna of Loreto,* created by Filippo Balbi in the late nineteenth century, shortly before Pius IX proclaimed the dogma of the Immaculate Conception (cat. 21).

Mary came to be compared to the moon, an enclosed garden, a mirror, and a fountain. These are all symbols employed in the iconography of the Immaculate Conception. As she is considered the new Eve, Mary steps on the serpent that seduced the first Eve (cat. 25). Saint Bernard referred to Mary as the "royal way," that is, the road to Christ. This idea, which is not new, has persisted into our times.

The Byzantine world created the iconography of the Mother of God as *Hodegetria* (the conductress; the guide of wayfarers, the subject of a sacred icon of the Virgin supposedly painted by Saint Luke). Here the Madonna shows the path to the *Logos,* whom she holds with her left arm while she intercedes by pointing with her right arm. As this gesture evolved, it took on characteristics both hieratical and human.[17]

17. Amato 1992.

Another image that developed both in the East and in the West (each with its own psychological and regional peculiarities) is that of the *martirium,* involving pain or suffering. The so-called Madonna of Tenderness (in Russian, *Glykophilousa*) depicts expressions of affection that become palpable. In these images, the cheek of the Child is close to that of the Mother. He is actively seeking affection, a characteristic evident in a painting of the *Madonna and Child* by Sassoferrato (cat. 1) and in another entitled *Flower Garland with Madonna and Child* by Daniel Seghers and Erasmus II Quellinus (cat. 17). In such works, occasionally one of the Child's arms is placed around the neck of the Madonna; often He clings lovingly to her.

A Western variation can be seen in the type of the Sicilian Madonna (cat. 15), the *Madonna del Carmelo.* The group, which mesmerizes the praying beholder, contemplates the essential aspect of the Redemption: Through His death, Christ has obtained for humankind the possibility for salvation. This image became popular in the Spanish empire, as exemplified by a mannerist altarpiece, the *Madonna del Carmelo with Saints Bernard and Diego* in the church of San Bernardino at Molfetta in Puglia. This type of image was promoted by the Carmelite monks who spread the cult through their confraternity, which was centered in the church of San Martino ai Monti in Rome.

The theme of the Virgin interceding for the souls in Purgatory is also present in the exhibition (cat. 20). We are reminded of the famous *Madonna of Intercession* painted after 1649 by Francesco Guarino (1611–1654) for the Church of Purgatory at Gravina in the region of Puglia. Here the Madonna is the path of salvation, for she is shown caught in a swirling, spiraling movement accompanying the angels who retrieve souls from the flames and carry them away to heaven.

## The Virgin Mary Is without Comparison
### *De Maria Virgine incomparabili* (Pietro Canisio)

The Protestant Reformation deeply affected Catholic emotions and prayer. Rejecting some of the beliefs concerning Mary, Lutherans and Calvinists curtailed her role in redemption. Some even went so far as to reject the authenticity of the words spoken by the angel: "Ave Maria, gratia plena."[18] Mary had never before been excluded from the vital cycle of theological history, and believers were extremely concerned. The response, collective and emotional, went beyond the expectations of the Council of Trent, which had not considered the utility of a session devoted to the Mother of God.

18. Mâle 1932, 29–49.

In the late sixteenth century Pope Pius V asked the theologian Pietro Canisio to respond to the Assembly of Magdeburg with a defense of Mary. The response came in two volumes, *De Verbi Dei Corruptelis* (published in Ingolstadt in 1571 and again in 1577) and *De Maria Virgine incomparabili.* Here he advised the faithful by responding to Protestant writings against the Virgin. As a result, the issues rejected by the

Protestants became, for Catholics, the objects of even greater passion and devotion than before. It is therefore very moving to encounter visions and ecstasies of saints talking with Mary in baroque art.

Saints also beg the Virgin to save their cities from the plague, as in *Saint Francis Supplicating Mary to Liberate Mantua from the Plague* by Franesco Borgani (died 1624) in the ducal palace at Mantua. Another example is the *Ex Voto to Banish the Plague in Naples*, in which a group of local saints intercedes with Mary, painted by Mattia Preti (1613–1699) in 1656, now in the Museo Nazionale, Naples.

A more poetic theme is that of the Virgin entrusting the Child to a saint. In 1629, Alessandro Tiarini painted the *Madonna Consigning the Child into the Arms of Saint Francis* for the Pagani Chapel of the sanctuary of the Madonna della Ghiara in Reggio Emilia (decorated between 1577 and 1668). This "vision" is expressed in an intimate embrace: Saint Francis enters into a communion of affection that is described in a classic manner. Mary's red tunic, highlighting her presence, stands out from the rest of the picture, which is painted in warm, dark tones. This theme appears in the exhibition (cat. 22) and reminds us of the splendid *Madonna Offering the Child to Saint Francis*, painted by Pietro da Cortona for the Chapel of Torquato Barbolano in the church of the Santissima Annunziata at Arezzo. A copy of this painting exists in the Vatican (fig. 6). The theme of Our Lady entrusting the Child is present in the exhibition in *The Virgin Hands the Christ Child to Saint Cajetan of Thiene* (cat. 11), attributed to Giovanni Lanfranco.

The Virgin is also honored by believers in the *Message of the Virgin*, sometimes called *The Virgin of the Letter*, a work in the regional museum at Messina, Sicily. It comes from the church of San Giovanni Decollato and is attributed to Mattia Preti. The painting tells the story of the Apostle Paul who, according to ancient tradition, made his way to Messina. Following the conversion of its citizens, the apostle returned to Jerusalem, offering the reverence of the people of Messina to Mary.

Among the literature accompanying Marian imagery is the *Atlas marianus*, published by the Jesuit Gumppenberg (Ingolstadt, Germany, 1657), a collection of the most famous Madonnas in Europe. In his *Historia Universale delle Imagini miracolose della Gran Madre di Dio* (Venice, 1624), the canon Astolfi attempted to prove to Protestants that images of the Mother of God have inspired thousands of miracles. Samperi reviewed all the images of the Virgin venerated in Messina in a work entitled *Iconologia della Madre di Dio, Maria, protettrice di Messina* (Messina, 1644). In the following century, Serafino Montorio wrote the *Zodiaco di Maria, ovvero le dodici provincie del Regno di Napoli come tanti Segni, illustrate da questo Sole per mezzo delle prodigiosissime Immagini che in esse quasi tante Stelle risplendono* (Naples, 1715), in which he described the veneration of Mary in the various regions of the kingdom of Naples. This work contained a map of the most famous sanctuaries of southern Italy.

In many church paintings, a precious crown was placed on the head of Mary. In Santa Maria Maggiore in Rome the words "Salus populi romani" (Salvation to the Roman people) can be seen in a magnificent chapel, dating from 1611, which is covered with marble decorations and with frescoes praising the virtues of Mary. Because it is traditionally believed that Saint Luke painted a portrait of Mary, some images of the ox (the attribute of Saint Luke) in Roman churches incorporate images of Mary (for example the pendentives of the domes of Sant'Andrea della Valle and San Carlo ai Catinari).

Baroque artists participated vigorously in the defense of Mary's virtues. Many of them, unlike some sixteenth-century artists, were passionate Christians; for example the Italians Giovanni Francesco Barbieri, called Guercino (1591–1666), Federico Barocci (1528?–1612), Carlo Dolci (1616–1686), Domenico Zampieri, called Domenichino (1581–1641), Guido Reni (1575–1642), the pious Ludovico Carracci (1555–1619), and Domenico Fetti (1589–1624), to name only a few. Among Spanish artists are Stefano Bartolomeo Murillo (1618–1682), Francesco Zurbarán (1598?–c. 1664), and Domenikos Theotokopoulos from Crete, also known as El Greco (c. 1541–1614). These masters addressed many of the themes that were attacked

by Protestants, for example the Immaculate Conception, the Rosary, and the Virgin helping believers or appearing to them.[19]

19. Stratton 1994.

The Church thus again was in charge of the arts. Priests, theologians, and laymen engaged in the study of iconography in order to guide the creation of sacred images. In Flanders, John Ver Meulen, called Molanus, published an important work on this subject, *De picturis et imaginibus sacris liber unus: tractans de vitandis circa eas abusibus et de earum significationibus* (1570). By 1626, four subsequent editions were published under the title, *De historia Sanctarum Imaginum, pro vero earum usu contra abusus, libri IV,* one in Louvain (1594) and three in Antwerp (1617, 1619, and 1626).

A work authored by Cardinal Gabriele Paleotti, the *Discorso intorno alle immagini sacre*, a discussion on sacred imagery published in Bologna in 1582, provided advice to Bolognese artists in stating the new direction of the Church. Two years later, in Florence, Raffaele Borghini published his *Riposo*, a work dedicated to instructing artists in the execution of cult works. Other writers of this generation declared their commitment to imagery dedicated to religious history, including Giovanni Andrea Gilio's *Dialogo degli errori dei pittori* (Camerino, 1564), Romano Alberti's *Trattato della nobilità della pittura* (Rome, 1585), Giovanni Battista Armenini's *De' veri precetti della pittura* (Ravenna, 1587), the Jesuit Antonio Possevino's *De poesi et pictura ethnica vel fabulosa collatis cum vera, honesta et sacra* (Rome, 1593), Gian Paolo Lomazzo's *Trattato dell'arte della pittura* (Milan, 1584) and *Idea del tempio della pittura* (Milan, 1590), and Cardinals Carlo and Federico Borromeo's *Instructiones fabricae et supellectilis ecclesiasticae* (Milan, 1577) and *De pictura sacra* (Milan, 1624). In dictating "fixed and severe rules," dioceses actively participated in the movement to create a new patrimony. They pressed for spaces to display art, especially works referring to the religious and cultural history of their respective regions.

The norms ruling Marian iconography, which were followed more or less everywhere, were discussed by Cardinal Federico Borromeo: "Symbols and mysteries used to depict the Blessed Virgin should be preserved . . . the Mother of God should not be depicted fainting at the foot of the cross, as this contradicts history and the authority of the Fathers. . . . The image of the Holy Virgin should look like a living divine Face. . . . And for painters to portray more precisely the image of the Blessed Virgin, I propose the example that Nicephorus gave us: . . . her complexion was the color of wheat; she had blonde hair and penetrating eyes with clear pupils that were almost olive colored. Her eyebrows were curved and dark, her nose long, her round lips made tender by the softness of her words. Her face was neither round nor sharp, but long, as were her hands and fingers."

Insisting on the resemblance of the Virgin Mother to the Son, the Archbishop of Milan prescribed iconographic characteristics that would persist to the end of the eighteenth century: "Respecting the creation of images of Christ and Mary, painters should remember that throughout antiquity one thing was believed and transmitted by the Fathers: the face of the Savior was admired for its perfect resemblance to that of Mary; thus anyone looking at the Mother or the Son might easily recognize the Son from the Mother and the Mother from the Son." He further observes, "It is not proper to depict the Divine Infant nursing in a position that shows the breast and the neck of the Virgin uncovered. Those parts may only be included if great care and modesty are used."

In general, artists obeyed these guidelines and, in the decoration of churches—particularly those of the orders—complied with the iconographic programs assigned to them. Jesuits, Carmelites, Augustinians, Dominicans, Franciscans, Trinitarians, and Servants of Mary all commissioned iconographic programs for their churches in which Mary occupies an important place in the spiritual history of their orders.

The Dominicans promoted the image of Our Lady in various ways. The Madonna of the Rosary came to be associated with the prodigious victory of Christian Europe over Islam in 1571; the dream of

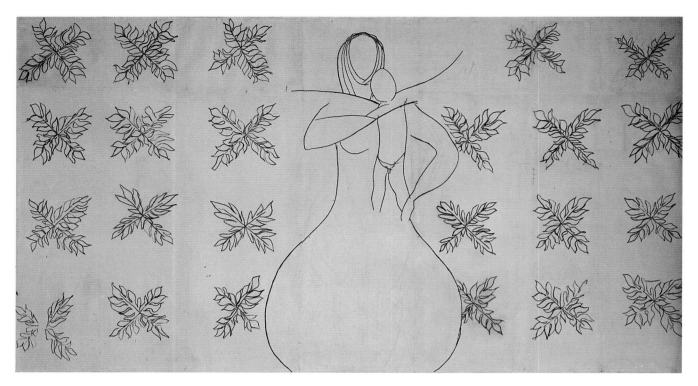

Figure 7. Henri Matisse (Cateau-Cambrésis 1869–Nice 1954), *Virgin and Child*, 1949, drawing in charcoal and ink, 333 x 598 cm (131⅛ x 235⁷⁄₁₆ in.), Vatican Museums, Collezione di Arte Religiosa Moderna e Contemporanea, Inv. 23756

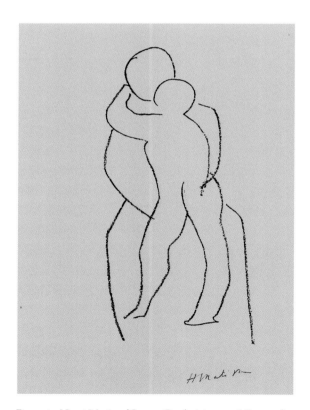

Figure 8. Henri Matisse (Cateau-Cambrésis 1869–Nice 1954), *Virgin and Child*, 1951, drawing, 40 x 32 cm (15¾ x 12⅝ in.), Vatican Museums, Collezione di Arte Religiosa Moderna e Contemporanea, Inv. 23387

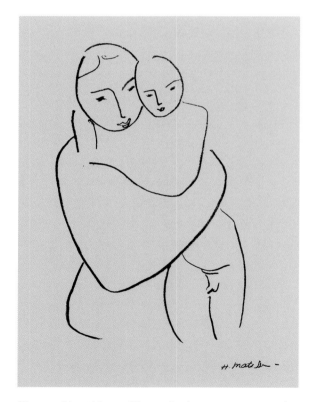

Figure 9. Henri Matisse (Cateau-Cambrésis 1869–Nice 1954), *Virgin and Child*, 1951, drawing, 43 x 33 cm (16¹⁵⁄₁₆ x 13 in.), Vatican Museums, Collezione di Arte Religiosa Moderna e Contemporanea, Inv. 23395

Saint Dominic was evoked by friars before the marveling eyes of believers; and the Virgin was shown displaying Saint Dominic with Saint Francis as the two great founders of the orders, together in order to please the Son. Churches and paintings were dedicated to images of Saint Dominic, a poor friar from Soriano, Spain, presented by the Virgin and accompanied by Saint Catherine of Alexandria and Mary Magdalen. The artist Zurbarán featured Saint Dominic in a splendid painting, *Saint Dominic of Soriano*, which is still preserved in the Church of the Magdalen in Seville. Many Dominican altars were dedicated to miraculous events from the saint's life.

While the Carmelites extolled devotion to the scapular (symbol of the yoke of Christ) on their altars, the Carthusians preferred to evoke piety through displays of the apparitions of Mary to members of their order. An extraordinary painting by Zurbarán shows the *Madonna of Mercy*, otherwise called the *Madonna of the Carthusians*, executed in 1635–1640 and formerly in the sacristy of the chapterhouse of Santa Maria de las Cuevas of Seville, now in the museum of fine arts of that city. It represents a group of Carthusian monks gathered in ecstatic silence under the protective pink mantle of the Virgin as Queen and Madonna of Mercy. They form a gallery of spiritual faces, described in soft, glowing colors, above the small allegorical flowers scattered on the ground.

Franciscans had a different iconographic vocabulary. They granted Saint Francis the privilege of receiving the Child directly from the arms of the Virgin. This privilege was also extended to Saint Felix of Cantalice, whose portrayal is always characterized by great tenderness and humility. Among the various religious orders, the spectrum of possible ways to represent Mary was broadened by the inclusion of scenes related to the *Apocrypha*, legends, visions, and ecstasies not discussed here, but which expressed to the faithful the desires of the soul in a way in which history by itself cannot.

Among the artists who depicted such episodes was Caravaggio (1573–1610). His *Madonna of the Pilgrim*, painted for the church of Sant'Agostino in Rome, shows a Virgin and Child walking toward a church so as to allow the Child to be venerated by an old peasant couple. Probably a Madonna of Loreto, rejected because it was not faithful to the iconography of that subject, this work demonstrates the jubilant sensitivity of the late sixteenth century, which sought such new subjects. A *Coronation of the Madonna with the Christ Child and Angels* by Claudio Ridolfi (1570–1644) follows in the same vein.

Another painting by Caravaggio, the *Madonna of the Grooms*, also known as the *Madonna of the Serpent*, now in the Galleria Borghese in Rome, and rejected because the Child is naked, suggests a more theological theme. Mary is the new Eve who steps on the serpent. Under the watchful eye of Saint Anne, the adolescent Child assists her with one foot. A Papal Bull on the Rosary issued in the late sixteenth century by Pius V approved this image: "The Virgin destroyed the serpent with the help of the Child."

The Madonna also participates, through her maternal suffering, in the immolation of the Son. A *Rest on the Flight into Egypt*, possibly of the Ligurian School of the seventeenth century (cat. 10), clearly suggests the destiny of the Child who lies on a rock not unlike His future tombstone. The mother looks at Him while washing a white cloth. Reading the Sacred Scriptures that describe the destiny of the Infant, Joseph, too, anticipates His suffering.

An *Adoration of the Shepherds* is the subject of a Greek-Italian painting that belongs to the cycle of the Childhood of Christ (cat. 8). It suggests that He is a sacrificial lamb. Inspired by more significant works, this theme flourishes throughout Europe during the Counter-Reformation. In seventeenth-century paintings colors are intensified to emphasize the relief from suffering through faith. Artists such as Francesco Solimena (1657–1747), Francesco Trevisani (1656–1746), Sebastiano Conca (1679–1764), Marco Benefial (1648–1764), and Corrado Giaquinto (1703–66) interpret the Virgin as a melancholy figure. This becomes one of the main characteristics of the Roman rococo style, which emphasized the suffering of the Virgin

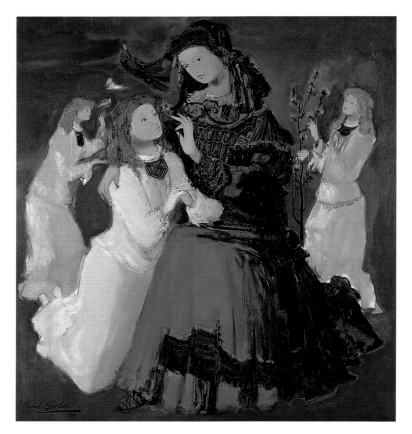

Figure 10. Raoul Soldi
(Buenos Aires 1905–Buenos Aires 1994),
*Saint Anne of the Thistles*, 1972, oil on
canvas, 129 x 120 cm (50 ¹³⁄₁₆ x 47 ⅜ in.),
Vatican Museums, Collezione di Arte
Religiosa Moderna e Contemporanea,
Inv. 23581

by, for example, placing a small cross in the hands of the Child (as in the *Madonna of the Rosary*, in the church of San Domenico at Molfetta, and the *Rest on the Flight into Egypt*, in a private collection in Rome).

TREATISE ON THE TRUE DEVOTION TO MARY (SAINT GRIGNON DE MONTFORT)

In the first part of the nineteenth century, literature focusing on Mary consisted largely of reprints. The most significant publication of this time was the *Treatise on the True Devotion to the Blessed Virgin Mary*, first published in 1843 after the death of its author, Grignon de Montfort (1673–1716). This small volume educated generations of Christians and has frequently been quoted by Pope John Paul II.

In the nineteenth and twentieth centuries, devotion to Mary was strong. Numerous religious congregations adopted the name of Mary. Pilgrimages to locations of apparitions became popular, and popular devotions multiplied during this time. Teachings, for example Pope Pius IX's Bull *Ineffabilis Deus* of December 8, 1854, on the definition of the Immaculate Conception; conversions, including the widely known of the Jew Alfonso Ratisbonne on January 21, 1842, in the church of Sant'Andrea delle Fratte in Rome; and congresses and theological studies all participated in the continued exploration of devotion to Mary. This demonstration of piety stood in contrast to a decrease in interest in Christian art. The French Revolution and its repercussions in Europe had created a vacuum, and Marian art began to look to the past.

In 1810 a group made up almost exclusively of young German painters who had converted to Catholicism came together in Rome; they adopted the name Nazarenes. Johann Friedrich Overbeck (1789–1869) was its instigator and, as a romantic, expressed regard for "the divine Raphael," as exemplified by his

*Triumph of Religion in the Arts*, executed between 1831 and 1840 and now in the Städelsches Kunstinstitut, Frankfurt. In the upper portion the painting reflects the influence of Raphael's *Disputa* of the Vatican, where the Virgin is seated to the right of the Savior, while the lower portion is inspired by Raphael's *School of Athens*. The conventional imitation of Raphael produced a technically proficient but cold and unemotional work. More moving is a fresco representing the *Miracle of the Roses*, which he painted as a youth in the Porziuncola at Assisi. The Nazarenes preferred grand and "inspired" art.

On the other hand, a *Madonna of the Rosary* painted by Tommaso Minardi (1787–1871) in 1840 and now in the Galleria Nazionale d'Arte Moderna, Rome, represents an attempt to create a new iconography, although it is still modeled on the unique perfection of Raphael. Minardi developed an image that merged the *Madonna of the Rosary* with the *Holy Shepherdess*, a devotion stemming from Seville and the Capuchins at the end of the eighteenth century, in which the Virgin appeared to a friar dressed as a shepherdess. This apparition, translated iconographically, came to be popular in Andalucia in Spain, in the South of Italy and Sicily, in the territories of France, and in the Spanish colonies. Indexed by the scholar Louis Réau, this image is a female version of the Good Shepherd described in the Gospel of Saint John (10:1–16), just as the *Pilgrim Virgin*, which originated in Spain in the second half of the eighteenth century, forms a pendant to the *Good Pilgrim* in which Christ is dressed with a hat and cloak.[20]

A painting entitled the *Divine Shepherdess* was executed by Gennaro Maldarelli (1795–1858) for Room VII in the royal palace at Naples. This work was designed for the personal devotion of Ferdinando II. It shows the Virgin in a rose garden; dressed as a shepherdess and wearing a realistic straw hat, she opens her mantle to provide refuge to the lambs, a clear allusion to the Madonna of Mercy.

The representation of the Virgin dressed in a costume is almost always shown outdoors in a garden, as can be seen in the *Madonna and Child with Olive Branches in a Field* by Nicoló Barabino from about 1888, in the church of Santa Maria della Cella at Genoa-Sampierdarena. The presence of olive branches as an iconographic device, together with the flowers in the foreground, anticipates the popularity of floral settings at the end of the century. The *Madonna of Spring*, or *Mystical Flora*, another devotional work by Barabino, further documents the rapport and sentimental relationship among Mary, the flowers, and the faithful.

The experience of the Nazarenes inspired the Pre-Raphaelite movement in England. The young painters who participated rejected the heritage that Raphael's paintings had established, accusing him of academicism. They looked for inspiration to medieval and Flemish art. To indicate heaven they relied on a surreal vision of the world. Paintings that embody these ideas include the *Maid-Servant of the Lord* by Dante Gabriel Rossetti (1828–1882) and the *Shop at Nazareth* by John Everett Millais (1829–1896), painted in the Holy Year 1850, both in the Tate Gallery, London.

A school of fresco painting dedicated to liturgical subjects was founded by Peter Lenz, the Brother Didier (Desiderius), in the Beuron Abbey in Germany. Producing primarily images of contemplation, this school avoided narrative works, favoring instead Byzantine-style representations of the Virgin in majesty, either praying or enthroned (Montecassino). This style was influenced by Egyptian art. Neo-romanesque and neo-Gothic churches displaying work without spiritual emotion sprang up all over Europe.

Exceptional quality in art can be fostered by individuality, often far from the rhetorical currents of sacred art. For the church of St. Denis-du-Saint-Sacrement in Paris, Eugène Delacroix (1798–1863) painted a powerful and mournful *Pietà* in 1844, whose sculptural beauty demonstrates a strong expression of religious sentiment. Jean Auguste Dominique Ingres (1780–1867), an artist who did not favor religious subjects, was asked to paint the *Vow of Louis XIII*. He responded by executing a Virgin and Child inspired by the poetic nature of Raphael's paintings: the *Virgin of the Eucharist*, now in the Louvre. It is impeccable in form yet lacks spirituality.

20. Réau 1955–1959, 2: 123–124.

Figure 11. P. Woellfel, *Annunciation*, 1952, photograph courtesy of Agência General do Ultramar, Lisbon

Figure 12. Lucas Hua, *Saint Joseph Returning from Work*, 1952, photograph courtesy of Agência General do Ultramar, Lisbon

Owing to the peculiarities of its stylistic language, impressionism contributed very little to Christian figurative art. The phenomenon of the so-called art of San Sulpizio, which preserved Christian iconography while attempting to modernize traditional forms of representation, acquired increasing importance in the years from 1850 to 1930. The creation of small figurines, or the remaking of familiar images in then-modern form, is based on widespread secularism and the lack of trust in new artistic expressions.

The twentieth century followed the previous one with further visions, pilgrimages, congresses, and guidelines. In 1942 Pope Pius XII dedicated humankind to the Immaculate Heart of Mary, and in 1950 proclaimed the dogma of the Assumption of the Virgin. Pope Paul VI named Mary the Mother of the Church, and in 1988 Pope John Paul II celebrated the conclusion of a year dedicated to Mary.

Great artists often produce exceptional works on commission. Called by the Dominicans of Vence to paint their chapel, Henri Matisse remained faithful to the artistic tenets he had expressed in 1904: "What I dream of," he had written, "is an art of balance, purity, tranquility, free of subjects that upset and worry" (*Luxe, calme et volupté*). The Chapel of the Rosary in Vence is a hymn to immediacy and simplicity. The poetic floral motifs are spontaneous translations and remembrances of Our Lady of the Rosary, a delicate commentary on yearning and spirituality: "I would like my work to be like a flower. I would like it to be my best work." The Vatican Museums hold the preliminary drawing for Matisse's 1949 *Virgin and Child* (fig. 7). Intended for the right wall of the chapel, it is executed in charcoal and ink on a large sheet of paper. There is also a very beautiful series of nine lithographs of the Blessed Virgin (figs. 8, 9).

Raoul Soldi, an Argentinian painter, left an extraordinary Marian cycle in the Chapel of Saint

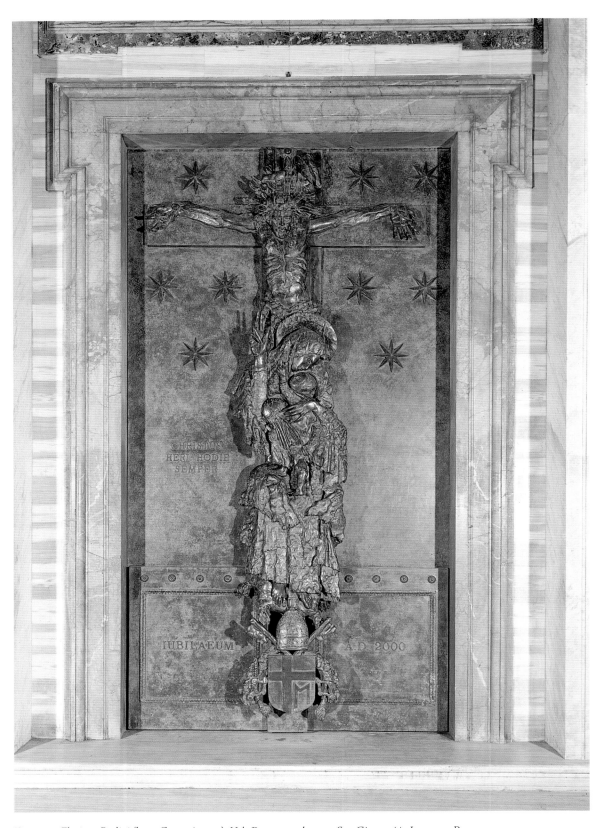

Figure 13.  Floriano Bodini (born Gemonio 1933), *Holy Door*, 2000, bronze, San Giovanni in Laterano, Rome

Anne at Glew, Buenos Aires. Because this artist was not bound by traditional religious conceptions, his creative freedom is inspired by a delightful innocence that illuminates and transforms the episodes, guided by the artist's religious feelings and his own imagination. The frescoes are imbued with atmosphere, spirituality, and luminosity. They show a world of fables and marvels, such as that found in Gothic painting. The narrative progresses from Saint Anne (for whom the church near Soldi's summer home was named) to Mary, the inspiration for his music (the parish priest played the harmonium while Soldi painted). The cycle includes events from the life of Mary, among them *The Birth of the Virgin*, *The Childhood of the Virgin*, *Saint Anne*, *The Presentation of the Virgin in the Temple*, *The Marriage of the Virgin and Joseph*, *The Visitation of Mary to Elizabeth*, *The Adoration of the Magi*, and *The Glorification of Saint Anne Meterza*.[21] Mary's path on earth is rendered in glorious blue skies and vivid, sunny colors. The Vatican collections include one work by this lyrical artist, *Saint Anne of the Thistles* of 1972 (fig. 10). Its iconography is based on the education of the adolescent Mary, performed by Saint Anne, in the fields where nature enchants and instructs.

21. Lainez 1979.

As demonstrated by the examples in the exhibition, Marian iconography in our times has essentially been based on two well-established subjects, the *Madonna and Child* (cats. 28–32, 34), showing Mary as Mother tenderly holding the Child, and the *Pietà*, expressing suffering and human tragedy (cat. 35). Other subjects or episodes are rare. An *Annunciation* by Bardi is a highly personal interpretation (cat. 36).

Countries in which missionaries have been active often contribute new iconographic interpretations, restating their lyrical and poetic tradition in religious themes. From French Africa, a scene of the *Annunciation* (fig. 11) by P. Woellfel shows an angel devotedly delivering a letter to the Virgin. The *Flight into Egypt* is translated into a voyage guided by Mary, who holds a flower to illuminate the path while carrying the Child on her shoulders. A donkey and Joseph, with a basket on his head, follow her.[22] A sculpture from Tanzania, *Nativity and Flight into Egypt* (cat. 12), provides an example of sculpture that transforms biblical episodes through simple and direct messages. The episode of the Flight into Egypt suggests the suffering of emigration, expressed in language tied to life and religious poetry.

22. Lisbon 1952.

Lu Hung Nien expressed intimate religious themes anew in his *Nativity* and *Adoration of the Shepherds*. Lucas Hua, relying on the suggestions of Cardinal Celso Costantini, painted an *Annunciation* and a *Nativity* in the figurative and descriptive language typical of China. In *Saint Joseph Returning from Work* (fig. 12), the Virgin and the Child are at home, awaiting the arrival of the chaste husband and father. Here the Holy Family is portrayed in a moment of intimate communion and emotion, despite the great distance suggested by the painter: Joseph is seen far away, on the opposite side of the painting, while the Mother and Child are on the threshold of their home. A marvelous Chinese landscape fills the area between them.[23]

23. Lisbon 1952.

Pope John Paul II placed a cross on his papal emblem, below which are an "M" for Mary and, signifying his trust in her, the words *Totus Tuus*. In Saint Peter's Square he added a mosaic to one of the windows of the Apostolic palace for all the world to see, the *Madonna Presenting the Child*, an image adapted from an Eastern icon. In the year of the Jubilee, the basilica of Saint John Lateran acquired a new holy door made of bronze by Floriano Bodini (fig. 13). At the foot of the cross, in the Crucifixion that reflects Christ's extreme pain of death, are a Madonna and Child. Thereby opens the new millennium, reflecting on suffering and love joined together in the difficult path of religious art.

Roberto Zagnoli

# The Teachings of Pope John Paul II on Mary, Mother of God

O F ALL THE POPES WHO HAVE WORKED and ministered over the course of the last century, John Paul II has undoubtedly given the greatest attention to the Virgin Mary. It is to her that he dedicated an Encyclical, *Redemptoris Mater*, and to her that he entrusted the conclusion of the second millennium of the birth of Christ, designating 1987 as the Marian Year of the Church. Taking inspiration in her as "the highest expression of the feminine genius" (*Letter to Women*, 10), he avidly proclaimed the dignity of women and their contributions throughout history in his Apostolic Letter, *Mulieris Dignitatem*. During the three years of preparation for the celebration of the Great Jubilee Year 2000, he called upon Mary to be present for the duration of the preparation phase (*Tertio Millennio Adveniente*, 43). On his pontifical emblem the Pope added the motto *Totus Tuus* to the "M" for Mary, which is placed next to the cross, unequivocally expressing the will to entrust to the Virgin his life and pontifical mission: "May the unassuming Young Woman of Nazareth, who two thousand years ago offered to the world the Incarnate Word, lead the men and women of the new millennium toward the One who is 'the true light that enlightens every man'" (John 1:9) (*Tertio Millennio Adveniente*, 59).

The love for the Mother of God is deeply rooted in the Pope, for the people of Poland have always perceived Our Lady as "the star of the Sea" for those who take the path of faith. Those who "lift their eyes to her from their earthly existence. . . do so because 'the Son whom she brought forth is He whom God placed as the first-born among many brethren'" (Romans 8:29) (*Redemptoris Mater*, 6). The Sanctuary of Our Lady Jasna Góra is undoubtedly the symbol for these profound, personal roots of the Polish people. "Jasna Góra has become the spiritual capital of Poland. Pilgrims from all the corners of the Polish land come here to again find unity with Our Lord Jesus through His Mother's heart. . . . Around the world, the image of Our Lady of Jasna Góra has become the symbol of the spiritual oneness of the Polish people. At the same time, it is a distinct symbol of unity in the large family of Christians, a family united in the Church."[1]

1. Częstochowa 1977, 12.

From the beginning of his papacy, the Pope has filled his life with gestures that set aside a special devotion to Our Lady: from the visit to the various Marian sanctuaries, the coronation of the holy images of Our Lady, up to May 12, 2000, when he gave Our Lady of Fatima the gift of the Episcopal ring received from Stefan Cardinal Wyszynski, Primate of Poland, immediately after his election. These are all signs of his dedicated filial devotion to the Mother of God.

Pope John Paul II's gestures are closely linked to his personality. His teachings, inspired by the Holy Spirit, benefit the entire Church of God. It is impossible to summarize them; considering the wealth of his teachings and our limitations of space, we can only touch on some of the most significant.

We should note that the Pope, in all his thinking—including his feelings for the Virgin Mary—has been faithful to the guidelines of the Second Vatican Council; in particular to *Lumen Gentium*, which is expressly dedicated to Mary and to her presence in the Mystery of Christ, the Mystery of the Church, and to her union with the person and the mission of salvation of the Son. This union is a theme he stresses continually. Within the indivisible union between Our Lady and the Son, one finds two significant themes: presence and dimension.

## THE PRESENCE OF MARY

The presence of Mary is a recurring theme in the teachings of the Pope. In the Encyclical *Redemptoris Mater*, which could be considered the highest expression of the Pope's teachings on Mary, Our Lady is seen in the light of a fundamental event: the Incarnation. Mary is called upon to become the Mother of the Savior and, as such, our Mother. Pope John Paul II has coined an expression to underscore the relationship between the Mother, the Son, and humankind, stressing the "maternal mediation" of Mary. This mediation is undoubtedly linked to the unique mediation of Christ, according to the Second Vatican Council (*Lumen Gentium*, 60), and is a "mediation in Christ" in accordance with Pope John Paul II's writings (*Redemptoris Mater*, 38). In a catechesis the Pope indicates that God "willed that this woman, the first to receive His Son, should communicate Him to all humanity. Mary is therefore found on the path that leads from the Father to humanity as the mother who gives the Savior Son to all" (General Audience of January 12, 2000).

Consequently, the Mother of Jesus is present in the path of the Church; she leads the Church and all Christians on the road to faith, hope, and charity. Mary is witness to the essence of the Church, its union with Christ. Mary is the archetype (*Redemptoris Mater*, 27), the image of the Church, not only the model (*Redemptoris Mater*, 42). After the Pentecost, the Church refers to Mary and considers her the privileged witness of Christ. The mystery of the Incarnation is the origin of the deep piety that connects the Church to Mary. In his teachings, Pope John Paul II often refers to the inseparable union between Christ, the Church, and Mary, and shows that Mary's faith is a fundamental component of the faith of the Church. Mariology is thus an internal requirement of Christology, a necessary emanation of the awareness the Church has of itself. "Mary, we beg you to shine on the horizon of the advent of our times, while we approach the third millennium after Christ. We wish to deepen our awareness of your presence in the Mystery of Christ and the Church, as the Council has taught us" (Saint Peter's Basilica, homily of January 1, 1987).

The Pope has repeatedly indicated that his vision of Mary stems from the profound study of Mariology by Saint Louis Grignon of Montfort. The doctrine of this saint is implicit in the statements of the Second Vatican Council. At the very core we always find the Mystery of the Incarnate Word in Mary. God has forever chosen her for this specific vocation. Within the Mystery of the love of the Holy Trinity, Mary is the keeper of treasures; she knows the most intimate secrets. "We should know Mary more than ever," writes Grignon de Montfort, "for the best knowledge and glory of the Holy Trinity."[2]

Pope John Paul II—and it could not be otherwise—focuses on the Incarnation of the Son of God, which is essential for understanding and explaining Mary: "Only in the Mystery of Christ is her mystery fully made clear" (*Redemptoris Mater*, 4). Motherhood as grace finds its own dimension from the conception to the birth of the Son, and in this its own explanation is embodied.

In the teachings of the Pope, we are constantly reminded and made aware of the maternal presence of Mary in the life of each Christian and in the life of the entire Church. This presence is an intrinsic element at the very core of the faith, but it is also evident in popular worship. It is a reality that should not be dismissed, as the Pope underlined on the occasion of the preparations for the 20th International Mario-

2. Grignon de Montfort 1983, paragraph 50.

logical-Marian Congress that took place in Rome for the Great Jubilee of the Year 2000. The Pope reiterated the idea that, between theological reflection and popular devotion, elements of profound connection and symbiosis may be detected. "I am delighted that reflection on Mary's unique role in the Mystery of Christ and the Church is being constantly developed in the light of the Second Vatican Ecumenical Council. This deepened understanding has its roots in popular devotion to Mary and, at the same time, helps to nourish, elevate, and purify it" (*Angelus* of July 4, 1999).

The presence of Mary is a gift Christ gave to humankind from the cross. Perhaps it is because of our weakness that Christ gave us such a mother. The Son of God knows better than we that we need the spiritual motherhood of the Virgin if we are to walk the path of evangelic conversion, which depends on us making ourselves small, so that we may become "poor in spirit" (Matthew 5:3)—an expression that stresses the need for a simple heart, a childlike heart. On this subject, we should refer to another teaching of the Lord: "Amen, I say to you, unless you turn and become like children, you will not enter the Kingdom of heaven" (Matthew 18:3).

Mary partakes both of the Mystery of God and the Mystery of humans. In his last visit to Częstochowa, the Pope said: "We are used to telling her everything. She is particularly present in the Mystery of Christ and the Church, in the Mystery of each man" (Speech, June 17, 1999).

It is as if the Pope were saying that God wants to see the Marian imprint in humanity, rendering it Marian in itself and in its manifestations. In fact, the heart of Mary is the fullness of the saving grace, mercy, and love of God that accompany humans, as symbolized by the Apostle John at Calvary, to "give him back his lost child." She is a model, but she also is a God-given maternal consolation with full powers of mediation (Wadowice, June 16, 1999).

During his last trip to Poland, the Pope again remembered this unique union of Mary with the Holy Trinity. This issue later became the theme of the Mariological-Marian Congress during the Jubilee: no one has experienced the Trinity love of Father and Son and Holy Spirit to the same extent as Mary, Mother of the Incarnate Word. On behalf of all his compatriots, the Pope addressed the Queen of Poland, Our Lady of Częstochowa, asking for her continued protection from the burdens that history has placed on them: "I beg you, Mother of Jasna Góra, Queen of Poland, embrace in your Maternal heart my entire Nation. Strengthen her courage and the power of her spirit, so that she may face her grave challenges. So that she may cross the threshold of the third millennium with faith, hope, and charity and renew her faith in your Son, Jesus Christ, and in his Church, built on the foundation of the Apostles. Our Mother of Jasna Góra, pray for us and guide us so we may witness Christ, Redeemer of all men. Take care of our entire Nation that lives for your glory, let it develop splendidly, Mary" (Częstochowa, June 17, 1999).

## MARIAN DIMENSION

We wanted to expressly quote the words of this fervent prayer because they reflect the doctrine developed by Pope John Paul II during his pontificate. *Totus Tuus*, the motto that accompanies the Papal emblem, is "the abbreviation of the most complete trust in the Mother of God"[3] and at the same time "an attitude of complete abandonment" to her.[4] The motto of the Pope expresses the fundamental Marian dimension of the life of each Christian.

In the Encyclical *Redemptoris Mater* (45), the Pope writes: "The Marian dimension of the life of a disciple of Christ is expressed in a special way precisely through this filial entrusting to the Mother of Christ, which began with the testament of the Redeemer on Golgotha."

On the subject of "Marian dimension" we should note that it contains another aspect repeatedly

3. John Paul II 1996, 38.

4. Messori 1994, 233.

underlined by the Pope in his teachings. In the *Mulieris Dignitatem* (27), for instance, John Paul II indicates the vital relationship that exists between the "Marian dimension" and the "dimension of Peter: . . .one can say the Church is both 'Marian' and 'Apostolic—Petrine.'" This Marian profile is as fundamental and typical—if not more—for the Church as the Apostolic profile of Peter, with which it is deeply linked. The Marian dimension of the Church precedes that of Peter, although they are closely connected and complementary to one another.

The Holy Father repeats in *Mulieris Dignitatem* (27) what he had stated in 1987 to the cardinals and prelates of the Roman Curia: "This link between the two profiles of the Church, the Marian profile and the Peter profile, is therefore profound and complementary; however, the Marian profile predates the latter both in God's design and in time, and it is more elevated and richer in personal and community implications for each ecclesiastic vocation. . . . Let her help us better discover this wealth that is within us and help us live it more authentically—I should say, more vitally and decisively; let her help us knowingly incorporate ourselves in this symbiosis between the Marian dimension and the Apostolic-Peter dimension from which the Church derives every day orientation and support."

Pope John Paul II has used emphatic, profound words to express the relationship linking Mary to the Church and therefore to all, "the Marian dimension of the Church." He used the words in 1984 in a homily celebrated in Spain where he stated that there is "a third, very deep and special dimension: the Marian dimension" (Saragoza, October 10, 1984).

The Marian dimension of the Church has been repeatedly recalled in the teachings of the Pope as a natural consequence of his teachings about the Virgin Mary. When reflecting on Our Lady, he continually emphasizes the doctrine of the indissoluble union between Christ and Mary, which begins with the Annunciation and ends at Calvary, inclusive of the wide range of the Redemption of Christ. One of the richest, most significant texts describing the union between Christ and Mary is found in a catechesis of the Pope. Understanding this text is essential to comprehending the truth of filial trust in Mary. Starting with the Mystery of the Cross, the Pope states: "Thus Mary is established, in that instant—or we could almost say, is 'consecrated'—from the cross, as the Mother of the Church. In this gift that Christ gives John and, through him, His disciples and all humankind, there is almost a complement of the gift of Himself that Christ gives humanity with His death on the cross. Mary and He constitute 'one,' not just because they are Mother and Son 'in the flesh,' but because, in the eternal design of God, they are contemplated, predestined, placed together at the center of the story of salvation; and so Jesus feels He should involve His mother, not only in His own offering to the Father, but also in the gift of Himself to humankind; and Mary, in turn, is in perfect harmony with the Son in this act of offering and gift, as if through a prolongation of the Annunciation *fiat*" (General Audience of November 11, 1988).

This entrusting of the Son should correspond to the entrusting of the disciple. Placing oneself in the hands of the Mother of Jesus is one of the "duties of the disciples," willed by Christ Himself. "The Marian dimension of the life of a disciple of Christ is expressed in a special way precisely through this filial entrusting to the Mother of Christ, which began with the testament of the Redeemer on Golgotha. Entrusting himself to Mary in a filial manner, the Christian, like the Apostle John, welcomes 'the Mother of Christ into his own home' and brings her into everything that makes up his inner life, that is to say into his human and Christian 'I': he 'took her to his own home'" (*Redemptoris Mater*, 45).

During the years of preparation for the celebration of the Great Jubilee and the beginning of the third millennium, the Pope entrusted the responsibility of the entire Church "to the maternal intercession of Mary, Mother of the Redeemer. She, the Mother of Fairest Love, will be for Christians. . . the Star which safely guides their steps to the Lord" (*Tertio Millennio Adveniente*, 59).

In the Papal Bull announcing the Great Jubilee, he begs Mary to "to guard the steps of all those who will be pilgrims in this Jubilee year. And through the coming months may she intercede intensely for the Christian people, so that abundant grace and mercy may be theirs, as they rejoice at the two thousand years since the birth of their Savior" (*Incarnationis Mysterium*, 14).

On the closing of the Holy Year, he again entrusts to her the entire Church and the path that the community of believers will take: "On this journey we are accompanied by the Blessed Virgin Mary to whom, a few months ago, in the presence of a great number of Bishops assembled in Rome from all parts of the world, I entrusted the Third Millennium. During this year I have often invoked her as the 'Star of the New Evangelization.' Now I point to Mary once again as the radiant dawn and sure guide for our steps. Once more, echoing the words of Jesus himself and giving voice to the filial affection of the whole Church, I say to her: 'Woman, behold your children'" (John 19:26) (*Novo Millennio Ineunte*, 58). In these expressions and in the spirit that informs them, we find the total filial devotion of a Pope who may be justly called "Marian."

# ·CATALOG·

## Eve and Mary

"But when the fullness of time had come, God sent his Son, born of a woman."

With these words in his *Letter to the Galatians* (4:4),

the Apostle Paul links together the principal moments that determine

the fulfillment of the mystery predetermined in God (Ephesians 1:9).

The Son, the Word one in substance with the Father,

becomes man, born of a woman, at "the fullness of time."

This event leads to the turning point of the history of man's history on earth,

understood as salvation history. It is significant that Saint Paul

does not call the Mother of Christ by her own name, "Mary,"

but calls her "woman:" this coincides with the words of the Proto-evangelium

in the Book of Genesis (3:15). She is that "woman" who is present

in the central redeeming event that marks the "fullness of time";

this event is realized in her and through her.

·

POPE JOHN PAUL II, *Mulieris Dignitatem*, 3

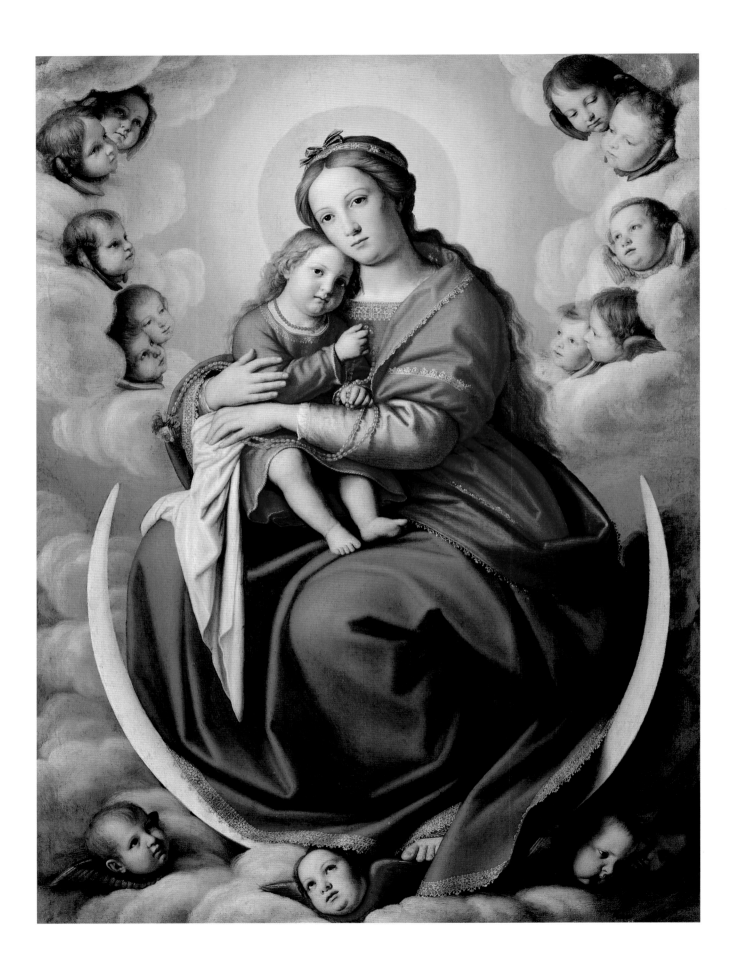

1      GIOVANNI BATTISTA SALVI, called SASSOFERRATO (Sassoferrato 1609–Rome 1685)

*Madonna and Child*

c. 1650

oil on canvas, 131.4 x 97.8 cm (51¾ x 38½ in.)

Vatican Museums, Vatican Pinacoteca, Room XIV, Inv. 40396

LITERATURE: *Indicazione* 1857; Macé de Lépinay 1990; Pietrangeli 1985;
Strinati 1986

This painting, given by Isabella II to Pius IX,[1] became part of the Vatican Pinacoteca collections in 1857[2] with an attribution, later unanimously accepted by critics, to Giovanni Battista Salvi, called Sassoferrato after his birthplace.

    As was customary during the baroque, a variety of iconographic elements were combined in this work. One finds symbols alluding to the Immaculate Conception and to Mary, Madonna of the Rosary. The half-moon beneath Mary's feet refers to the Immaculate Conception. Mary is seated amid clouds and surrounded by the heads of cherubs, a reference to the Book of Revelation (12:1). Clearly inspired by the Virgin as the Madonna of the Rosary is the Child who holds an amber rosary topped by a rose, a symbol of Mary, Queen of Heaven.

    The Child's necklace of coral prefigures Christ's Passion, pointing to the salvation of humankind and the victory of good over evil that results from Christ's sacrifice. The identification of red coral with blood has its origins in antiquity. Ovid, describing the death of Medusa in *Metamorphosis*,[3] writes of the soft rushes beneath the severed head, which on contact with the blood "hardened and assumed a rigidity unknown to branches and fronds. Even today the nature of coral remains unchanged: upon contact with the air, it assumes a hardness; and however flexible the rushes in the water, once outside the water, they become hard as stone." According to Claudio Strinati, the painting was executed around 1650.[4]

    Images of the Virgin occupy a prominent position in Sassoferrato's oeuvre. In 1865 Théodore Lejeune noted that the artist was "rightfully called the painter of Madonnas" because of his "utterly exceptional talent for depicting the divine image of the Mother of Christ."[5] Over the course of his career the artist created literally hundreds of canvases representing Mary.

    Little is known of the artist's early training, except that he learned the rudiments of painting from his father, Tarquinio. While some have identified Domenichino as Sassoferrato's teacher, it is more likely that, as a young man, he spent time in Perugia where in 1632 he painted a copy of Giovanni di Pietro of Spagna's *Madonna of the Lily* for the cell of Leone Pavoni, abbot of the monastery of San Pietro.

    Sassoferrato's presence in Rome in 1641 can be confirmed by a canvas of that year depicting the *Madonna and Child with San Francesco di Paola,* commissioned to decorate the ceiling of the sacristy of the church. A second canvas, *Madonna of the Rosary,* was executed in Rome in 1643 for Santa Sabina. Sassoferrato's activity between 1650 and 1683 remains uncertain. It is known, however, that he created copies of at least three Madonnas painted by Pierre Mignard and engraved in Rome by F. de Polly, as well as a *Self-Portrait,* which Cardinal Flavio Chigi gave to Cosimo III de' Medici.

    The painter died August 6, 1685, at the age of seventy-six, leaving his estate to his six children. His style reveals a variety of influences, including the Carracci circle, Domenichino, Spadarino, and Cecco del Caravaggio, as well as "utopian" classicists such as Eustache Le Sueur and Laurent de La Hyre.[6]

<div align="center">A.M.D.S.</div>

1. Pietrangeli 1985, 177.

2. *Indicazione* 1857, 5, 26, 27.

3. Ovid, *Metamorphosis*, Book 4, 745–752.

4. Strinati 1986, 13–16.

5. Macé de Lépinay 1990, 37.

6. Strinati 1986, 13, 14.

2   *Cover Plate for the Burial Niche of Pontiana*
early 4th century
fine-grained white Italian marble with gray veining, 25.9 x 140 x 4.4 cm
(10³/₁₆ x 55⅛ x 1¾ in.)
Vatican Museums, Museo Pio Cristiano, Inv. 32458
INSCRIPTION:  VIBAS PONTIANA / INAETERNO
EXHIBITION:  Vatican City 1997
LITERATURE:  Ferrua 1963–1964, 118; Ferrua 1979, 48; *ICUR* 1, 1723; F. Bisconti and
C. Lega in Di Stefano Manzella 1997, 301–302, no. 3.8.1

This plate was reconstructed in the eighteenth century from five fragments; it is incomplete at both sides.
An inscription dates to the nineteenth century. At the left edge, between two lambs, is an engraved figure
of the Good Shepherd. Only the lower portion of the figure is intact, including the legs and hips; the shep-
herd is clothed in a scant tunic. The upper left corner of the plate is lost. Adjacent to the Good Shepherd
is a rustic dwelling, with a seated woman who is spinning and winged farmyard animals that are possibly
chickens. Three peasants follow. The first brandishes a cane in order to drive oxen toward an enclosure

while the other two appear to be helping. At the center of the plate are Adam and Eve, depicted on either side of what is perhaps a palm tree with a serpent wound around it. Carved to the right of this scene are the words *Vibas* [sic] *Pontiana / InAeterno*, "May you, Pontiana, live in eternity." The text is irregularly spaced with one letter inverted. Below it a man guides a plow pulled by two oxen, which are chased by a dog. The representation concludes with a scene showing the Old Testament story of Daniel, who is naked and praying among the lions.

If the composition seems at first confusing and cryptic, a closer look reveals a distinct logic. The biblical scenes, which alternate with scenes of rural life, begin at the left with an image of the Good Shepherd, a metaphor of God's divine love for His flock. At the center, Adam and Eve represent the existence of evil in the world and the origin of human suffering. Daniel among the lions concludes the biblical passages, underscoring the prophet's faith in God as an unmistakable expression of the path one must follow to heavenly life. This is further emphasized in the inscription, which affirms that Pontiana's death should be seen as the beginning of eternal life. The episodes described in the two pastoral scenes, the rural dwelling with the woman spinning and the oxen as well as the plowing scene, are tied to contemporaneous agrarian themes. They allude to everyday life, yet also recall an existential philosophy that is both ascetic and contemplative. Here, death is part of nature, and thus the lives of humans follow the inexorable cycle of the seasons.

G.S.

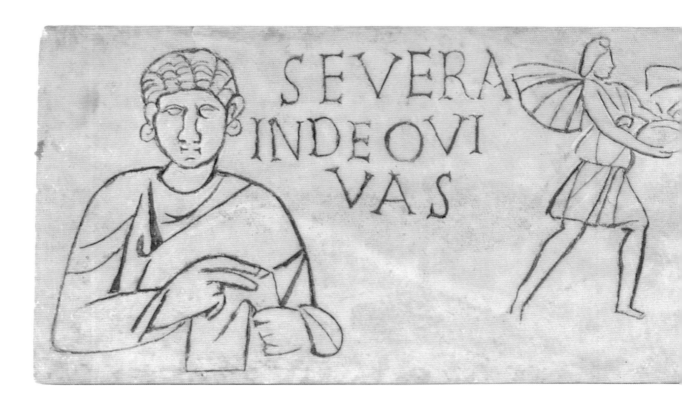

3    *Lid for Sarcophagus of Severa with Scene of the Epiphany*
early 4th century
fine-grained white Italian marble,  31.8 x 101.3 x 2.5 cm (12½ x 39⅞ x 1 in.)
Vatican Museums, Museo Pio Cristiano, Inv. 28594
INSCRIPTION:  SEVERA / IN DEO VI / VAS
PROVENANCE: Taken from the catacombs of Priscilla in 1751, the slab was placed
in Santa Maria in Trastevere and later entered the collection of the Museo Pio
Cristiano in the Lateran.
EXHIBITIONS:  Brisbane 1988; Rimini 1996; Vatican City 1997; Montevideo 1998;
Santiago 1998
LITERATURE:  ICUR 23279; Calcagnini Carletti 1988, 65–87; Daltrop 1988, 98, no.
21; Spinola 1996, 221, no. 70; Spinola 1998, 93; C. Lega and F. Bisconti in Di Stefano
Manzella 1997, 302, no. 3.8.2; G. Spinola in Di Stefano Manzella 1997, 26, 34; Testini
1972, 271–347

This cover was reconstructed from three fragments in the second half of the eighteenth century, and the
edges were smoothed. In the mid-nineteenth century the slab was exhibited in the Museo Pio Cristiano
(then in the Lateran); at this time the carvings were also retraced and the entire surface repolished.
     On the left side is the portrait of the deceased, dressed in a tunic and palla and holding a scroll in

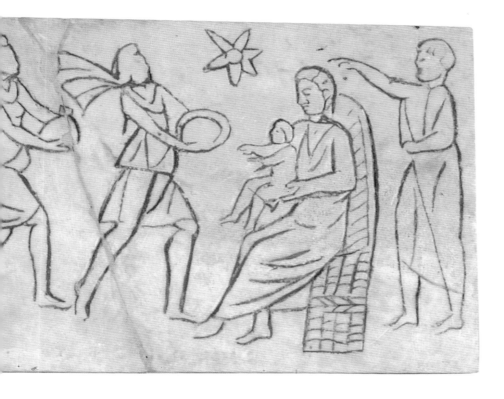

her left hand while raising her right hand in a gesture of greeting. Intended to highlight the social status and cultured life of the deceased, her stance is similar to that used in portraying philosophers. Her face is round and characterized by closely spaced eyes and a broad nose. Her mouth and chin are small, and her uncovered ears are adorned with two large hoop earrings. Her coiffure is arranged in wide, wavy bands that are divided horizontally into smaller parts. It is a late variant of the *Nestfrisur*, a hairstyle introduced by Giulia Domna, wife of the emperor Septimus Severus, in the late second century AD. The earlier Severian hairstyle has been reinterpreted in a new form, in accordance with a fashion adopted by the empress Fausta in AD 325.[1] The fixed gaze and high-ridged coiffure are similar to a portrait attributed to the Constantine era that was recently located in the Basilica Hilariana on the Coelian hill.[2] Consequently, although this hairstyle—and therefore the slab—was previously dated to the second half of the third century, it is now possible to place the work in the Constantinian era. Carved on the left side of the slab is *Severa in Deo Vivas,* "May you live in God, Severa." The deceased is thereby entrusted to a new life in the glory of God. On the right side is a scene of the Epiphany, announcing the beginning of the new Christian era (Matthew 2:1–12). The three Magi are walking rapidly toward the Madonna, who has the Child in her arms. They are clothed in short tunics, with mantles fluttering behind them. Phrygian caps recall their oriental origin. Guided by the star, they bear gifts of gold, incense, and myrrh. The Madonna, seated on a wicker throne, awaits them with the infant Child who extends His arms toward the Magi. It should be noted that the Madonna's hair is styled in the same manner as that of the deceased. At the far right is a figure with one arm pointing upward; this may be Saint Joseph, gesturing toward the Magi, or perhaps the prophet Balaam (or Isaiah), pointing to the star.

G.S.

1. Calza 1972, 249, pl. LXXXVI, fig. 302.

2. Carignani 1990, 189–191.

4      MASTER OF SANT'IVO (?) (Florence late 14th–early 15th century)
*Madonna and Child (Madonna Queen of Heaven)*

1390–1395

tempera and gold on panel with incorporated frame, 83 x 47.5 cm
(32 11/16 x 18 11/16 in.), painted surface, 78.7 x 44.5 cm (31 x 17½ in.)

Vatican Museums, Vatican Pinacoteca, Storage, Inv. 40524

PROVENANCE: Vatican Pinacoteca since 1909

EXHIBITION: Exhibited for the first time

LITERATURE: Amato 1988a; Amato 1988b; Antal 1960; Andaloro 2000; Bernardini 1916, 80; Bertini Calosso 1920, 66; Boskovits 1968a; Boskovits 1968b; Boskovits 1975; Byam Shaw 1967; Di Fabio 1988; Gandolfo 1988; Meiss 1982; Pietri 1988; Rossi 1994; Salmi 1930; Salmi 1955; Sbrilli 1987, 561; Tambini 1982, 118

In the illusory space contained within the arched frame, the Madonna sits enthroned against a damask drape that functions as a flat, two-dimensional backdrop. The pattern of the fabric, densely decorated with arabesques, fills the image area, obliterating any suggestion of depth and volume in favor of line. The chair is hidden by the presence of a large cushion, its contours echoing the flow of the Virgin's mantle. The Virgin is clothed in a tunic that is gathered at the waist by a knotted cord. She wears a crown of lilies and holds on her lap the Child, who has His arms around her neck. The spirituality of the image is heightened by the brilliant, flickering colors, which have been embellished with a profusion of gold, and by an engraved halo.

From a thematic and doctrinal point of view, the painting is a variation of the iconography of the *Maestà*, or Virgin in Majesty. It follows the traditional formula for this theme, from the throne to the crown to the tabernacle drapery, employing an intentionally didactic scheme that emphasizes the regal nature of Mary and her identification with the Church.[1] The private purpose of the altarpiece, on the other hand, explains the "everyday affability" seen in the stance of the Son. The individuality and liveliness of facial expression suggest a nascent late-Gothic sensibility.[2]

While modest in its pictorial approach, this painting nonetheless bears the weight of a demanding iconographic legacy, codified at the beginning of the mid-third century in Roman funerary painting and devoted to the Virgin in her central role of maternity (the *Theotókos*, in the Greek sense) and to the theological supremacy that this role implies (the iconography of the Enthroned Madonna, or *Panaghía Nikóroia*). Early representations of Mary's majesty that reflect this perspective can be found in mosaics with scenes of the Infancy of the *Logos* in the triumphal arch of Santa Maria Maggiore. There, Mary appears adorned in rich vestments like a Byzantine empress, with diadem, necklace, earrings, and a purple tunic woven with golden threads, and as a Queen of Sorrow, in the same shell-shaped apse, at the height of the cycle's ideological and formal program.[3]

Mary is later depicted as *Theotókos*, or Mother of God, in the so-called little basilicas of the catacombs of Commodilla (panel of Turtura, generally dated 528), the three icons of Santa Maria Nova (fifth century), Santa Maria in Trastevere (late sixth–first half seventh century), and Santa Maria ad Martyres (early eighth century), as well as in other contexts, such as the wall-palimpsest of Santa Maria Antiqua (second half sixth century) and the scenes from the life of Christ in the presbytery of the same church (seventh–eighth century), arriving at a formulation of solemn stateliness that is shared by the entire Christian Church.[4] The image of Mary rendered in Roman iconography recurs in mosaics in Ravenna during the

1. Cipriano di Cartagine, *Oratio dominica* 5; *Testimonia* 2, 21.

2. Boskovits 1975, 241, 378.

3. Gandolfo 1988, 85–123; Pietri 1988, 1–6.

4. Amato 1988a.

5. Amato 1988b, 8, 7–17.

Theodoric era, in Sant'Apollinare Nuovo (before 526), in the Basilica Eufrasiana in nearby Parenzo (530–560), in Panaghía Kanakaría in Lythrankomi in Cyprus, and finally in the icon of Saint Catherine of Mount Sinai (second half sixth century) with its Syrian-Palestinian origins. Here "the Virgin, unlike in Rome, is not idealized as a regal image," but is described as a "woman of the people, yet imbued with the important place she occupies in salvation through virginal maternity."[5] This is the first indication of a humanization in the relationship between Mother and Child, echoing that of the Byzantine *Glykophilousa*, which will undergo important developments later. From this time forward, "the group of the Virgin and Child, rendered in conformity with these prototypes—or according to variations that, in any case, will not erode the original impression—will long characterize" the iconography of Mary in the West.[6]

6. Andaloro 2000, 147–151.

This scheme, as formulated in early Christian art, easily moves into medieval imagery. It is progressively embellished with ornamental details, at times inspired by sources from the Bible or Church Fathers, at other times by contemporary courtly literature (such as the French *Vierges au buisson de roses* and the *Schöne Madonnen* from the central European tradition). Between the late thirteenth and the early fourteenth centuries, the Gothic model of the *Maestà* is particularly manifest around Florence and Siena, where it is linked to the work of Cimabue, Giotto, Duccio, and Simone Martini. In the second half of the fourteenth century, the theme, similar to the "doctrine of the Virgin in Majesty in Île-de-France culture,"[7] is charged with additional symbolic meaning linked to the changing ethical-religious leadership that followed the plague of 1348.[8] The Florentine Madonnas of Jacopo and Nardo di Cione, Agnolo Gaddi and Niccolò di Pietro Gerini, characterized by the two-dimensionality preferred by their conservative patrons,[9] constitute the closest antecedents for this painting.

7. Di Fabio 1988.

8. Meiss 1982, 46–62, 103–108, 207–245.

9. Antal 1960, 464–467.

It is significant that Giorgio Bernardini, who was the first to examine this panel in depth, pointed out its tenaciously archaic character (the lack of depth, the disproportionate halo, and the decorative use of color) in its graphic presentation and its composition, already potentially late-Gothic. Thus he aligned it with a signed triptych in the Galleria Nazionale in Rome (no. 4129; now in the Museo Capitolare of Santa Maria Maggiore ad Alatri), attributing it to Antonio d'Alatri (active c. 1440–1450), an eclectic exponent of a lingering culture in which isolated elements related to the Sienese and Umbrian-Marches regions resurface.

10. Byam Shaw 1967, 38.

From an entirely different critical perspective, Byam Shaw, relating an opinion of Federico Zeri,[10] changed the attribution to the Master from Lazio (taken up again by Bertini Calosso in 1920 and by Antonella Sbrilli in 1987) in favor of a "follower of Agnolo Gaddi, rather close to Cenno di Ser Cenni," painter of a Madonna in Christ Church Gallery, Oxford (no. 17), which is of superior execution and has an identical cultural approach. Miklos Boskovits attributed both works to a hypothetical Master of Sant'Ivo, "Florentine, probably from the workshop of Agnolo Gaddi, but also influenced by Lorenzo di Nicolò and by Mariotto di Nardo,"[11] a modest copier of devotional images between the late fourteenth and the early fifteenth century. Boskovits' attribution definitively shifted the emphasis to a Florentine context, reconnecting it to a broader debate concerning the artist's oeuvre. Anna Tambini, for example, attributed to the same master a Madonna in the church of Santa Maria Assunta in Bagno di Romagna, but Francesco Rossi did not agree with this or with any other attribution. Rossi perceived the Vatican panel to be "the provincial product" (or in any case destined to the provinces) of a "not necessarily Florentine" imitator of the (Florentine!) creator of the Oxford Madonna. He saw in the Romagnese panel "the first sign of 'marginal' activity outside specifically Tuscan confines" of this master.[12]

11. Boskovits 1975.

12. Rossi 1994, 151–153, cat. 46.

Taking into account the current condition of the painting (a thick, yellowish compound clouds the entire surface, making it difficult to evaluate what is probably extensive retouching), its Florentine origins nonetheless do not appear to be in doubt. Despite the reservations of Rossi, who assigns the work to

the years 1410–1420, the iconographic canon of the panel, in fact, anticipates that of comparable compositions by Lorenzo Monaco around 1405, for example the Madonna of the Empoli Triptych (1404) and that in the Gangalandi Museum in Lastra a Signa, which is slightly later in date. Also, the absence of an "international" style of execution (such as the lack of blending of colors and the specific linear developments of Masolino's circle in the 1420s) makes a dating later than the very early quattrocento highly unlikely. Considering all these factors, we can fully agree with the dates of 1390–1395 proposed by Boskovits.

As for the Master of Sant'Ivo and a possible attribution of the Vatican Madonna to him or to his workshop, it is worthwhile to note strong similarities with the polyptych in the church of San Giovanni Battista degli Zoccolanti in Pesaro (now in the Museo Civico, Pesaro), attributed by Mario Salmi[13] to Mariotto di Nardo, an opinion that is confirmed by Boskovits' studies.[14] This group, from the period in Pesaro mentioned by Ghiberti,[15] is dated 1400, in accordance with an inscription on the step of the central element. It depicts the Madonna and Child, two angels, and the Redeemer offering a blessing, flanked by Saint Michael the Archangel and Saint Francis. The striking correspondence in style between the two works—including identical expressive elements in the figures of the Mother and Child—supports a common origin in the circle of Orcagna in the previous century. The more limited abilities of this master would explain the qualitative discrepancies seen in the Vatican panel.

<div align="center">G.C.</div>

13. Salmi 1930, 303; 1955, 147.

14. Boskovits 1968a, 3–13; 1968b, 21–31; 1975, 140, 245, no. 221, 400.

15. Ghiberti, Commentari, 1447–1455.

# The Incarnation

And the angel said to her in reply, "The holy Spirit will come upon you,

and the power of the Most High will overshadow you. Therefore the child to be born

will be called holy, the Son of God."

Luke 1:35

·

And the Word became flesh and made His dwelling among us, and we saw His glory, the glory

as of the Father's only Son, full of grace and truth.

John 1:14

·

For Mary, the time to give birth came to pass in Bethlehem (Luke 2:6), and filled with the Spirit,

she brought forth the First Born of the new creation. Called to be the Mother of God,

from the day of the virginal conception, Mary lived the fullness of her motherhood,

crowning it on Calvary at the foot of the Cross. There, by the wondrous gift of Christ,

she also became the Mother of the Church, and showed to everyone

the way that leads to the Son.

·

Pope John Paul II, *Incarnationis Mysterium*, 14

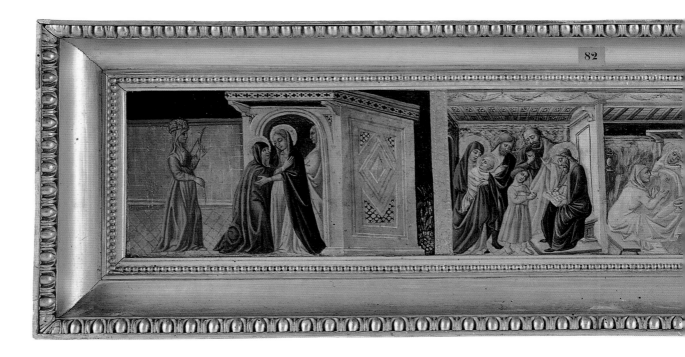

5    MASTER OF THE STORIES OF THE BAPTIST (active Foligno c. 1450–1475)
*Visitation and Stories of Saint John the Baptist*
1450–1475
tempera on panel, 15.2 x 92 cm (6 x 36¼ in.)
Vatican Museums, Vatican Pinacoteca, Inv. 40571
INSCRIPTIONS: [–NO]MEN / [—] EIVS / [IO]ANNES, on the book held by
Zachariah in the central scene; VOA / CLA/MA/NTIS / IN DE / SERTO: /
PAR[ATE], on the scroll held by the Baptist in the scene of the sermon
PROVENANCE: Apostolic Vatican Library, 1909
LITERATURE: Todini 1987; Todini 1989

1. Todini 1987, 5–6;
1989, 1:192; 2:392–393,
ills. 901–903.

This predella has recently been attributed[1] to the circle of Niccolò di Liberatore, the Alunno from Foligno, or more precisely to the "Master of the Stories of the Baptist," a collaborator of the Alunno in the 1460s. The predella, now in a more recent gilded wooden frame, may originally have been wider, either to the right or to the left or both, as each short side shows evidence of having been trimmed. The work was most likely part of a larger painting, perhaps even a polyptych; it may have been situated at the base of a section depicting the Baptist or an episode from the baptism of Christ. This is suggested by the series of scenes centered around the figure of the great Precursor of Christ, which concludes immediately before his decisive encounter with the Messiah on the Jordan. Scenes missing from the cycle, in addition to the baptism of Jesus, are those depicting the announcement to Zachariah (see Luke 1:5–22) and the decapitation following Salome's dance (see Matthew 14:6–11).

    The stories that appear on the panel, inspired by passages from Luke, begin with references in the Visitation to the Child not yet born: "When Elizabeth heard Mary's greeting, the infant leaped in her womb" (Luke 1:41). The scene unfolds, "where she entered the house of Zechariah and greeted Elizabeth"

(v. 40). Elizabeth prostrated herself before the Virgin, acknowledging her as "the mother of my Lord" (v. 43). Behind Mary is a maid, half-hidden by the door she must have just opened, while a second maid at the left concentrates on the task of spinning, a likely reference to the "weaving" of the bodies of John and Jesus within the wombs of the two holy cousins. A monumental door with cornices, quatrefoil ornaments, a large diamond on the exterior, and a rounded entry is shown condensed to fit the confines of the image area.

The second scene, separated from the first by a simple strip decorated with punch work, is subdivided into two parts, revealing a bustling domestic interior that is rendered in perspective. The double scene reads from right to left: at the right, Elizabeth is about to give birth, as is evident from the gestures of the midwives, one at her feet with her hands ready to receive the baby and the other standing, arms folded. Beyond the wall, the baby has been born and is in Elizabeth's arms, while the father, Zachariah, dumbstruck following the apparition of the angel who predicted his paternity, writes the name the newborn shall receive ("Ioannes est nomen eius" [John is his name], *Vulgata* v. 63) in a book (rather than on the "tablet" of v. 63).

The next scene illustrates the Baptist's way to fulfillment of his mission as "prophet of the Most High, for you will go before the Lord to prepare His ways, to give His people knowledge of salvation through the forgiveness of their sins" (v. 76–77). The withdrawal to the desert in prayer after abandoning the ways of the world refers to v. 80: "The child grew and became strong in spirit, and He was in the desert until the day of his manifestation to Israel." The rugged side of the mountain enables the artist to make the space-time leap to the sermon: "A voice of one crying out in the desert: Prepare the way of the Lord. . . " (Luke 3:4), which can be read on the scroll turned to the "crowds," to the "people" (verses 7, 10, 18). The presence of two figures with halos on the right among the crowd introduces a quote from the fourth gospel, "two disciples" heard John speak of the "Lamb of God" and followed Jesus, later to become apostles: "Andrew, the brother of Simon Peter, was one of the two who heard John and followed Jesus" (John 1:35–37, 40).

U.U.

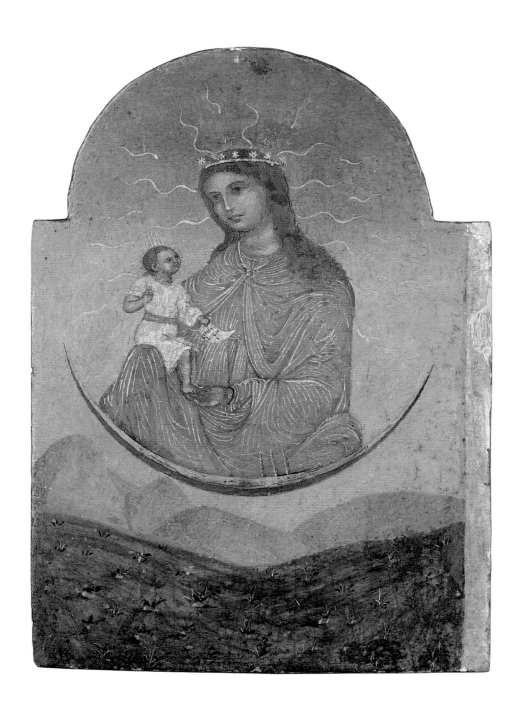

6     Greek-Italian

*Diptych with Mary as "Woman of the Revelation" and the Visitation*

16th–17th century

tempera on panel, 16.5 x 12 cm (6½ x 4¾ in.) (40550);

15.9 x 12 cm (6¼ x 4¾ in.) (40554)

Vatican Museums, Vatican Pinacoteca, Inv. 40550; 40554

INSCRIPTIONS:  *M(éte)r Th(eo)û*, above Mary's head (40550); *Pn(êum)a K(yrío)u ep'emé*, on the scroll held by the Child in the same panel

PROVENANCE:  Vatican Apostolic Library, 1909 (Christian Museum of the Library since 1762)

RESTORATION:  1984

LITERATURE:  Barbier de Montault 1867, 118, nos. 609, 611; Bianco Fiorin 1991, 216; Bianco Fiorin 1995; D'Agincourt 1824–1825, 193–194, panel cxiii; *Index Musei Sacri* 1762, 79v–81r; Muñoz 1928, 13, no. 47

These two panels, showing the Virgin and Child and the Visitation, together with two similar panels (Inv. 40552, 40553), were part of a diptych with two compartments, painted on both sides. Recorded as such in the *Index* of the Museum of the Vatican Library in 1762, the diptych was reproduced in its entirety by Jean-Baptiste Seroux d'Agincourt at the beginning of the nineteenth century. However, prior to Barbier de Montault's published description in 1867, the two panels were cut apart to permit viewing of all four sides at once. The French priest illustrating the collections of the Library in the second half of the nineteenth century described the works as two different diptychs that originally flanked a Byzantine icon. The other two panels illustrate the birth of the Virgin and her presentation at the Temple of Jerusalem. As becomes obvious when examining D'Agincourt's reproduction, these panels constitute the interiors of the diptych, while those presented here are the exteriors. The painting may be "the work of a young painter of Madonnas, working in the late sixteenth century or shortly thereafter, who, with a technique still Byzantine in style, was looking to the West for inspiration. He found it in Dutch prints (for the Visitation) and in folkloric iconography (for the Virgin). It is possible that the commissioning patron was a faithful Catholic rather than an orthodox."[1]

1. Bianco Fiorin 1995, 48, no. 56, ills. 81–85.

The depiction of the Mother of God on the first of the tablets seen here is derived from the motif of the "woman clothed with the sun" (Revelation 12:1). For the author of the Apocalypse, that image encompasses the holy people of God, who gave birth to the Messiah at the end of time. It identifies Mary with the new Eve who embodies the fallen angel of Genesis 3:15, "I will put enmity between you and the woman, and between your offspring and hers; He will strike at your head, while you strike at his heel." The reference to the sun is demonstrated by cascading golden rays that emanate from the body of the Virgin, especially her head. "The moon under her feet" (Revelation 12:1) is here a soft crescent that functions more as a throne than as a pedestal. Three rays point toward the Virgin, indicative of the trinity's light dwelling within her (the rays are placed around her womb) in the inscrutable mystery of the Incarnation. The crescent moon, echoing the panel's scalloped crowning, embraces the image of Mary with the Child in a curved space. The "crown of twelve stars" (only six are visible), placed on the head of the Virgin, forms a diadem with the stars held together by a circle of gold. Above it, between the rays, is the faded Greek inscription that identifies the Mother of God.

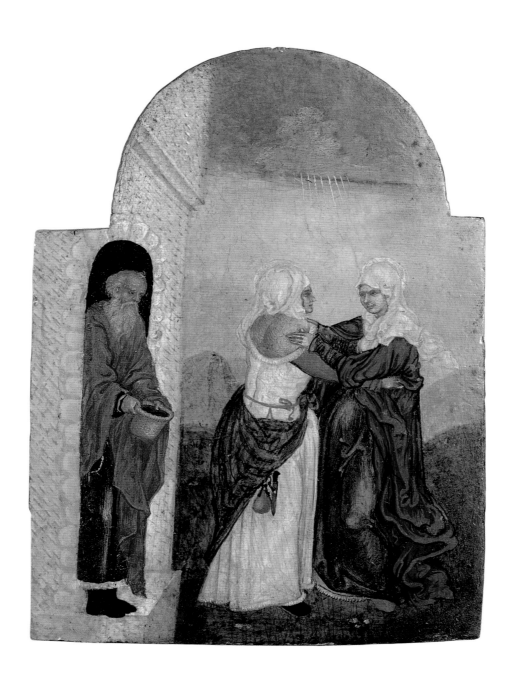

In Mary's arms, the Child—from whose head the rays spring like arms on a cross—holds a small scroll written in Greek with the beginning of the Messianic prophecy of Isaiah, repeated by Jesus in the synagogue of Nazareth: "The Spirit of the Lord GOD is upon me. . ." (Isaiah 61:1 and following; Luke 4:16–21). This inscription seems to be the key for the interpretation of the entire scene. Jesus, indeed, is truly the Messiah, and the Child, borne of woman, is "caught up to God and His throne" (Revelation 12:5). In Him the expectations of those remaining are met, and the earth blossoms again, as shown in the field filled with flowers and the grass with golden blades below: "As the earth brings forth its plants, and a garden makes its growth spring up, So will the Lord GOD make justice and praise spring up before all the nations" (Isaiah 61:11). It is noteworthy that this blossoming field, symbolizing the image of Mary as Mother Earth from which the Savior springs forth (see Isaiah 45:8), is not a later addition or an overpainting, as recently concluded based on an erroneous interpretation of the reproduction published by D'Agincourt, who had magnified the tiny inscription on Jesus' scroll.

The second tablet, based on an etching by Albrecht Dürer, depicts the canonical iconography of Mary's visit to Elizabeth (see Luke 1:39–45). Zachariah appears at the door, receiving the guest with a basket that perhaps contains food, while Elizabeth carries with her, tied to her waist, objects most likely related to domestic activities. From the skies, which have reopened following God's silence, the divine light falls on the two cousins, both future mothers of prophets. Elizabeth will give birth to John, the last prophet of the Old Covenant; Mary, in turn, will be the "mother of my Lord" (see Luke 1:43), Jesus, the ultimate Prophet of the Father, who can truly speak on behalf of God (from the Greek *prophetes*). He is the Word Incarnate, becoming man in the womb of the expectant Virgin.

U.U.

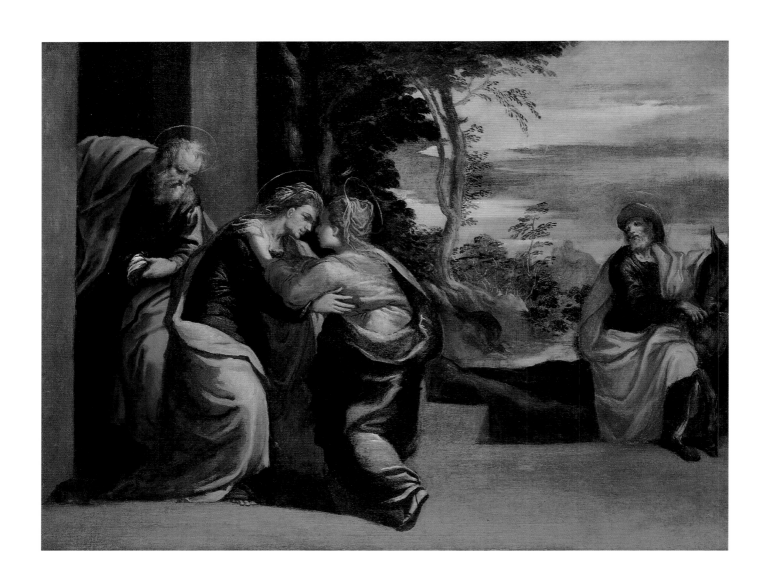

7    Ippolito Scarsella, called Scarsellino (Ferrara c. 1550–Ferrara 1620)
*The Visitation*
late 16th century
oil on canvas, 68.6 x 89 cm (27 x 35 in.)
Vatican Museums, Vatican Pinacoteca, Storage, Inv. 40366
PROVENANCE:  Gift from Antonio Castellano, 1926
RESTORATIONS:  1927; 1998–1999
LITERATURE:  Berenson 1936; Buscaroli 1935; Novelli 1955, 1964; Porcella 1933

This painting was attributed without certainty to Paolo Veronese when it was donated by Antonio Castellano of Naples, who gave a large number of paintings to the Vatican between 1924 and 1926.[1] It was attributed to Scarsellino for the first time by Amadore Porcella in 1933,[2] an attribution accepted by Renato Buscaroli in 1935,[3] by Bernard Berenson in 1936,[4] and finally by Maria Angela Novelli in 1955 in her monograph on the painter from Ferrara.[5]

Ippolito Scarsella, called Scarsellino, born around 1550 in Ferrara, studied first with his father Sigismondo. During his stay in Venice between 1570–1576 he joined Paolo Veronese and later brought Veronese's style back to his own town. On a second trip to Venice in about 1615 he studied the work of Jacopo Bassano. Influenced by Bassano and the milieu of Ferrara, which was dominated by the cultivated and refined tradition of Dosso Dossi, Scarsellino acquired a new, more narrative style.

Veronese's cold, delicate colors are transformed by Scarsellino into an easy and candid vision. Extremely prolific and highly praised by the critics of his time, Scarsellino excelled in the poetry of the narrative, in a consistently fresh and innovative manner. Examples include the stories of a saint in the Pinacoteca Nazionale in Naples, exquisite, graceful sketches in vivid color. Equally fresh are mythological subjects, such as Diana and Endymion from the Galleria Borghese, which display a daring combination of the rich color of the Venetians and the simplicity of Francesco Albani. According to Novelli, this small painting dates to the last decade of the sixteenth century. With its pure harmony of hues, it seeks an equilibrium of the senses in the bucolic idyll. The episode of the encounter (Luke 1:39–45) is staged on the threshold of the house. While Elizabeth and Mary's embrace is filled with devotion, the eye of the observer quickly moves to the enchanting scene of Joseph on the right, who has just dismounted from his donkey—and then to the hazy panoramic ravine in the background, a true classicist landscape despite its limited size.

M.A.D.A.

1. ASMV, b. 62a, Castellano Donation, 1924–1926, 3rd donation, March 17, 1926, no. 11.

2. Porcella 1933, 178.

3. Buscaroli 1935, 221.

4. Berenson 1936, 445.

5. Novelli 1955, 69; 1964 ed., 41.

8      Greek-Italian
*Adoration of the Shepherds*
mid–late 16th century
mixed media on panel, 30.5 x 66 cm (12 x 26 in.)
Vatican Museums, Vatican Pinacoteca, Inv. 40916
PROVENANCE:  Gift from Monsignor Enrico Felici, priest of S. Maria Maggiore,
1935–1936
LITERATURE:  Bianco Fiorin 1991, 212, fig. 2; Bianco Fiorin 1995, 47, no. 53, fig. 78;
Nogara 1936, 325, fig. 7

This work is characteristic of the style of the so-called Madonna Painters from Constantinople or of Greek origin, who moved west after the fall of the Byzantine empire. Established along the shores of the Adriatic and as far away as Crete, their activity was centered in the capital of the Venetian Republic. Initially Orthodox Christians (with their own church and school), they were slowly exposed to Western cultural and artistic influences, especially during the sixteenth century. The painters (or better "writers") of icons came into contact with the work of the Venetian mannerists and emulated their style and use of colors, giving a new liveliness to the dignified figures of their saints. The results of this melding of East and West were not always successful. The Madonna Painters frequently produced Byzantine "Madonnas" in great quantity (hence the name) for buyers of every nationality, or they inexpertly copied Renaissance works. Nevertheless, cer-

tain artists emerged who effectively combined two artistic worlds that were seemingly impossible to reconcile. Among them were Giorgio Klontzas (one of his triptychs is in the Vatican Pinacoteca) and the great artist Domenikos Theotokopoulos who, after leaving Crete and, later, the Venice of the Madonna Painters, became known as El Greco in his adoptive country, Spain.

The panel shown here became part of the Vatican collections in 1936 through a gift of Monsignor Enrico Felici of Santa Maria Maggiore. It is attributed to a Greek-Italian painter of the second half of the sixteenth century, inspired by the Italian manner, from Venice or perhaps Ferrara, who specialized in the Adoration of the Shepherds, a theme close to the heart of Western religious painting. The composition is harmonious in the successful placement of Christ in the center, with the figures of Mary and Saint Joseph turning toward him. Beyond them are the images of six shepherds, stepping forward and bowing to the Child. The landscape is equally well balanced, with the city of Bethlehem to the left and a rugged mountain to the right, while the barn with the donkey and the ox is slightly foreshortened, in a correct rendition of perspective. However, there is an obvious awkwardness in the figures resembling the shepherds. The image of the Virgin shows clear evidence of being a copy. The small figure of the Christ Child is rendered more skillfully, with golden curls on His head, a humanistic reference to the new Dionysus who is "the true vine" (John 15:1). As a result of the destruction of false idols (to the right is the canonical broken column), He will "bring to light (for all) what is the plan of the mystery hidden from ages past in God who created all things, . . .and to know the love of Christ that surpasses knowledge, so that you may be filled with all the fullness of God" (Ephesians 3:9, 19).

<div align="center">U.U.</div>

9     *Front of Sarcophagus with Epiphany*
       fine-grained white marble, 31.8 x 84.2 x 3 cm (12½ x 33⅛ x 1³/₁₆ in.)
       Vatican Museums, Pio Cristiano Museum, Inv. 31450
       EXHIBITIONS: Rome 1988a; Manila 1994
       LITERATURE: Deichmann 1967, 5–6, no. 5, pl. 1; Vicchi 1994, 44, no. 3

Found in the seventeenth century in the Vatican area and kept at S. Ivo alla Scrofa, this relief was reconstituted from five fragments. The restored portions include the right arm of Christ *Logos* with the stick, the noses of many figures, and the star above the Christ Child.

     The relief is from the front of a child's sarcophagus or the closure of a child's burial niche. Two scenes are represented, the vision of Ezekiel and the Epiphany. To the left, the vision of Ezekiel (see Ezekiel 37) is narrated by the presence of the Lord in the figure of Christ *Logos,* who begins to revive dry bones with a stick. Covered anew with flesh, living men surge from previously dead bodies. Christ *Logos,* wearing a tunic and pallium, is shown standing. With the stick in hand, He raises a man from the dead. The recumbent man is lifting his head; two other figures are next to him, one without features and the other with features that are roughly defined. Two nude men stand next to Christ *Logos;* a third one behind Him, draped in cloth, may be a prophet. To the right side of the slab is a scene of the Epiphany. The three Magi walk

toward the Christ Child, who is sitting on the lap of the Madonna, held in her arms. Visible behind the Magi are two of the three camels that led the way to the manger. The Magi are wearing short tunics, covered by capes, and Phrygian caps on their heads. They bring gifts to the Child, while the first points to the star (a modern restoration) that guided them. The Madonna is shown veiled, sitting on the throne with her feet on a taboret. The curvature of the slab at her back suggests the entrance to the manger or grotto.

The narrative sequence is straightforward. The prophetic vision of the Resurrection takes shape in the announced coming of the Savior, with the first episode introducing the salutary event of the second. The Old Testament thus finds its natural continuation in the New Testament. The deceased are assured life beyond the grave, promised as a result of their faith in Christ. In the symbolic repertory of the early Christian era, the initial sequence of the Apocalyptic letters alpha and omega—A and Ω, the first and last letters of the Greek alphabet—signify the beginning and end of human life. They are frequently inverted as omega and alpha, reminding us that death coincides with the beginning of a new eternal life in God. The first episode shown here, in which the dead are revived by divine intervention, conveys the birth of the Savior and the devotion expressed to Him by the Magi. It is an obvious synthesis of the Christian message, which associates eternal life with the advent of the Messiah.

G.S.

10     Ligurian School
       *Rest on the Flight into Egypt*
       early–mid-17th century
       oil on canvas, 31.8 x 40 cm (12½ x 16 in.)
       Vatican Museums, Vatican Pinacoteca, Storage, Inv. 40794
       RESTORATION: 2000

This painting was recorded in 1742 in the inventory of the residence of Castelgandolfo, along with another one whose subject was the daily life of the Madonna: "Two such [paintings], on canvas, in a proportion of 1¾ and 1¼, one representing Saint Anne, Saint Joachim, and the Holy Madonna reading, and the other the Holy Madonna washing, Saint Joseph, and the Child, in yellow frames with a gold line."[1]

1. ASV, *Palazzo Apostolico, Amministrazioni* 1063, 32.

Exhibited for the first time, the work has recently been skillfully restored by Master Claudio Rossi de Gasperis, revealing an overall effect of cold hues that were previously hidden beneath a heavy yellowed varnish. The painting, whose theme is the Rest on the Flight into Egypt, contains not only a genre scene with the novel detail of Mary as a washerwoman, but also introduces an unsettling mood in the image of the Child. The face of the Christ Child is clouded with an expression of suffering, and His arms are raised toward the small angels who mysteriously appear in the air. He lies on a stone suggestive of a tomb slab. Characteristic of many paintings of the late sixteenth century, the image alludes to Christ's suffering and death on the cross. Similar allusions are found in bas-reliefs of the period that depict scenes of cruelty or the offering of fruits, both symbols of suffering or death, or that portray adult expressions on the face of the Christ Child.

Executed by a sure hand, the painting is innovative and vivacious in all its details, despite its small size. Witness the donkey that peers from behind the trees, the Egyptian-style landscape with pyramids and palm trees, and the crystalline waters of the river with its dramatic bends and abundant cascades. The entire image is delicately painted with the tip of a brush, from the pensive half-hidden face of Joseph to the edging on Mary's bodice, which reflects the style of the sixteenth century. Every aspect of this painting suggests the Ligurian School at the beginning of the seventeenth century. It is rich in Venetian influences, especially the work of Veronese, who relishes delightful genre scenes such as children at play.

M.A.D.A.

II        Attributed to GIOVANNI LANFRANCO (Parma 1582–Rome 1647)

*The Virgin Hands the Christ Child to Saint Cajetan of Thiene*

c. 1620–1630

oil on canvas, 119.4 x 152.4 cm (47 x 60 in.)

Vatican Museums, Vatican Pinacoteca, Storage, Inv. 41708

INSCRIPTIONS: QVERITE ERGO / PRIMVM / REGNVM DEI / ET /
IVSTITIAM EJVS // ET HAEC OM[N]IA / ADIICENTVR / VOBIS / MAT: VI
(Matthew 6:33)

RESTORATIONS: 1996–1998

This splendid painting, never before exhibited, was almost certainly commissioned by the Theatine Fathers on the occasion of the beatification of Saint Cajetan of Thiene, founder of the Order of Clerks Regular, with the backing of Pope Urban VIII in 1629.[1] This thesis is supported by the motto of the Theatines, *Quærite Regnum Dei*, which is quoted in full (Matthew 6:33) in the book on the right whose pages are being turned by angels, as was first observed by Umberto Utro. The passage is extremely significant, as it appears in the context of the gospels, with the sermons of Jesus, which also include the "Beatitudes" and the *Pater Noster*. It crowns the words offered by Jesus concerning the eye as the lamp of the body and the impossibility of serving two masters. Consequently, the passage from Matthew is a perfect exegesis both of the "vision" of the saint and of the precious gift given by Mary to Saint Cajetan.

      Cajetan of Thiene (Vicenza 1480–Naples 1547) had a vision of the Virgin and Child on Christmas night 1517 in Santa Maria Maggiore.[2] It is described in a letter written by the saint to the Servant of God Sister Laura Mignani: "I, the daring one, at the hour of His Birth, I found myself right in the very Holy Crèche. I was heartened by my Father, adorer of the Crèche, the blessed Jerome, whose bones are hidden in the cave of the Crèche, and, with the confidence of the old man, from the hand of the timid Virgin, a new Mother, my mistress, I took the tender Baby, flesh and embodiment of the Eternal Word. My heart must have been quite hard, believe me, because if it did not melt at that moment, it must surely have the hardness of diamonds."[3]

      The painting shows Saint Cajetan dressed in a cassock, extending his arms toward Mary who hands him the Child. Another saint, dressed in a chasuble and white shirt, seems to encourage him with a gesture of his right hand. The initial assumption that this is Saint Jerome, as stated in the letter (the saint is closely linked to Santa Maria Maggiore, where he celebrated Mass at the altar of the Crèche and was the patron of the Oratorio del Divino Amore, in which Saint Cajetan was a member[4] before founding his own order) is not completely convincing. More likely, the fragile old man in liturgical habit, whose eyes are turned upward and directed at an angel, is Saint Andrea Avellino (1521–1608), another member of the Congregation of the Theatines, who was beatified in 1624. Andrea Avellino died suddenly during a Mass celebration and is represented only in this particular iconography.[5]

      The painting is a superb, precocious example of a nocturne, with the only light coming from the body of the Child. The scene, tightly composed on the diagonal, is framed at the right by the capricious flight of angels who hold a book bearing the Theatine motto. Sprinkled throughout the picture are small blue and white flowers, symbols of the beauty of the earth and the virtues of the soul.[6] To the left is the broad fold of the Madonna's cape, suspended by an angel and suggestive of a theater curtain.

      The most prominent stylistic feature of this painting shows the strong influence of Correggio,

1. Pastor 1908–1934, 13:601.

2. *Bibliotheca Sanctorum* 1961–1970, 5, col. 1346.

3. Luciani 1996, 227–228.

4. Pastor 1908–1934, 4, 2:548 and following.

5. Réau 1955–1959, 3, 1:86.

6. Heinz-Mohr 1984, 158.

which is characteristic of the work of the Parma painter Giovanni Lanfranco. The source is Correggio's *Night* (Gemäldegalerie, Dresden), adapted previously by Lanfranco in two Adorations, a youthful one now in Alnwick Castle (1606–1607) and a later one at Santa Maria della Concezione (1631). In a reference to Correggio, Giorgio Vasari characterized the quality of the light in all three paintings as "splendor . . . and the light of divinity."[7] Bernini's monograph on Lanfranco makes no mention of this painting, and the same applies to the study of the artist's oeuvre of drawings at the photograph library at the Hertziana Library in Rome. However, this does not detract from its resemblance to Lanfranco's work, influenced by Correggio, as it appeared in approximately the third decade of the seventeenth century. It is evident in the revival of the nocturnal topic of the Adoration in the Cappuccini della Concezione. There is also a strong similarity in the heads of the angels, for example between that of Saint Andrea Avellino and Saint Corrado Gonfalonieri (Musée des Beaux-Arts, Lyon) and between the Virgin and Herminia in *Herminia among the Shepherds* (Capitolina Gallery, Rome), painted by Lanfranco in the third decade of the seventeenth century. There is also a reference to Caravaggio in the figure of the angel holding the drape, who emerges from the softly colored shadow reminiscent of Caravaggio's chiaroscuro in the "Parma" style.[8] We have already noted the large cape worn by Mary, lifted by an angel and resembling drapery, which also suggests the vault of the sky. This element is similar to another painting by Lanfranco, a later Virgin with Saints Dominic and Januarius of Afragola in the Rosary Church, Naples.[9] Lanfranco produced a number of works for the Theatine, including the famous frescoes of San Andrea della Valle commissioned by cardinals Alessandro and Francesco Peretti, for whom he also worked in Naples.[10] Finally, we know from Giovan Pietro Bellori[11] that he worked on a similar subject of the Blessed Felice da Cantalice who receives the Child from the Virgin, a painting for the Capuchins that is today lost. The two saints appear without halos, suggesting a date that precedes their beatification, which occurred between 1624 and 1629. Placing the halo or rays on the head of the blessed was optional, however.[12] The painting may have been a gift to an influential cardinal to promote the cause of the two saints.

During a recent restoration, the only one documented although it is certain that the painting had been restored at least one other time, a rough, thick mixture of umber and cinnabar red was noted. The position of the thick layer of material on the upper right suggests that the canvas had been reused. A compound of animal glue and linseed oil, baked with copper acetate, had been placed on the back for drying purposes during a previous restoration (Painting Restoration Laboratory of the Vatican Museums).

<div align="right">M.A.D.A.</div>

7. *Le Vite*, ed. Milanesi, 1878–1885; 1873 ed., 4:117.

8. Kessler 1992, 180 and following.

9. Bernini 1985, ill. 134.

10. Bernini 1985, 70–76, 123.

11. Bellori 1672; rev. ed. 1976, 395.

12. Casale 1999, 73–76, esp. 73.

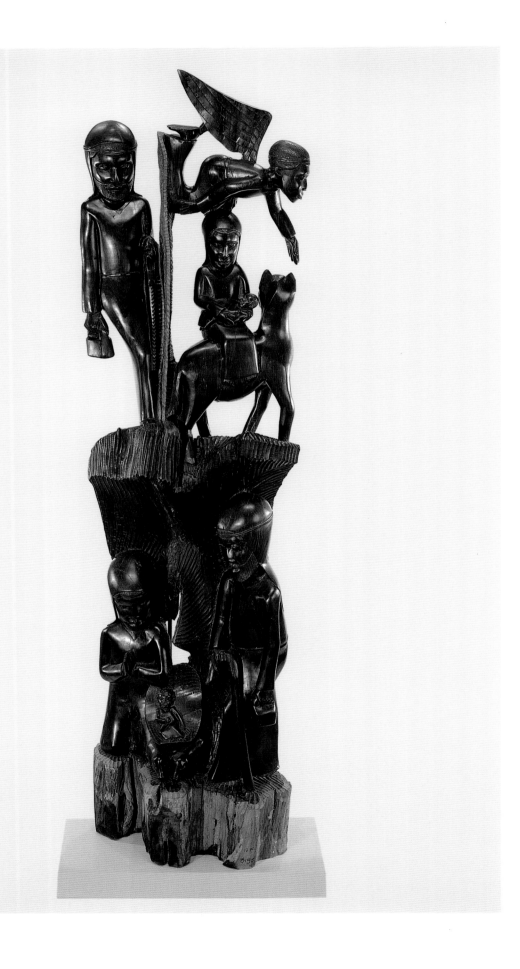

12      Anonymous (Tanzania)
*Nativity and Flight into Egypt*
c. 1989
wood, 164.5 x 49.5 x 21.8 cm (64¾ x 19½ x 8⅝ in.)
Vatican Museums, Missionary-Ethnological Museum, Inv. AF 8197
PROVENANCE:  Tanzania
LITERATURE:  Mohl Max 1990–1997

This sculpture, made from a single block of dark wood, represents two episodes in the life of the Holy Family, the Nativity and the Flight into Egypt. The work follows the sculptural tradition of the Maconde of recent decades. In the Maconde tradition, every individual work of art is an original that cannot be copied. The very shape of the wood blocks from which the works are sculpted inspires the artist to seek different solutions each time. Beyond the uniqueness of the form, another important element of Maconde sculpture is the narrative value of the work. It must tell a story, often impossible for us to understand in its most obscure forms, especially the older scenes. In regard to the work shown here, the meaning is clear. Although not without Western elements such as the garments of the various figures, this sculpture unequivocally expresses its African roots, especially in the rendering of the faces. It is developed on two levels. In the lower part is the Nativity with Mary, Joseph, and the Baby Jesus in the manger. Its spiritual message embraces earthbound values through the carpenter's tool placed in the hand of Joseph. The grotto that surrounds and protects the family is represented by a background of wood containing deep vertical incisions, which separates the two scenes yet melds them into a single sculptural entity. The grotto becomes the base, the ground on which the second scene takes place, the Flight into Egypt. Articulated in two vertical sections, Joseph appears on one side while Jesus, Mary, the donkey on which they ride, and the angel of the Lord appear on the other. Joseph is again identified by the presence of his tools, the saw and the plane. The prominent vertical element in this scene is the figure of Joseph, who contrasts with the other sculpted figures and dominates the image. In the other portion of the sculpture's upper section is Mary, seated on a donkey with Jesus in her arms. The angel of the Lord towers above the Madonna, showing her the way. The sculpted figures are rendered frontally while the figure of the angel is shown in profile. This motif gives a sense of movement to the entire sculpture, which would otherwise appear rigid, defined by the static nature of the other figures. The work was a gift to Pope John Paul II in 1989. Placed in the Private Storerooms, it was later brought to the Missionary-Ethnological Museum and is currently exhibited in the museum gallery dedicated to Christianity in Africa.

D.D.

## The *Theotókos* (The Mother of God)

The Virgin of Nazareth truly becomes the Mother of God.

This truth, which Christian faith has accepted from the beginning,

was solemnly defined at the Council of Ephesus in AD 431. In opposition to the opinion

of Nestorius, who held that Mary was only the mother of the man Jesus,

the Council emphasized the essential meaning of the motherhood of the Virgin Mary.

At the moment of the Annunciation, by responding with her *fiat*,

Mary conceived a man who was the Son of God,

of one substance with the Father. Therefore, she is truly the Mother of God,

because motherhood concerns the whole person, not just the body,

nor even just human "nature." In this way the name

*Theotókos* — Mother of God —

became the name proper for the union with God

granted to the Virgin Mary.

•

Pope John Paul II, *Mulieris Dignitatem,* 4

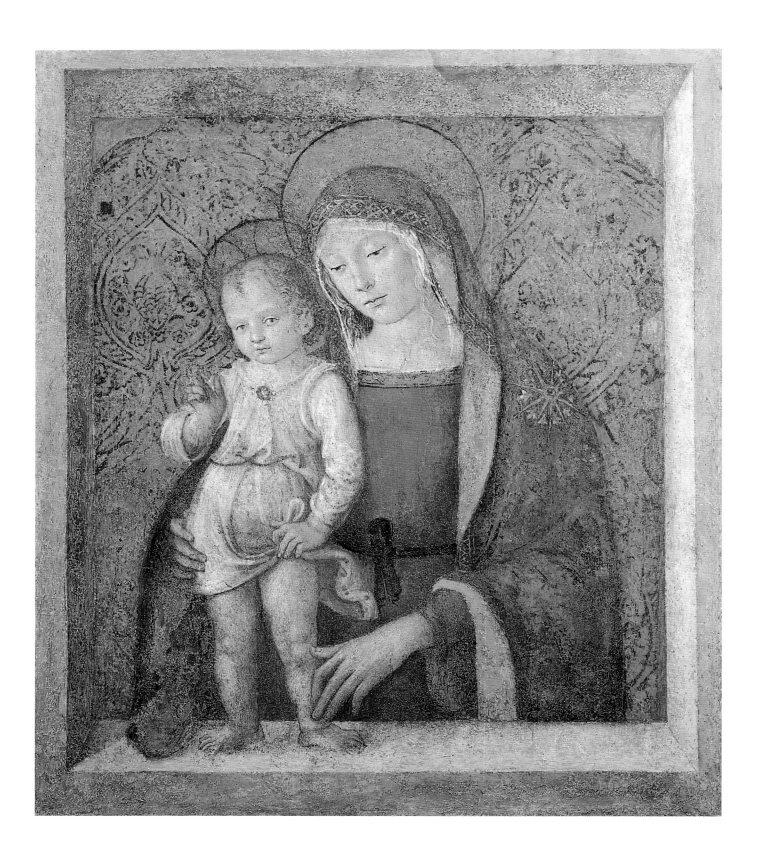

13     Follower of Bernardino di Betto, called PINTURICCHIO (Perugia c. 1452–Siena 1513)
*Madonna of the Windowsill*
early 16th century
fresco transferred to cadorite, 105.4 x 91.4 cm (41½ x 36 in.)
Vatican Museums, Vatican Pinacoteca, Inv. 40324
RESTORATIONS:  1953, 1976
EXHIBITIONS:  Rome 1988; Tokyo 1989; Paris 1990; Mexico City 1993; Manila
1994; Montevideo 1998
LITERATURE:  D'Achiardi 1913, 101; Ikuta in Tokyo 1989, 148, no. 44; F. Mancinelli in
Paris 1990, 130–131, no. 53, with biblio.; De Angelis in Mexico City 1993, 358, no. 244; De
Angelis in Manila 1994, 93, no. 24; De Angelis in Montevideo 1998, 136–137

Although attributed to Pinturicchio by Bernard Berenson in early guides to the Vatican Pinacoteca,[1] this painting is not mentioned in important monographs dedicated to Umbrian painters of the Renaissance, for example C. Ricci's *Il Pinturicchio* of 1912[2] or E. Carli's *Il Pinturicchio* of 1960.[3] More recently, Francesca Bottair, who reexamined the painting after its last restoration, definitively rejected its previous attribution, maintaining instead that the work reflects a level of skill appropriate to that of a follower of Bernardino di Betto or to Antoniazzo Romano, active in Rome in the early years of the sixteenth century.[4] The image, whose background has been repainted, joined the collection of the Vatican Pinacoteca in 1909.

   Iconographically the painting is similar to Pinturicchio in its portrayal of the Virgin, who is seen here in three-quarter view with her head inclined and leaning close to her Son's. Less customary in the work of Pinturicchio is the rendition of the entire figure of the Child standing in a parapet, thus giving this motif its name, "of the windowsill."[5] This particular type is seen more frequently in the art of Florence in the 1480s, for example in the work of Desiderio da Settignano or the sculpture of Andrea Verrocchio. The motif came to have a significant influence on the work of numerous Umbrian artists, including Fiorenzo di Lorenzo, Bartolomeo Caporali, and Pinturicchio himself.

M.A.D.A.

1. Berenson 1936, 1: 395.

2. Ricci 1912.

3. Carli 1960.

4. Bottari in Rome 1988, 122–124.

5. Scarpellini 1984, 18–20.

14     CLAUDIO RIDOLFI (Verona 1570–Corinaldo, Marches, 1644)
*Madonna Crowned with the Christ Child and Angels*
1600
oil on canvas stretched on panel (lunette), 90.1 x 269.2 cm (35½ x 106 in.)
Vatican Museums, Vatican Pinacoteca, Inv. 44944
INSCRIPTIONS: ANNO IVB[ILEI]–MDC, lower left on a scroll
PROVENANCE: Church of San Onofrio, Rome
RESTORATION: 1991
EXHIBITIONS: Ancona 1994; Los Angeles 1998
LITERATURE: Carloni in Ancona 1994; De Angelis in Los Angeles 1998

This painting in the shape of a lunette came to the Vatican in 1990. It was originally located above the entrance of the Church of San Onofrio in Rome, which, together with the adjoining convent, was the Casa Generalizia of the Order of Saint Jerome of the Blessed Gambacorta of Pisa. The poet Torquato Tasso lived there during the last years of his life (he is buried in the church), leaving behind personal objects and numerous documents related to his literary activity.

     The church and cloister are adorned with the works of many artists from the seventeenth century, including Domenichino, to whom the lunette was long attributed in error.[1] Giulio Mancini, however, identified Claudio Ridolfi as the painter in his *Viaggio per Roma* of 1623–1624.[2] We do not know whether this work was a commission or a votive gift for the occasion of the 1600 Jubilee. The date is indicated by an inscription on the painting. It is also uncertain whether it was executed while the artist resided in Rome or if it was shipped from Verona. Regardless, the work demonstrates Ridolfi's keen knowledge of Counter-Reformation painting.

1. Titi 1675; rev. ed. 1987, 19.

2. Carloni in Ancona 1994, 50–51.

Claudio Ridolfi, who trained under Veronese, moved to the Marches in the early years of the seventeenth century, leaving behind a considerable number of paintings, almost all religious and devotional in nature. They were executed in the simple, sober narrative of the Counter-Reformation style, in accordance with the preferences of patrons in the Marches at the time. In this lunette, Ridolfi adheres closely to the motif of the Madonna and Child wrapped in a regal cape, as seen in the altarpiece for the Church of San Sebastiano in Venice executed by his great teacher, Paolo Veronese.[3] This particular iconography, present in many works by Veronese, appears to be linked to the typology of the *Mater Misericordiae* in connection with the Son, whom the Virgin protects by covering Him with her cape.[4] The crowned Madonna surrounded by angels is frequently found in late medieval and Renaissance painting, inspired by the *Golden Legend* of Jacobus de Voragine. Originally placed above the entrance of the church, it also alludes to the venerated image of the Madonna of Loreto, protector against the plague, and especially the "Gate of Paradise," according to the Litanies of Loreto. In a 1576 etching illustrating a text by Bernardino Cirillo, printed in Macerata, one can see the Madonna with the Child in her arms; above them two angels hold a veil that envelops a group of supplicants.[5] The etching may have been commissioned by a member of the Venetian Madruzzo family, Cardinal Ludovico, who was the protector of the Order of Saint Jerome and Chief Cardinal of San Onofrio until 1600 (deceased April 20, 1600). Ludovico Madruzzo was also a devoted admirer of the Madonna of Loreto, so much so that he founded a chapel dedicated to her in San Onofrio, which became the chapel of the Madruzzo family in Rome in 1569.[6] At the beginning of the seventeenth century a student of Annibale Caracci, perhaps Domenichino, painted another Madonna crowned by angels in the image of the Virgin of Loreto for the altar of the Madruzzo chapel.[7] Ridolfi's image above the entrance of the church thus intensified its religious impact.

M.A.D.A.

3. De Angelis in Los Angeles 1998, 196–197.

4. Réau 1955–1959, 2:113.

5. Grimaldi 1987, 47–49, fig. 18.

6. Spezzaferro 1993.

7. Index card by F. Grimaldi in Loreto [1995], 138.

15      Sicilian

*"Sicilian" Madonna*

17th century

oil on copper, 24.1 x 18.4 cm (9½ x 7¼ in.)

Vatican Museums, Vatican Pinacoteca, Inv. 44859

PROVENANCE: Gift from the President of the Sicilian District, 1988

LITERATURE: Bianco Fiorin 1995, 50, no. 60, fig. 89

This painting on copper was given to the Vatican Museums in 1988 by the President of the Sicilian District. It is representative of Sicilian art with Byzantine influences, prevalent on the island after the arrival of the Albanian immigrants who fled their country in the wake of the Ottomon conquest at the end of the fifteenth century.

The iconographic type known as Madonna Siciliana combines Western and Eastern ways of portraying the Mother of God. The Western source is clearly the icon of *Brephokratoûsa* (the one holding the Child), a variation of the *Eleoûsa*, the Madonna "of tenderness." This format, otherwise characterized by an embrace in which both faces are drawn together, does not include the loving gestures of the *Glykophiloûsa* (the one who loves with softness). Other Western influences include the adornments of the splendid garment worn by Mary and the gem-studded crown offered by the angels, indicating the royalty of the Virgin. A star is visible on the right shoulder, a reference to the three stars on the Eastern garment of the *Theotókos*, a symbol of Mary's perpetual virginity. Of particular note as an Eastern influence are the architectonic background of the work as well as the encounter between East and West in the two figures of the souls in purgatory that emerge in the lower part of the painting. They are not religious figures or art patrons but rather the faithful dead who await Mary's help from purgatory through their devotion to the Carmelite scapular, which hangs from the hand of the Madonna and repeats the image of the painting in miniature.

The Carmelite saint Simone Stok received the scapular as a token of the protection of the Virgin Mary, who appeared to him in 1251. The Virgin assured him then that he and all the followers of Carmel who died wearing the scapular would not suffer eternal death. The belief gained widespread acceptance following the false Bull of Pope John XXII (1316–1334) that addressed the so-called "Saturday Privilege." According to the Bull, on the first Saturday following Carmel's death, the Madonna freed from purgatory the soul of the devoted Carmelite who died with the scapular (Saturday is a day traditionally dedicated to Christian devotion to Mary). The depiction of the Virgin with scapular in hand, in connection with souls in purgatory, appears in Sicily at the end of the fifteenth century (compare a fresco by Tommaso de Vigilia in the Church of Carmine in Corleone), before spreading to other regions, under the influence of the order, in the sixteenth and seventeenth centuries.

An unusual element is the dark complexion of Mary and the Child (in contrast to the pale bodies of the two faithful). It is characteristic of Sicilian art and a reference to the Eastern origin of certain venerated images of the Virgin, including the so-called Black Madonna of Tindari found in the Song of Songs, *"nigra sum, sed formosa. . . ."*[1] "Who is this that comes forth like the dawn, as beautiful as the moon, as resplendent as the sun, as awe-inspiring as bannered troops?"[2]

U.U.

1. Book of the Song of Songs 1:5, *Vulgata.*

2. Book of the Song of Songs 6:10.

16    Greek-Italian
*Nicopéia*
16th–17th century
tempera on panel, 49.5 x 42.5 cm (19½ x 16¾ in.)
Vatican Museums, Vatican Pinacoteca, Inv. 40540
INSCRIPTIONS: *M[éte]r/ Th[eo]û*, to the left and right of Mary's head;
*I[esoû]s/Ch[ristó]s*, to the left and right of Jesus' head
PROVENANCE: Vatican Apostolic Library, 1909
LITERATURE: Bianco Fiorin 1995, 29–30, no. 24, fig. 40

Created with tempera on pine, this icon is a fifteenth–sixteenth-century copy of the famous Madonna *Nicopéia*, the venerated image of the Virgin "who brings victory." Taken by the Venetians from Constantinople in 1204, the icon was placed in the basilica of Saint Mark in the lagoon city, where it quickly became famous. It was later reproduced by the Byzantine Madonna Painters who came to live in Venice after the fall of the Eastern Roman Empire. Copies similar to this one are kept today at the Hellenic Institute of Venice and in the icon collection of the Classense Library in Ravenna.

The image of the Virgin *Brephokratoûsa* (holding the Child) is characterized by the splendid halos of both figures, which are decorated with painted punches and gems, simulating two golden, gem-studded crowns. As in the Byzantine prototype, the eyes of the Virgin and Child are averted from those of the spectator, repeating an iconographic motif found as early as the sixth century in the famous icon of the Mother of God enthroned in the monastery of Saint Catherine in the Sinai desert. Christ, centered on Mary's body as if contained in it, exemplifies the Eastern motif of the Virgin *Platytéra*. In this motif, Mary is limitless, that is, from the heavens (*tôn ouranôn*). She contains the noncontainable, the eternal Son of the Father. She is therefore the "Arc of the New Covenant"; her womb is the Tabernacle of God, and she is "highly favored," as the angel of the Annunciation told her (see Luke 1:28). That Child "filled with wisdom" (Luke 2:39 [40 in the King James version]) borne in her womb also identifies her as the Throne of Wisdom made flesh (a reference to the throne in the Sinai icon), finding her "more vast than the Heavens," a throne comparable to that of the heavens themselves.

The *Akàthistos* hymn, standard of the Eastern liturgy of Mary, lauds the *Theotókos Platytéra*: "Hail, you dwelling of God, infinite. . . . Hail, most holy throne of the cherubic throne. . . . Hail, sacred vessel of God's Wisdom. . . . Hail, oh Tabernacle of God the Word; Hail, golden arc of the Holy Spirit" (*Akàthistos* hymn, stanzas 15, 17, 23). Another Byzantine hymn, reproduced on a fragment of papyrus from the sixth century, praises Mary in these words: "Hail, Mother of God, you pure one of Israel! / Hail, you, whose womb is more spacious than the Heavens. / Hail, you Holy one, oh, celestial Throne."

U.U.

17     DANIEL SEGHERS (Antwerp 1590–Antwerp 1661) and ERASMUS II QUELLINUS
(Antwerp 1607–Antwerp 1678)
*Flower Garland with Madonna and Child*
c. 1644
oil on canvas, 115.6 x 82.6 cm (45½ x 32½ in.)
Vatican Museums, Vatican Pinacoteca, Inv. 40416
PROVENANCE:   Probably Roman collections of the Society of Jesus
EXHIBITIONS:   Mexico City 1993
LITERATURE:   Couvreur 1967; De Angelis 1990, 197–201; De Angelis in Mexico
City 1993, 362, no. 267; De Bruyn 1980, 261–329; Hairs 1955; Pietrangeli 1982;
Porcella 1933, 215; Redig de Campos 1943, 179

On a shield painted to imitate stone and decorated with three garlands of flowers, this Madonna in the
style of Peter Paul Rubens holds the Christ Child in her arms. Although it is not signed, the painting can
be attributed to Daniel Seghers based on its composition and floral elements, while the central scene can
be attributed to one of his primary collaborators, Erasmus II Quellinus of Antwerp.

    This type of religious painting, showing sacred scenes framed by flowers, was almost always exe-
cuted by two artists: one specialized in naturalistic and the other in figurative elements. The floral painter
Seghers was born in Antwerp on December 3, 1590. In 1614 he joined the Society of Jesus, spending his
novitiate in Malines (Mechelen) until 1617. Between 1625 and 1627, he resided in Rome. His immediate
master in the painting of flowers is said to have been Jan Brueghel dei Velluti, whose style was reinterpreted
by Seghers with greater emphasis on detail and with a porcelain-like finish. Seghers' patrons included
prominent people of the time, including the Cardinal and Infant of Spain, Don Ferdinand; Archduke
Leopold William, brother of Emperor Ferdinand III; Constantijn Huygens, father of the mathematician
Christian; and Charles III of England. Marie Louise Hairs has identified fifty-three of his paintings, docu-
mented or signed, of which ten date to the years between 1635 and 1651.[1] His patrons and the painters who
executed the central scenes were researched by Walter Couvreur in 1967.[2]

    Seghers may have executed this painting in Antwerp and then sent it to Rome, as he appears to
have done with another one of his paintings in the Vatican Pinacoteca (Inv. 40441), *Garland of Flowers with
Saint Ignatius*.[3] It could also have been acquired directly from the Novitiate Home of San Andrea in Monte
Cavallo, whose property was assumed by the Vatican in 1773 during the temporary closing of the Society
of Jesus.[4] In 1800 the work is listed in an inventory of the Vatican Pinacoteca, recorded by the Prefecture
of the Apostolic Palaces after the Napoleonic pillage.[5] In 1889, however, the painting was in the Mosaic
Factory, where it may have served as a model.[6]

    Seghers' works tend to be linear and almost humble in their purity. He paints delicate garlands of
flowers on a shield in luminous, transparent hues. Occasionally, numerous butterflies and tiny insects visit
his garlands. The workmanship of the corollas reveals a careful student of nature. Falling buds are scattered
in individualized, disorderly arrangements, a method employed by Seghers to minimize repetition, which
was greatly feared by those in the profession. Particularly intriguing is the symbolic quality of the culti-
vated flowers chosen by the artist for his garlands. In addition to the omnipresent rose—Mary's flower par
excellence—there are vines of ivy, a symbol of the humble Incarnation of Christ and of the Madonna;
carnations, a symbol of Divine Love; campanula, symbol of Holy and perfect love; funereal references in

1. Hairs 1955, 78.

2. Couvreur 1967,
87–158.

3. De Angelis 1990, 198,
no. 3.

4. Pietrangeli 1982, 163.

5. Pietrangeli 1982, 152,
194.

6. ASV, *Palazzo Apo-
stolico Amministrazioni
1079*, no. 124.

the form of narcissus, daffodil, and anemone; and other flowers typically associated with the Virgin Mary, including hyacinth and pink oleander. Simple wildflowers and medicinal plants seen in this work probably symbolize the goodness of Creation.[7]

Also particularly beautiful in this work is the Rubenesque central painting attributed to Erasmus II Quellinus, one of Seghers' main collaborators. The attribution of the Madonna with the Child to Quellinus, already suggested by Hairs, is evident when one compares Seghers' garlands in a painting from the State Hermitage Museum in Saint Petersburg[8] with the figure of the Christ Child with the Holy Family by Quellinus at the Koninklijk Museum voor Schone Kunsten in Antwerp.[9] The painting in the Hermitage is signed by Quellinus and dated 1644, the approximate date for this painting as well.

M.A.D.A.

7. Levi d'Ancona 1977.

8. De Bruyn 1980, 270–273.

9. De Bruyn 1980, 312.

# Images of Prayer

Images of the Virgin have a place of honor in churches as well as private homes.

In these images, Mary is represented in a number of ways:

as the throne of God carrying the Lord and giving him to humanity *(Theotókos)*;

as the way that leads to Christ and manifests him *(Hodegetria)*;

as a praying figure in an attitude of intercession and as a sign of the divine presence on the

journey of the faithful until the day of the Lord *(Dêesis)*; as the protectress who

stretches her mantle over the people *(Pokrov)*, or as the merciful Virgin of tenderness *(Eleoûsa)*.

She is usually represented with her Son, the Christ Child, in her arms:

it is the relationship with the Son that glorifies the Mother.

Sometimes, she embraces him with tenderness *(Glykophiloûsa)*;

at other times she is a hieratic figure, apparently rapt in

contemplation of He who is the Lord of history (Revelation 5:9–14).

Pope John Paul II, *Redemptoris Mater*, 33

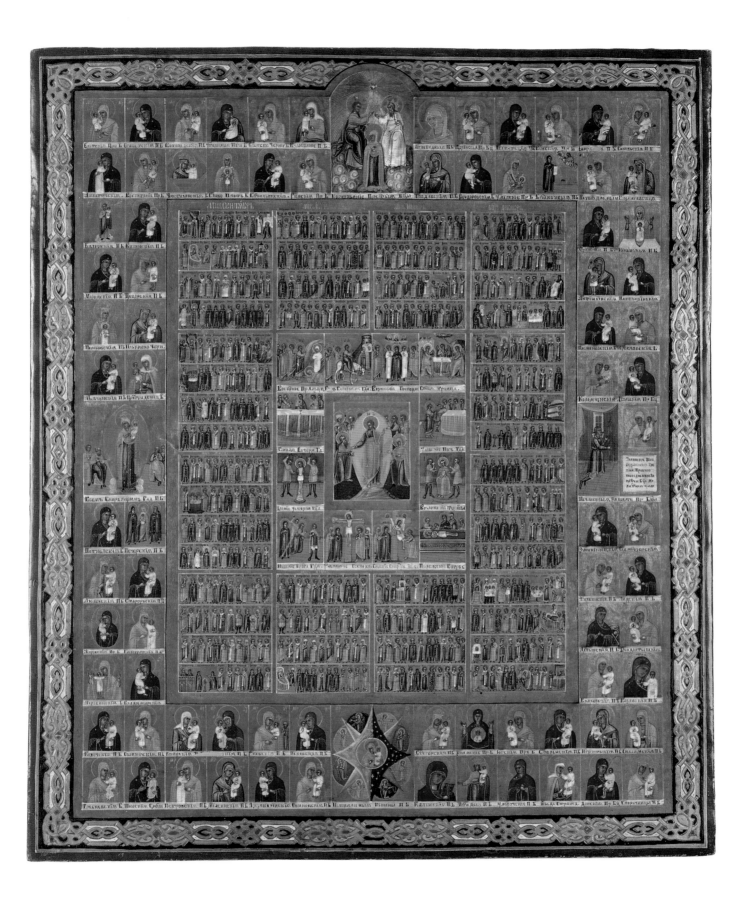

18   Russian (Kholuj, near Vladimir)
*Annual Religious Calendar*
mid–late 19th century
tempera and gold on panel, 52 x 42 cm (20½ x 16½ in.)
Vatican Museums, Vatican Pinacoteca, Inv. 44382
INSCRIPTIONS:  Hundreds of inscriptions appear on this icon; for the transcription and translation of the most important ones, see Amato 1988, 182–183.
PROVENANCE:  Gift from Reverend G. Fussghangen, 1983
RESTORATIONS:  1985, retouching of peeling gold leaf
EXHIBITIONS:  Rome 1988
LITERATURE:  Amato 1988, 179–183; Bianco Fiorin 1985/1987, 152–156; Bianco Fiorin 1995, 78–79

This complex, multifaceted icon depicts important holidays in the Christian Orthodox liturgical year. The panel consists of three iconographic cycles, arranged concentrically, with scenes from the Passion of Christ in the center, culminating in the central icon of *Anástasis*, the Resurrection of the Lord. Flanking the scenes of the Passion are twelve icon-months, which represent saints whose feast days occur in each month of the year. On the outer edge is a third iconographic cycle with Mother of God icons most venerated in the Byzantine world, framed by a stylized motif of intricate vines.

The representation of the icon-month has been known since the Greek-Byzantine Middle Ages, although it was typically limited to individual months. Starting in the eighteenth century, icons began to appear that reflected all twelve months in a single panel. Passion scenes surrounding the *Anástasis* had been portrayed in Russian art since the end of the sixteenth century, while more complex icons, including an annual religious calendar and icons of Mary, such as the one seen here, began to be produced in the second part of the nineteenth century. This work is characteristic of the iconographic school of Kholuj near Vladimir, which flourished throughout the nineteenth and twentieth centuries. It was inspired by the Old Believers, custodians of the theological and iconographic traditions of the classical Christian East.

The Old Believers sought to include in a single icon the ideal representation of the entire Mystery of Christian salvation. This particular icon depicts, precisely at its center, the Resurrection of the Savior. In accordance with Byzantine canon, it is presented as the descent of Jesus into purgatory, or His emergence from purgatory (*anástasis, re-surrectio*), leading the forefathers, patriarchs, and righteous of the Old Covenant into the Kingdom of Heaven. It is no coincidence that the icon of the Ascension of Jesus appears above the icon of Easter, interrupting the chronological cycle of the Passion. It is also no coincidence that, as Pietro Amato has correctly indicated,[1] the Coronation of Mary crowns the main composition. In her are joined the new Eve and the first of redeemed humanity, the eternal fruits of the Resurrection of Christ. The icon is thus immersed in the reality of time and space: liturgical time becomes an "icon" of time, a symbol of the story of Salvation, whose central moment is the salvation event, the Resurrection of Christ and Christians. The icons of the Mother of God, repeated and arranged throughout the entire Christian world, reveal the eternally new Mystery of the Incarnation and Redemption made possible through the Son of God, "born of a woman" (Galatians 4:4). All the events shown here are accompanied by inscriptions in Slavonic (an ancient Russian dialect), indicating an interest in recovering traditions and in accommodating Western elements. The icon of the Resurrected is surrounded by the following scenes of the Easter

1. Amato 1988, 182.

cycle: the Resurrection of the Righteous Lazarus and the Entry of the Lord into Jerusalem, followed by scenes of the Mystery of the Last Supper, the Lord Washing the Feet of the Apostles, the Flagellation at the Pillar, and the Placement of the Thorns. In the lower row are the Lord Bearing the Cross, the Crucifixion, the Removal from the Cross, and the Lowering into the Grave. The Descent into Purgatory chronologically follows the last scene but is here placed above it, next to the icon of the Trinity in the Old Testament. There one finds three angels received by Abraham, the figure of God, One and Trinity, which is understood as the visible image of Christ who, risen from the grave and lifted to heaven, "sits to the right of the Father" with the Holy Spirit.

The icons typical for the annual religious calendar are accompanied by lengthy inscriptions, starting with the identification of the month at the top and continuing through all the holidays of the saints, among them holidays of the Lord or of the Virgin, such as the Annunciation (March 25) or the Assumption of the Virgin Mary (August 15, equivalent to the Western Assumption). The list of months begins with September, the beginning of the liturgical year, proceeding from left to right and including the central panel with the Passion and Resurrection.

The simultaneous presentation of the most venerated icons of Mary is not seen in Russia before the end of the eighteenth century. A comparison is offered by another icon in the Vatican collection, which includes as many as 144 icons of the Mother of God in miniature (a similar icon in the Leoni Montanari palace in Vicenza includes approximately 238). Among the 84 icons of Mary presented here, three are especially important in the Byzantine world, in addition to the coronation of the Virgin. They are the "Mother of God, Joy of all Believers," combined for space reasons (to the left, center); "Mother of God of the Burning Bush" (lower part, center), which contains a reference to the appearance of the burning bush to Moses (Exodus 3:1–7). Just like the bush surrounded by flames, the womb of Mary remains intact, even though it has received the fire of the divine *Logos* turned into man. Also noteworthy is the image of the "Mother of God, Unexpected Joy" to the right, accompanied by a figure shown in prayer, whose presence is explained by an inscription below the small icon: "A sinner used to pray a little every day to the Holy Mother of God. . . ." These are the first words of an edifying story (published for the first time in 1680) that tells of a miraculous apparition to a sinner. Among the other icons, importance is given to the "Holy Mother of God of Rome" (*Salus Populi Romani* of S. Maria Maggiore), which is placed near the coronation of Mary to the left in the lower section. Other known icons of the Mother of God, among many linked to religious customs in individual local churches, are the so-called *Eleoûsa* (of Tenderness, at the top left) or "of the Sign" (second on the top right, following the Burning Bush), with Christ contained in a shield—symbol of divine infinity—inside the glorious body of Mary who can contain the noncontainable.

<div align="right">U.U.</div>

19     Italian-Cretan

*The Mysteries of the Rosary*

late 16th – early 17th century

oil on panel, 87.6 x 63.5 cm (34½ x 25 in.)

Vatican Museums, Vatican Pinacoteca, Inv. 41409

INSCRIPTIONS:   DEVOTA ROSARI/BEATAE MARIAE VIRGINIS CONTEM-
PLATION TRIPLEX GAVDIOSI; Annunciation: ECCE ANCILLA DOMINI,
FIAT MIHI/SECVUNDV(M) VERBV(M) TVVM (Luke 1:38); Visitation: BENE-
DICTA TV INTER/MVLIERES ET BENEDICTVS F(R)V/CTVS VENTRIS
TVI (Luke 1:42); Nativity: ECCE ENIM EX HOC NVNC BEATAM/ME DICENT
OMNES GENERAT/IONES (Luke 1:48, *Magnificat*); Presentation of Jesus in the
Temple: NVNC DIMIT(T)IS SERVVM TVVM/DOMINE, SECVNDVM
VE(R)BVM TVVM/IN PACE (Luke 2:29, Simon's Chant); Christ among the
Doctors: NESCIEBATIS QVIA IN HIS/QV(A)E PATRIS (MEI) SVNT
OPORTET/ME ESSE [?] (Luke 2:49); central tondo, Madonna and Child: EGO
QVASI VITIS RVCTIFICAVI/SVAVITATEM ODORIS (Sirach 24:17; *Vulgate*
24:23); lower part, Moses and the Red Sea: CANT(E)MVS DOMINO GLORIOSE
ENIM MAGNIFICATVS EST EQVVM ET/ANSC(EN)SOREM DEM(E)RSIT
(in *Vulgate*: ASCENSOREM DEJECIT) IN MARE (Exodus 15:1)

DOLOROSA

Jesus Praying in the Garden: PATER, SI VIS TR(A)NSFER CALICEM/ISTVM
A ME, NON TAMEN (in *Vulgate*: VERUMTAMEN NON) MEA VOLV/NTAS,
SED TVA FIAT (Luke 22:42); Flagellation: ET FVI FLAGEL(L)ATVS TOTA
DIE ET/CASTIGATIO MEA IN MATVTINIS (Psalms 72:14); The Crown of
Thorns: CORONA TVA CIRCVMLIGATA SIT TIBI (Ezekiel 24:17); Christ Bear-
ing the Cross: QVI(S) VVLT VENI(RE) POST ME (in *Vulgate*: QVIS VVLT POST
ME VENIRE), ABMEG(E)T/SEMETIPSVM ET TOLLAT, CRVCEM/SVAM ET
SEQVA TVR ME (Matthew 16:24); Crucifixion: MVLIER, ECCE FILIVS TVVS,
IOAN(N)ES ( John 19:26; in addition, in *Vulgate*: IOAN(N)ES); central tondo, Pietà:
O VOS OMNES QVI TR(A)NSITIS [PER VIAM], AT(T)ENDITE [ET VIDETE]
SI EST/DOLOR SICVT DOLOR MEVS (Lamentations 1:12); lower part, Joseph
Thrown into the Empty Well by His Brothers: GVRCVMDEDERVNT (in *Vulgate*:
CIRCVMDEDERUNT) ME SICVT APES ET EXARSERVNT SICVT IGNIS IN
SPINIS (Psalms 118:12; *Vulgate*: 117:12)

GLORIOSA

Resurrection: EXVRREXI QVIA DOMINVS/ SVSC[E]PIT ME (Psalms 3:6);
Transfiguration at the Place of the Ascension: NEMINI DIX(E)RITIS
VISIONEM/DONEC FILIVS HOMINIS A MOR/TVIS RESVRGAT (Matthew
17:9); Pentecost: SPIRITVS DOMINI REPLEVIT/ORBEM TER(R)ARVM

(Wisdom 1:7); Ascension: SPIRITVS ENIM MEVS SV/PE(R) MEL DVLCIS (Sirach 24:19; *Vulgate* 24:27); Coronation: TOTA PVLC(H)RA ES, AMICA MEA/ ET MACVLA NON EST IN TE (Book of the Song of Songs 4:7); central tondo, Madonna Regina: IN ME GRATIA OMNIS VIT(A)E (in *Vulgate*: VIAE) ET V/ERITATIS, IN ME OMNIS SPES VIT/(A)E ET VIRTVTIS (Sirach 24:25 *Vulgate*); lower part, Wisdom Offers Food to a Poor Man: TRANSITE AD ME OMNES QVI CONCVPISCITIS ME [ET] GENERATIONIBVS MEIS IMPLE-MINI (Sirach 24:17; *Vulgate* 24:26; completely restored inscription)

As indicated by the title of this work, the artist sought to demonstrate the "devout triple contemplation of the Rosary of the Blessed Virgin Mary" by creating a composition depicting the fifteen Mysteries of the Rosary associated with episodes or figures from the Old Testament. Each image is accompanied by a verse in Latin that refers to the scene represented, taken either from the Old or New Testament.

A broad landscape with a verdant field is subdivided in the foreground by three large trees. An episode from the Old Testament is shown at the foot of each, and on the branches—attached like fruit or the beads of the Rosary—are the scenes of the Mysteries of the Rosary, enumerating the joys, sorrows, and glories of the Virgin Mary and Christ. The scenes are summarily rendered, the surroundings roughly sketched, and the features of the figures reduced to what is indispensable for understanding the event.

The palm tree at the left, which here holds the Joyful Events (more often it is used in connection with the Glorious Mysteries)—was a symbol of glory for the pagan world, adopted by the primitive church to represent the victory of Christ over death. It is therefore a symbol of resurrection and immortality. Circular images on each tree contain scenes of the Joys of the Virgin, in which the Madonna appears clad in a blue cape and red garment. In the center of the Joyful Mysteries, among the stories of the Virgin and Christ (the Annunciation, Visitation, Nativity, Presentation of Jesus in the Temple, and Christ among the Doctors), is a Madonna with the Child, emphasizing Mary's divine maternity and the incarnation of Christ, which made the redemption of Christians possible. These Mysteries are associated with passages in Exodus. Moses, pursued by the Egyptians, crosses the Red Sea, then raises his staff and closes the passage through the water, drowning the Egyptian army and its leader. The Red Sea passage has been interpreted as the purification of the sons of Israel by water, a reference to the Baptism (see 1 Corinthians 10:1–5), while the Egyptian persecutors, swallowed by the sea, represent the fall of humanity's tormentors and the defeat of their leader, the Devil, as celebrated in Exodus (15:1): "I will sing to the LORD, for He is gloriously triumphant; horse and chariot He has cast into the sea."

Moses is depicted with two blazing rays on his forehead and a heavy book under his arm, a symbol of the Law. These attributes are not consistent with the biblical account of the parting of the Red Sea but relate to a long iconographic tradition associated with this prophet. The two blazing rays on Moses' forehead result from an erroneous interpretation of the *Vulgate*, in which the rays that illuminate the face of the prophet upon his return from Sinai are likened to golden "horns" (see Exodus 34:29–35).

The blackberry bush, a symbol of death, encloses the Sorrowful Mysteries among its thorns. In these stories, the Virgin appears dressed in a red cape and a blue gown, reversing the usual colors of her garments in a reference to the Passion. Among the Passion scenes are Jesus Praying in the Garden; the Flagellation; Crowning with Thorns; and Christ Bearing the Cross, rather than the Crucifixion. In the center is a tondo with the *Pietà*, to emphasize the deep sorrow of the Virgin. The representation of the *Pietà* and

of Christ Bearing the Cross, focusing attention on the scene at Calvary, are common to the Italian-Cretan School of the sixteenth to seventeenth century.

In the tondo of the Crucifixion, the sun and moon are depicted at each side of the cross. This was customary in the Middle Ages but is rarely seen after the fifteenth century, except in late Byzantine art or when following an older illuminated manuscript. In medieval Crucifixions, the moon was added to the sun in a desire to balance the composition or as a reference to the moment of Christ's death, when the sun set and night fell. The two heavenly bodies also have symbolic meaning, for the Old Testament (the moon) can only be understood in the light of the New Testament (the sun).

The Old Testament scene that completes the Sorrowful Mysteries is that of Joseph Thrown into the Well by His Brothers. The episode is found in Genesis (37), but it is Psalm 118 that is identified here; it is ideally suited to the scene, charging it with greater dramatic meaning. The image of Joseph brutally thrown into the well forebodes the burial of Christ, while the brothers who crowd around him are reminiscent of the executioners during the Passion of Jesus. Psalm 118, v. 12, begins: "They surrounded me like bees; they blazed like fire among thorns," and ends, "in the Lord's name I crushed them," suggesting that the defeat was temporary. Through the Resurrection Christ defeats sin and death in eternity.

The third tree is a large rose bush, a reference to the Glorious Mysteries, and is adorned with red and white roses, symbols of purity and charity (S. Bernard, *Sermo de Beata Maria*: red for love, white for virginity). The rose is traditionally considered the symbol of the Madonna and is also linked to the Rosary. Among the Glorious Mysteries represented here, it is noteworthy that the Ascension was replaced by the Transfiguration and that the Pentecost departs from traditional Byzantine iconography, in which Twelve Apostles personify the Cosmos. The Virgin, not always present, is placed in the center of the scene, and the number of Apostles is reduced to six. The Coronation of the Virgin also differs from traditional iconography, in which the Madonna is crowned by Christ. Here, Mary appears as a Queen, next to God the Father, with the dove flying above them as a symbol of the Holy Spirit. The inscription that completes the scene, *Tota pulc(h)ra es, amica mea/et macula non est in te,* from the Song of Songs (4:7), typically accompanies representations of the Immaculate Conception. The exceptional approach taken here is confirmed by the appearance of a Madonna Queen in the central tondo.

The personification of Divine Wisdom complements the Glorious Mysteries (understood as Mary, Mother of the Word and Throne of Wisdom), offering fruit to a poor man. Next to them, several baskets are filled with flowers, symbolizing the gifts of the Wisdom-Mary to the believer. The poor man represents the Christian who is saved by Mary's intercession and receives needed spiritual nourishment. Hence, the Virgin is the mediator, the Merciful, and the personification of Charity, the Eucharist, and the Church itself. The image is accompanied by the inscription, "Come to me, all you that yearn for me, and be filled with my fruits (Sirach 24:18)" and the song from which it is taken: "Wisdom sings her own praises..." (Sirach 24:1 and following verses). This interpretation is also confirmed by other scenes in which additional verses are quoted from the same song, for example in the central tondo of the Joyful Mysteries with the Madonna and Child: "I bud forth delights like the vine, my blossoms become fruit fair and rich" (Sirach 24:17); in the Glorious Mysteries, the tondo of the Ascension: "You will remember me as sweeter than honey" (Sirach 24:19); and the central tondo with Mary Queen: "In me there is every grace of life and truth, in me there is every hope of life and strength" (Sirach 24:25; this verse exists only in the *Vulgate* version).

The background of the painting is developed in several tiers. Behind the field in the front is a body of water, followed by a chain of mountains, among which one can glimpse the silhouette of imagined oriental towns with domes and spires. The aridity of the landscape is inconsistent with the trees and scenes in the foreground, which appear almost two-dimensional. The images are painted with faint colors in a dry,

rapid manner, and perspective and shadow are without depth. The scenes are superimposed on the landscape, not integrated, reminiscent of the separation between a painted subject and its background of gold in Byzantine images. This work was executed by a Greek artist inspired by fifteenth- and sixteenth-century Venetian landscapes. He adapted and individualized numerous iconographic motifs characteristic of Western art, both in the rendition of the Virgin and in the scenes of the Mysteries (*Pietà*, Christ Bearing the Cross, Pentecost, and others).

After the fall of Constantinople at the hands of the Turks in 1453, the iconographic and stylistic traditions of Byzantine art were adopted by artists in northern Greece and Crete, especially in Candia, which became the center of icon production during the fifteenth and sixteenth centuries. Clients for these works came from diverse social, ethnic, and religious backgrounds and included merchants and Church dignitaries, Greeks or Italians, Orthodox or Catholics, Christians or Jews. Painters received commissions for traditional "Greek" icons or icons in Italian or "Latin" style, depending on the client. Greek icons were in especially great demand because they were thought to express Christian dogma more authentically, owing to their conservative character.

The patron who commissioned the "Triple Contemplation of the Rosary" was an Italian, or possibly a Spaniard. He is seen kneeling at the bottom left; his face is visible. He wears an ample Spanish-style collar and his hands are joined, perhaps holding a Rosary. In all likelihood he was a religious man who commissioned a painting from a Greek artist not conversant in Latin. This is apparent in the subtitle, "Gaudioso, Dolorosa e Gloriosa" (Joyful, Sorrowful, and Glorious), in which the gender is not in agreement, or in the biblical verses, such as the inscription that accompanies the scene of Joseph Thrown into the Well. Instead of CIRCVMDEDERVNT, the artist wrote GVRCVMDEDERVNT. In other verses, the words SVAVI-TATEM and CASTIGATIO are separated by a comma and a space: SVAVI, TATEM and CAS, TIGATIO, suggesting a rote transcription from another source.

The Greek artist who created this panel represents faces and silhouettes similarly. Faces are rendered dark in color, enlivened by white highlights. Silhouettes are diminutive, with the clothing redrawn on the surface with highlights. In Old Testament scenes and in the organization of the painting, one notes a vivacity and inventiveness that demonstrates the painter's familiarity with mannerism. Assimilating Western cultural and stylistic elements of the sixteenth century, the artist presents them in a new language, characterized by strong, glazed colors in variations of red, blue, brown, and ocher. The work bears some similarity to that of Giorgio Klontzas (c. 1540–c. 1608). However, we see here a more pronounced taste for the archaic and a less fluid combination of Western and Eastern stylistic influences.

The work dates to the end of the sixteenth or beginning of the seventeenth century. The biblical text used as the source for the icon differs in comparison to the *Vulgate*, as seen in the quotes from Exodus (15:1) and Matthew (16:24). At the corners of the panel, among numerous stars at the top, are the sun and the moon: the sun, to the right, is anthropomorphic; the moon, to the left, is a crescent, a reference to the Virgin whose source is Song of Songs 6:10: *Pulchra ut Luna, electa ut Sol.* The moon, a symbol of virginity since antiquity (Diana), is also present; together with the sun, it refers to the "woman clothed with the sun, with the moon under her feet, and on her head a crown of twelve stars" (Revelation 12:1). It is possible that the sea is a reference to Mary's name, *Stella Maris*.

A.B.

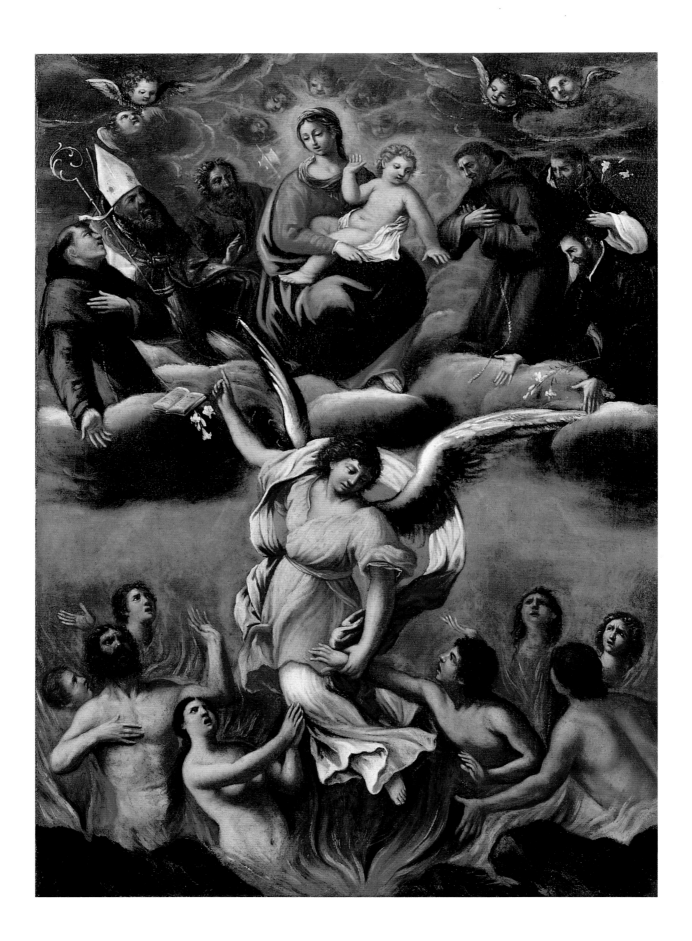

20    Tuscan School
*The Madonna Intercedes for the Souls in Purgatory*
early 17th century
oil on canvas, 41.9 x 30.5 cm (16½ x 12 in.)
Vatican Museums, Vatican Pinacoteca, Storage, Inv. 42523
RESTORATIONS: 1937; 1996–1997
EXHIBITION: Los Angeles 1998
LITERATURE: Breda in Los Angeles 1998

This painting, of unknown provenance, was at Castelgandolfo in 1721 in the dining room, "the room where His Holiness takes his repasts."[1] Rendered with great attention to detail, this is almost certainly a painting dedicated to the souls in purgatory. The Madonna, majestically seated on clouds, holds the Christ Child who, with His right hand raised (in a gesture reminiscent of the Christ Judge of the Sistine Chapel), absolves the souls in purgatory; the angel in the lower center frees one such soul. The body of the Child is large, certainly an allusion to the Mystery of the Christ-Man who, glorified by the Resurrection, descends into Limbo to save the souls of the just. Surrounding the Mother and Son are saints placed in a circle, who also intercede. From the left, one can see Saint Anthony of Padua (in Franciscan habit, with lily), Saint Eligius (in bishop's habit, with crosier and hammer), Saint Jude of Thaddaeus (with halberd), Saint Francis (in Franciscan habit, in a position of adoration), Saint Dominic (in Dominican habit, with lily), and Saint Ignatius Loyola (in a cassock, with lily). The erroneous identification of Saint Eligius, patron of metalworkers, goldsmiths, and saddlers, as Saint Petronius, patron of Bologna (who holds a model of the city, not a hammer), led Adele Breda[2] to speculate that the painting belonged to the Bologna workshop of the Carracci brothers, exponents of classicist painting during the fifteenth and sixteenth centuries. However, the small painting is rich in the soft, contrasting shades of the mannerists, suggestive of Tuscany and an artist closer in the style to that of Francesco Curradi (Florence 1570–Florence 1661), who worked for various Umbrian churches[3] and whose renditions of faces (including those of the supplicant souls in this painting) show comparable traits.

Provenance and date may be related to the Provençal Saint Eligius, Bishop of Noyon (near Limoges), who lived in the sixth century and whose cult was well established in Rome at the beginning of the seventeenth century. In 1628, one of his relics was brought from France to Rome.[4] His typical attributes are the bishop's habit with crosier, symbol of his election as Bishop of Noyon, and the hammer, emblem of goldsmiths and blacksmiths ("metalsmiths").[5]

The painting is one of devotion to supplicant souls, whose liberation through the prayer of the faithful is due to the intercession of Mary the Mediator and to the intervention of saints and angels. This theme, prevalent since the *Decretum de Purgatorio*, issued on December 3–4, 1563, during the Council of Trent, is frequently seen in Counter-Reformation painting. The work is remarkable for its formal simplicity and its accuracy of iconographic detail—all precepts recommended by the Council. Mary, among the intercessors, is the prominent figure, having been formally recognized in the fifteenth century as Queen of Heaven and as Immaculate Conception.[6]

M.A.D.A.

1. ASV, *Palazzo Apostolico, Amministrazioni* 1051, 34.

2. Breda in Los Angeles 1988, no. 78.

3. Spoleto 1989, 162.

4. Lipinsky 1954, 28–32.

5. Baussan 1932.

6. Mâle 1932; Wazbinski 1987; Pacelli 1989.

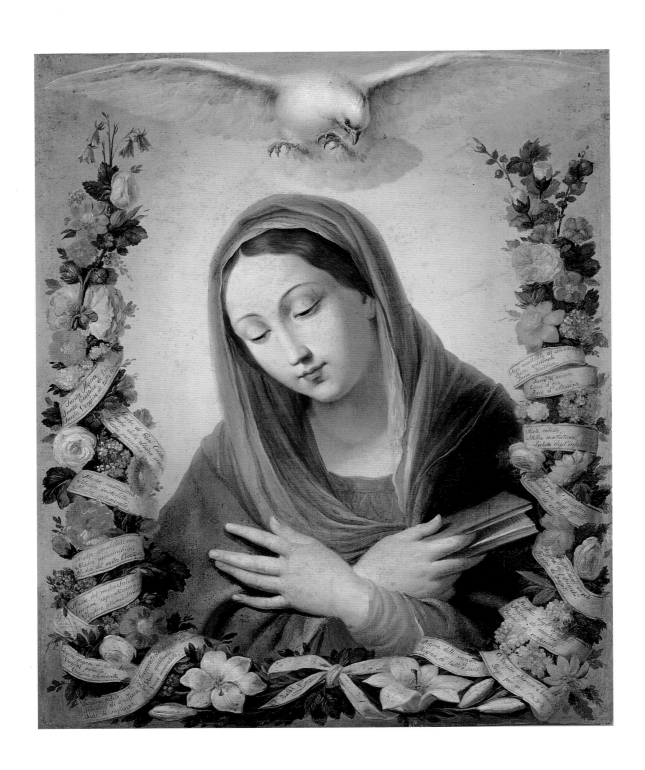

21    Filippo Balbi (Naples 1806–Alatri 1890)
*Madonna of Loreto*
1846–1850, 1854
oil on canvas, 71.1 x 58.4 cm (28 x 23 in.)
Vatican Museums, Pinacoteca, Inv. 41486
INSCRIPTIONS:

SANTA MARIA,
SANTA GENITRICE DI DIO,
SANTA VERGINE DI TUTTE
  LE VERGINI,
MADRE DI GESÙ CRISTO,
MADRE DELLA DIVINA
  GRAZIA,
MADRE PURISSIMA
MADRE CASTISSIMA,
MADRE INVIOLATA,
MADRE INTEMERATA.
MADRE AMABILISSIMA,
MADRE AMMIRABILE,
MADRE DEL NOSTRO
  CREATORE.
MADRE DEL NOSTRO
  SALVATORE
VERGINE SAPIENTISSIMA,
VERGINE ADORABILISSIMA
VERGINE DEGNA DI TUTTE
  LAUDI,
VERGINE POTENTE,
VERGINE CLEMENTE.
VERGINE FEDELE,
SPECCHIO DI GIUSTIZIA,
SEDE DI SAPIENZA.
COOPERATRICE DELLA
  NOSTRA SALVEZZA,
VASO SPIRITUALE,
VASO VENERABILE

VASO ECCELLENTE DI DIVOZIONE
ROSA SPIRITUALE,

TORRE DIVIDICA.
TORRE D'AVORIO

CASA D'ORO,
ARCA D'ALLEANZA,
PORTA CELESTE,
STELLA MATUTINA,
SALUTE DEGLI'INFERMI,
RIFUGIO DE' PECCATORI,
CONSOLATRICE DEGLI AFFLITTI,

SOCCORSO DE' CRISTIANI,

REGINA DEGLI ANGELI,
REGINA DE' PATRIARCHI,
REGINA DE' PROFETI,

REGINA DEGLI APOSTOLI
REGINA DE MARTIRI
REGINA DE' CONFESSORI,
REGINA DELLE VERGINI
REGINA DI TUTTI SANTI
O, VERGINE GLORIOSA E BENEDETTA

PREGA PER NOI
F. BALBI PIN(XIT)

The Virgin Mary appears with her eyes downcast, hands crossed on her chest. She has a half-closed book in her right hand. Above her is the dove, a symbol of the Holy Spirit, as in the images of the Annunciation in which the angel startles her as she prays. Mary is surrounded by a garland of flowers, adorned with a

long ribbon ending in a bow at the bottom, where one finds the signature of the artist. On the ribbon, written in cursive letters, are the Litanies of the Virgin in groups of three, ending with the invocation "pray for us," which must be repeated after each litany.

The word litany, from the Greek for "prayer, supplication," represents a means by which Christians unite in the prayer of the priest, addressing a supplication to Christ, the Virgin, or saints. The Litanies of the Virgin are an invocation to the Madonna, usually recited after the Rosary and classical in origin. Litanies for Mary have been widespread among Eastern Christians since the first centuries. A Magonza codex from the twelfth century contains a *Letania de Domina nostra*. By 1601 there were so many litanies that Pope Clement VIII prohibited the composition of new ones and the reprinting of old ones, except for those "usually sung in the Holy House of Loreto," which gave them the name "Litanies of Loreto." The first documents referring to the Litanies of Loreto date from the beginning of the sixteenth century and were officially approved by Pope Sixtus V in 1587. The Sacred Congregation of Rites guaranteed their stability and inalterability by three decrees of 1631, 1821, and 1839. Litanies added later required the approval of the Holy See.

This painting represents forty-four litanies, compared to forty-nine in the currently used version. The five missing litanies were added on special occasions between 1854 and 1950, as follows: *Regina sin labe concepta,* which already existed in the liturgy of many churches as a special concession under Pope Gregory XVI (list of concessions from 1839 to 1847 in *Summa Aurea* 7, 608 and following), was extended to the entire church in 1854 by Pope Pius IX on the occasion of the definition of the Dogma of Immaculate Conception; *Regina sacratissimi Rosari* was added on December 24, 1883, by Pope Leon XIII; *Mater boni Consili* was added by Pope Leon XIII in 1903; *Regina pacis* was introduced by Pope Benedict XV in 1917; and *Regina in coelum assumpta* was added in 1950 by Pope Pius XII on the occasion of the definition of the dogma of the Assumption.

Concerning the currently used litanies of Loreto, there are numerous variations. Early litanies were written in Latin. In the painting seen here, some are reminiscent of the originals, by contrast to more contemporary ones, which have been translated more freely. This is clearly demonstrated by comparing the litany appearing in the painting in Latin with that used in contemporary devotion: instead of the litany in the painting, *Santa Genitrice di Dio* (Holy One Who Gave Birth to God), derived from the Latin *Sancta Dei Genitrix,* what is used is "Holy Mother of God." *Madre inviolata (Mater inviolata)* (Mother inviolate) has become "Mother always Virgin"; *Madre intemerata (Mater intemerate)* (Mother undefiled) was replaced by "Mother without Fault"; *Specchio di giustizia (Speculum iustitiae)* (Mirror of justice) has become "Model of Sainthood"; *Vaso spirituale (Vas spirituale)* (Spiritual vessel) has been transformed into "Temple of the Holy Spirit"; *Vaso venerabile (Vas honorabile)* (Vessel of honor) has been replaced by "Temple of Glory"; *Vaso eccelente di divozione (Vas insigne devotionis)* (Singular vessel of devotion) has become "Model of True Clemency"; *Rosa spirituale (Rosa mystica)* (Mystical rose) has become "Masterpiece of Charity"; *Torre davidica (Turris davidica)* (Tower of David) has been transformed into "Glory of the Seed of David"; *Torre d'avorio (Turris eburnea)* (Tower of ivory) has become "Model of Strength"; and, finally, *Casa d'oro (Domus aurea)* (House of gold) has been replaced by "Splendor of grace."

The choices of the litanies cited in the painting have their origins in theology. Rather than the contemporary litany, "Source of our joy" (*Causa nostrae laetitiae),* the painting reflects "Helper of our salvation," stressing the fact that Mary is the mediator of salvation for Christians who put themselves in her hands. Instead of the contemporary litany, "Mother most prudent," the preferred one was "Mother most wise," stressing the idea of Mary Mother of the Word, therefore, Throne of Wisdom and She Herself Most Wise, which is reinforced with the image of the Virgin with a book. The book is the Book of Wisdom, and Mary is the *Sedes Sapientiae,* the Divine Word, although the translation used by the artist, "Seat," may be an

additional reference to the house or abode of the Divine Word.

Finally, there are insignificant variations in certain litanies or, in the case of *Torre dividica*, a simple transcription error. Many of the titles referring to the Virgin derive from the Song of Songs. In the medieval religious tradition, the protagonist of this Song, the Shulamite girl (see Song 7:1), was identified with Mary. These litanies are the "Tower of David" (4:4) and the "Tower of Ivory" (7:5), while the litany "Ark of the Covenant," taken from Exodus (31:7), refers to the building of the Temple and is intended to suggest a parallelism between the Virgin and the Church.

The flowers that frame the Virgin have unambiguous symbolic meaning, including the lilies in the foreground, which represent purity and are reminiscent of the iconography of the Annunciation. The roses are symbolic of Mary and the Rosary. The various wildflowers symbolize humility—primroses and pansies as well as forget-me-nots, and gentians which, by their blue color, indicate the Virgin's cape. The narcissus, on the other hand, is a funereal symbol or one of eternal life.

Filippo Balbi, who was born in Naples in 1806 and died in Alatri in 1890, was a student of the neoclassic portraitist Costanzo Angelini. He was active mainly in religious circles in and around Rome between 1850 and 1865. Among his works are the frescoes for Certosa di Trisulti as well as those in Rome at S. Paolo Fuori le Mura, the Chapel of Tasso in S. Onofrio, and in a Carthusian Chapel near Tor Pignattara.

The Virgin of the Litanies is stylistically close to the works of the Italian purists of the first half of the nineteenth century. Quite likely, the painting was recorded in the comprehensive 1922 inventory of furniture, tapestries, paintings, and so forth in the Floreria Vaticana and in various apartments and offices of the Sacri Palazzi Apostolici and the Palazzo Pontificio of Castelgandolfo. In this inventory, the painting is listed as no. 197 and is entitled *The Virgin with Flowers*. The same inventory also contains another painting by Balbi, no. 69, entitled *Two Children,* also never before shown. It was painted in Trisulti in 1861 and represents a little girl with a bundle of branches on her head and a smaller boy who is eating a piece of bread. The children hold hands and are dressed poorly, with the typical *ciocie* (shoes) on their feet. This popular subject reflects a special sensitivity for genre painting with realistic nuances, conveying a warm romantic feeling. Balbi's sweet and vivid imagery distances him from formal academicism. This is especially obvious in his portraits, genre scenes, and still lifes, rather than in his works with historic or biblical themes. An example exists in the frescoes in the refectory and small adjoining room in Certosa di Trisulti, which contrast markedly with biblical themes and stories about saints in the church and in the choir of the lay brothers.

The Virgin of Litanies was painted between 1846, the year the artist came to Rome, and approximately 1850. The litany "Queen conceived without original sin" was added in 1854. Most likely commissioned by a church dignitary, the work reflects the litanies approved by the Church and in this respect is an important record of the evolution of this religious custom, still alive today. The transcription into nineteenth-century Italian demonstrates the updating and transformation of the litanies. Although touched by the academic taste of the time, the work shows a particularly dignified sweetness in Mary's rapt face and a hasty, self-confident manner in the quickly sketched flowers.

A.B.

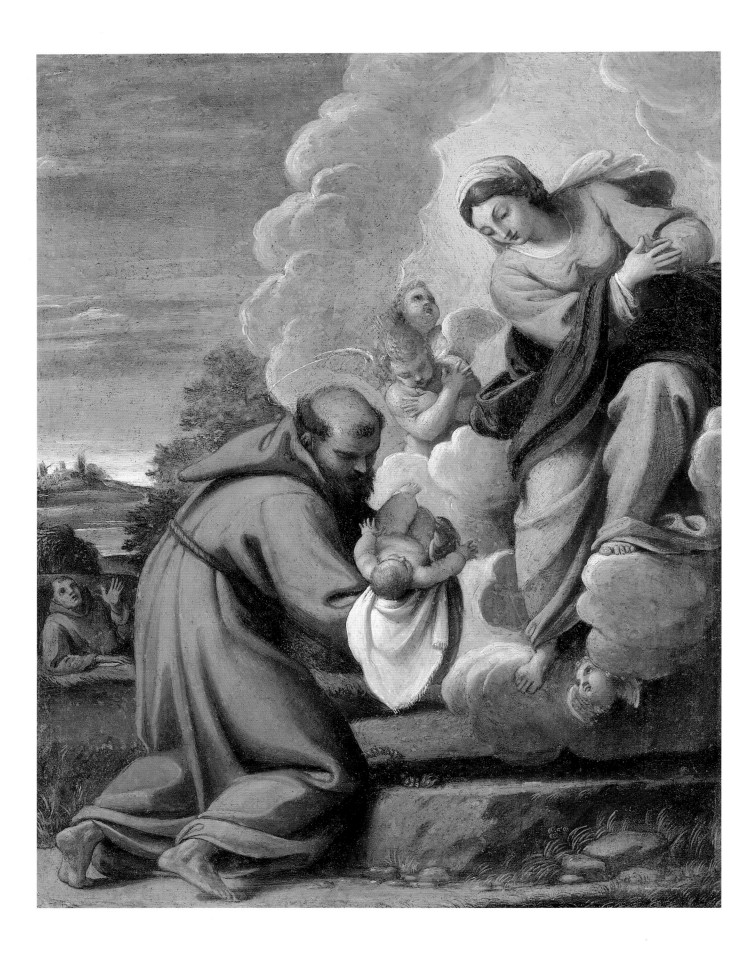

22    School of Carracci (Antonio Carracci?)
*The Virgin Offers the Child to Saint Francis (or to a Franciscan Saint)*
late 16th–early 17th century
oil on copper, 31.8 x 26.7 cm (12½ x 10½ in.)
Vatican Museums, Vatican Pinacoteca, Inv. 40728
PROVENANCE:  Gift from Sir Antonio Castellano, 1925
EXHIBITION:  Exhibited for the first time

This small painting on copper, depicting the Virgin and Child with a Franciscan saint, was among the works donated to the Vatican Museums in 1924 and 1925 by Sir Antonio Castellano. Consisting of at least forty-two paintings, this significant private collection included two masterpieces by Guido Reni, *Saint Matthew with the Angel* and the so-called *Fortuna "Gavotti,"* as well as *The Sacrifice of Isaac* by Ludovico Carracci.

Attributed to the Carracci Circle or, more precisely, to the cousin of Agostino Ludovico, the painting seen here joined the Vatican collections on March 14, 1925. Although it is a workshop painting produced for the Franciscan faithful, its noteworthy features include the refinement of the Virgin's face (derived from Carracci), the harmonious lines in the complex positions of both the saint and the Child, the delicacy of the landscape, and the color palette overall. Although the work was not widely known and kept in storage at the Vatican Pinacoteca, it was noticed by the great scholar of Italian baroque painting, Denis Mahon, during a visit to the Vatican Museums in preparation for the major Carracci exhibition in Bologna in 1956. On that occasion, this small painting was attributed by him to Antonio Carracci, natural son of Agostino, who lived for a short time during the late sixteenth and early seventeenth centuries.

However, its attribution is uncertain, clouded by the ambiguity of its subject. Shown is an event shared by several Franciscan saints, including Saint Francis himself, that is, the apparition of the Virgin offering the Child to the saint. The saint's habit, identical to that of the friar who stands nearby, is gray-brown, a color more closely resembling the habits worn by the Capuchin friars than those of the conventual monks (often appearing with Antonio of Padua). Another Capuchin saint, also depicted as having this vision, is Felice da Cantalice (1515–1587), who is typically rendered older than the saint who appears in this painting. The identification with the Poverello of Assisi is also dubious, because the Carracci school depicted him as a thin, short man bearing no resemblance to the saint represented here.

<div align="right">U.U.</div>

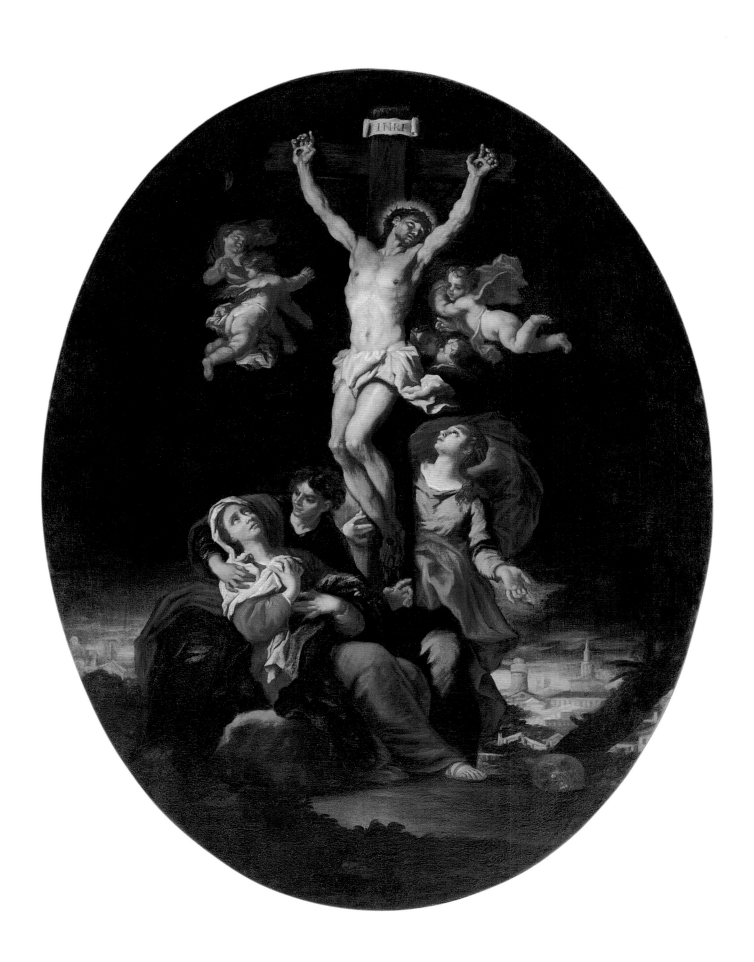

23      School of Naples, late 17th–early 18th century
        *Crucifixion with the Madonna, Saint John, and Mary Magdalene*
        oil on canvas, 129.5 x 101.6 cm (51 x 40 in.) (oval)
        Vatican Museums, Vatican Pinacoteca, Storage, Inv. 44449
        RESTORATION: 1999
        EXHIBITION: Rome 1999
        LITERATURE: De Angelis in Rome 1999

This painting, whose date of acquisition is unknown, was recovered in 1998 after having been stolen from the Vatican Museums. During a recent restoration by Bruno Mattei of the Painting Restoration Laboratory of the Vatican Museums, several observations were made. The painting was originally rectangular and later made oval. It had once been lined and was restored several times, as indicated by the presence of a variety of pastes as well as evidence of a drastic cleaning, which resulted in the removal of the original dark blue background, revealing brown primer. The current cleaning uncovered technical workmanship of good quality, similar to that found in the Naples region.

The artist, in general, retained the elaborate figurative models of Crucifixions by Francesco Solimena and Luca Giordano, which include several figures in theatrical poses and a sky filled with small angels. The basic chromatic scheme—carmine lacquer for the Madonna's garment, intense blue for the stormy sky, and flesh-colored pink in the shadows—suggests a date close to the end of the seventeenth or the beginning of the eighteenth century. Details such as the angels, the emphasis on round eyes, and the nervous brushstrokes seen in the draperies (especially the white ones) are reminiscent of the style of Sebastiano Conca (Gaeta 1680–Gaeta 1764). The technical execution, however, is inferior, precluding an attribution to him. Another possibility is Giovanni Conca, who lived in Rome with his cousin Sebastiano beginning in 1719. Conca (1690–1771) created five canvases (in need of restoration) that adorn the walls of the Oratorio della Dottrina Cristiana next to the church of S. Maria della Traspontina. They were painted around 1715[1] and have certain stylistic features in common with this Crucifixion.

1. Gigli 1990, 122.

                                    M.A.D.A.

## Mary in Cultures around the World

And Mary said: "My soul proclaims the greatness of the Lord;

my spirit rejoices in God my savior. For he has looked upon his handmaid's lowliness;

behold, from now on will all ages call me blessed."

Luke 1:46–48

.

Because the Church is communion, which joins diversity and unity

in being present throughout the world, it takes from every culture all that it encounters

of positive value. Yet inculturation is different from a simple external adaptation,

because it means the intimate transformation of authentic cultural values through

their integration in Christianity in the various human cultures.

Second Extraordinary Bishops' Synod, 1985

.

At the Second Extraordinary Bishops' Synod called by Pope John Paul II in 1985,

the bishops expressed their hope for mutual enrichment between the

Catholic faith and the cultures of the world. In the dialogue that followed,

art played a significant role and Mary, the Mother of God,

was frequently the subject of the works of art.

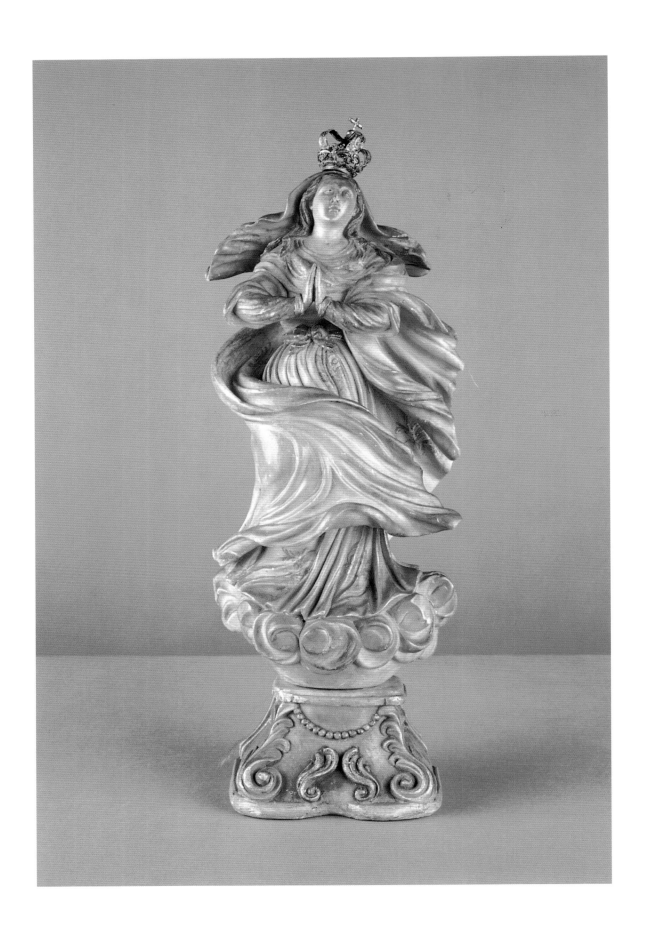

24     Anonymous (Brazil)
       *Our Lady*
       1740/1770
       soapstone with silver crown, 40.6 x 14.9 x 9.5 cm (16 x 5⅞ x 3¾ in.)
       Vatican Museums, Missionary-Ethnological Museum, Inv. AM 7044
       PROVENANCE:  Brazil
       EXHIBITIONS:  Lisbon 1994; Ravenna 1999
       LITERATURE:  Lisbon 1994

This statue, which demonstrates excellent workmanship, was made in Brazil sometime between 1740 and 1770 by a sculptor whose name is unknown to us. Baroque in style, it reflects the classical canons of Western culture. The garment of the Virgin is magisterial, ultimately defining the work's dynamic style. The cape is blown by the wind, the face lost in contemplation; the joined hands are skillfully rendered. The clouds that sustain the Virgin's body and the crown placed on her head suggest an image of the Madonna Queen, raised to the heavens. The statue thereby echoes well-known themes brought to Brazil during the period of colonization. It reflects European culture, and there is no hint of the indigenous traditions of Brazil, in marked contrast to our modern interest in acknowledging the traditions and individualities of each civilization.

                                                                    R.Z.

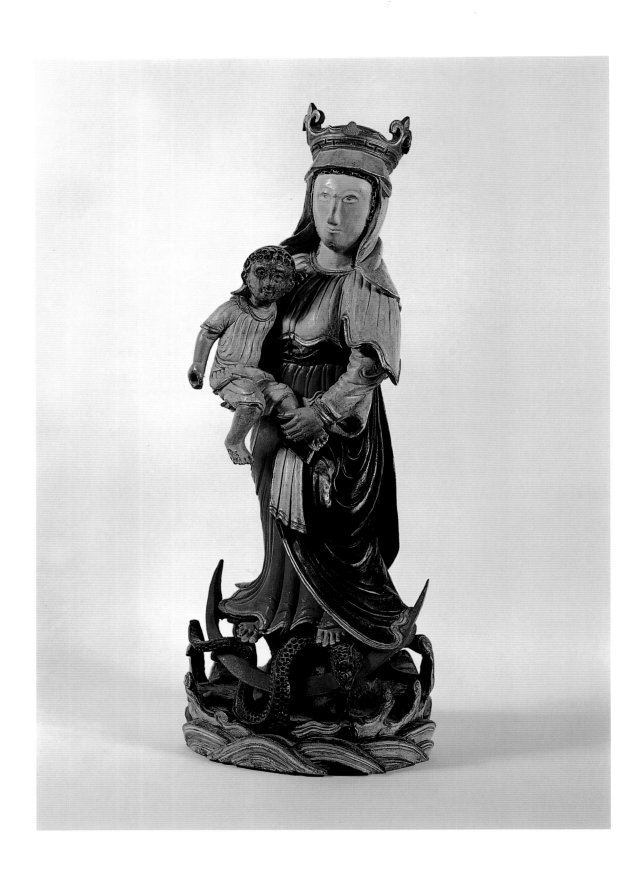

25   Anonymous
     *Madonna and Child*
     early 19th century
     painted wood, 64.3 x 25.8 x 22.9 cm (25 5/16 x 10 1/8 x 9 in.)
     Vatican Museums, Missionary-Ethnological Museum, Inv. 2944
     PROVENANCE:  Vietnam
     EXHIBITION:  Manila 1994

This statue of the Madonna, by an unknown artist, is accompanied by two small angels of adoration that are not included here. The Madonna holds the Child in her arms. Her face, with its transfixed gaze, and the majestic pose of her body contrast with the vivid expression on the face of Jesus. His head is lifted upward, suggesting energy and motion. The crown on the Madonna's head and her rich clothes highlight her royalty: Mary is Queen by virtue of the Son's royal status.

The symbols beneath her bare feet are part of the traditional iconography of the Virgin and relate to two passages in Genesis (3:15): "I will put enmity between you and the woman, and between your offspring and hers; He will strike at your head," and Revelation (12:1): "a woman clothed with the sun, with the moon under her feet, and on her head a crown of twelve stars." The artist thus combines two sets of symbols and conveys the concept of the stars in a simple crown. The image simultaneously refers to the Divine maternity, Mary's Royalty, the Immaculate Conception, and the idea of co-redemption. Its style is classically Spanish. With the exception of certain oriental traits in the Madonna's features, the details suggest origins in European rather than Asian culture.

                                        R.Z.

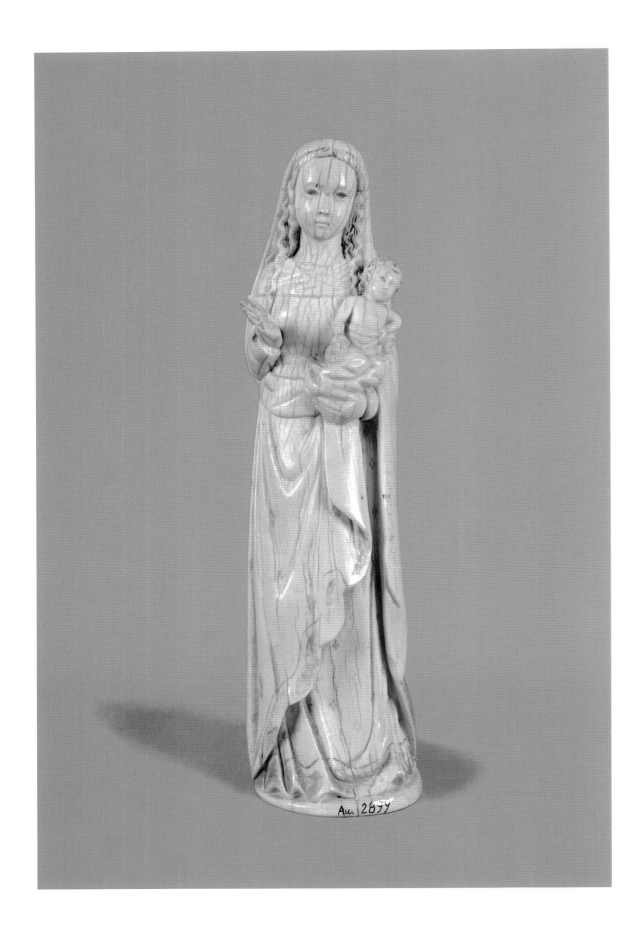

Au. 2677

26      Anonymous (Philippines)
        *Madonna and Child*
        18th century
        ivory, 22.9 x 5.9 x 7 cm (9 x 2⁵/₁₆ x 2¾ in.)
        Vatican Museums, Missionary-Ethnological Museum, Inv. AU 2899
        PROVENANCE:  Philippines

This ivory sculpture of the Madonna and Child is executed in a Western style, probably Iberian. The Madonna, standing, holds the Child with her left arm while her right arm is bent, with the hand of the Child raised. Mary wears a tunic with a long cape. The left corner is held by the Madonna with her left hand, resulting in a softly draped garment of rich, voluminous folds. Mary's elaborate clothing retains a trace of gold decoration, both on the tunic and in the cape. In this rendering of the Madonna and Child, the artist was attentive to realistic details. Notice her face, the curled, cascading hair, her long, thick fingers, and the face of the Child, which, despite its small size, is not without detail. The elongated shape and slight curve of the sculpture's upper section result from the shape of the tusk from which it was carved. The sculpture was given to Pope Paul VI (1963–1978) and placed in the Pontifical Antechamber. Since 1973, it has been part of the Christian art collection of the Missionary-Ethnological Museum and is displayed in a gallery dedicated to Christianity in the Philippines.

                                                                      D.D.

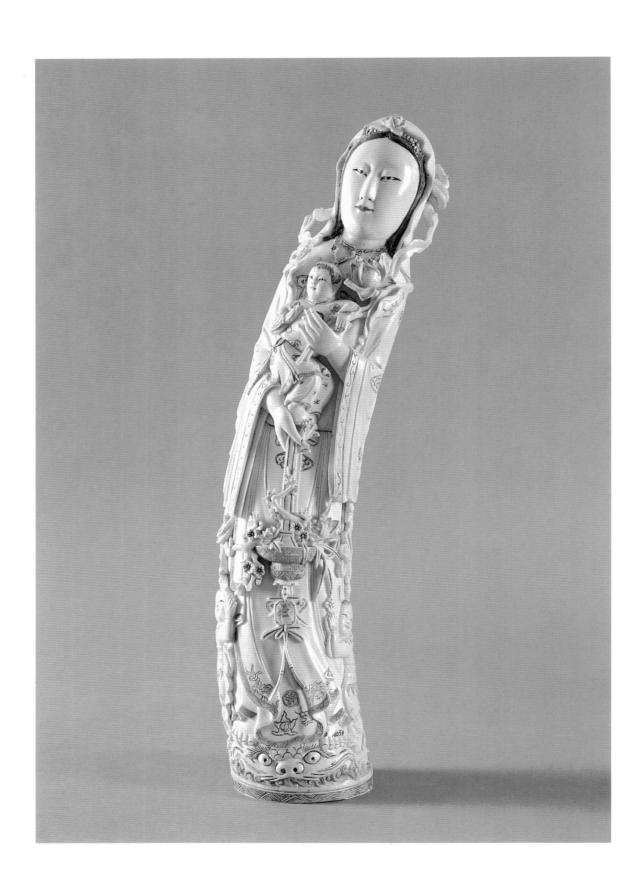

27      Anonymous (China, Ming Dynasty)
*Madonna and Child*
ivory, 41.7 x 9.9 x 7.9 cm (16⅜ x 3⅞ x 3⅛ in.)
Vatican Museums, Missionary-Ethnological Museum, Inv. AS 10059
INSCRIPTIONS: DA MING NIAN ZHI (executed at time of the great Ming
Dynasty); apocryphal mark under the base
PROVENANCE: Vietnam

This ivory sculpture, carved from a single elephant tusk, represents Mary standing, with the Child in her arms. The work is most likely by a Chinese artist. In carving the figure of Mary, the sculptor was inspired by Guanyn, the goddess of infinite compassion and the female form of the god Avolokiteshvara, one of the most revered divinities in the Buddhist pantheon. To lend the work a Christian content, the sculptor added two small angels, placed at Mary's feet, to the classic iconography of the Chinese divinity. Guanyn is often represented with a child in her arms, riding a dragon, and situated in front of cascading water or on a rock leading sailors caught in a storm to safety. The physiological resemblance of the figures as well as their clothing and accessories further reveal the work's uniquely Chinese context, as do the lotus flowers adorning Mary's dress, which symbolize longevity and purity. Made in relief and finely cut, the sculpture demonstrates the artist's attention to detail, underscored by a delicate but decisive chromaticism. Particularly notable are the faces of the sculpted figures, the detail of the hair, and the lips, colored in red, as well as the meticulous execution of the dragon at Mary's feet.

    This work takes full advantage of the shape of the tusk from which it was carved, its gentle curve in harmony with the motion inherent in the figures. The sculpture was given to Pope Paul VI (1963–1978) and placed in the Pontifical Antechamber. Since 1973, it has been part of the Christian art collection of the Missionary-Ethnological Museum and is currently located in the section dedicated to Christianity in Southeast Asia.

<div align="center">D.D.</div>

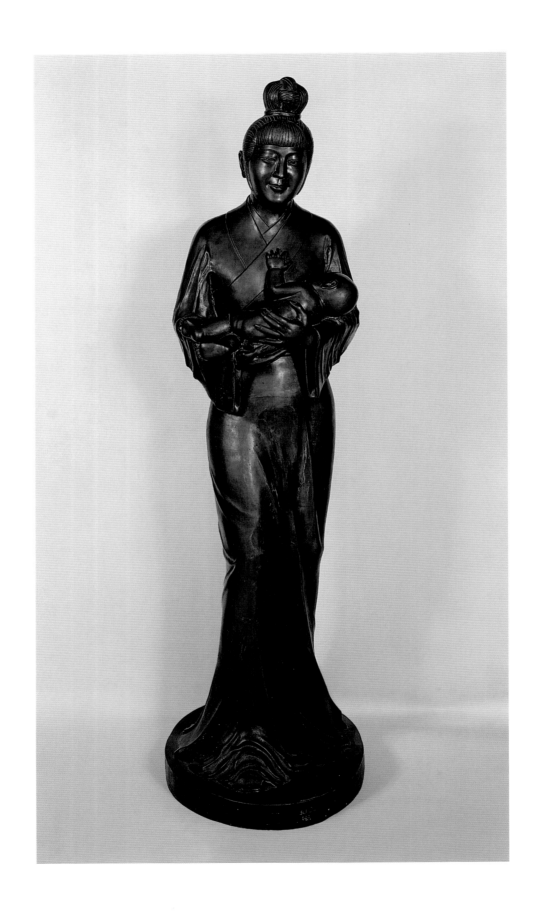

28     DEN FET-MA (China)
*Madonna and Child*
c. 1870
bronze, 169.3 x 45.5 x 59.4 cm (66 $^{11}/_{16}$ x 17 ⅞ x 23 ⅜ in.)
Vatican Museums, Missionary-Ethnological Museum, Inv. AS 9174
PROVENANCE: Private apartment of Pope Paul VI
EXHIBITION: Manila 1994

This life-size bronze statue represents a tender young woman lovingly holding a baby, who nestles into her arms. Her left leg is in a slightly forward position, suggesting a slow walk or a rocking motion intended to encourage the Child to sleep. The Chinese origins of this sculpture are evident in the face of the Madonna and in her long hair, gathered on top of her head. Also typically Chinese is her formfitting gown.

     The sculptor Den Fet-ma is Chinese, and the statue was given to Pope Paul VI (1963–1978) in 1970. The Pope's secretary, Monsignor Pasquale Macchi, placed it in the Pontiff's studio, where it remained until his death. Shortly thereafter, it was transferred to the Vatican's Missionary-Ethnological Museum and displayed in a gallery dedicated to Christianity in Asia. The sculpture represents the Madonna with the Child Jesus. Mary, as Mother of the Savior, is seen as the archetype and final reference on maternity and can therefore be legitimately represented in the faces and clothing of any people.

<div align="right">R.Z.</div>

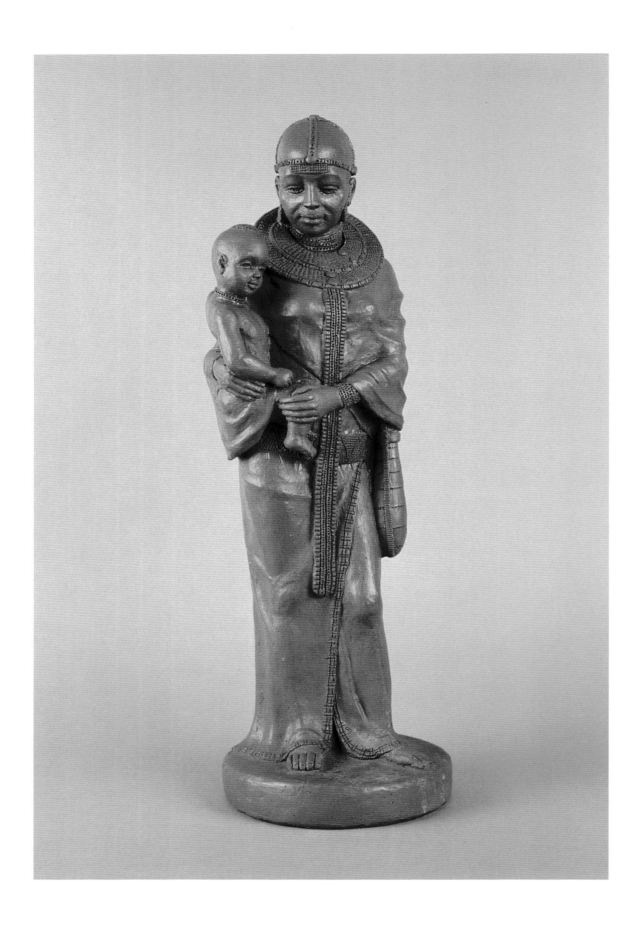

29    Anonymous (Kenya)
*Madonna and Child*
1978
terracotta, 59.4 x 17.8 x 17.8 cm (23⅜ x 7 x 7 in.)
Vatican Museums, Missionary-Ethnological Museum, Inv. AF 7912
PROVENANCE:  Kenya
EXHIBITION:  Ravenna 2000
LITERATURE:  Fischer 1984, 13–17, 27–29

This terracotta sculpture of Mary with the Child in her arms unequivocally has its origins in the Masai people of Kenya. Both Mary's head and that of the Child are shaved and polished in accordance with local custom. The richness of detail in the neck plates, which consist of small threaded beads, and the drop earrings worn by Mary further attest to the sculpture's African origins, as do the finely chiseled features of the figures' faces and the additional ornaments they wear. All reflect the cultures of the Nile and Western Africa. The sole reference to Western tradition is the long tunic worn by the Madonna, not found in Kenyan female garb.

While the sculpture's ethnic origin is evident, the artist nonetheless expresses a universal concept of femininity and maternity through the figure of Mary, who tenderly holds the Child in her arms. The work was created in 1978, as indicated by a brief inscription at the base of the sculpture. After being given to Pope John Paul II, it was placed in the Private Storeroom and, in 1980, joined the Christian art collection of the Missionary-Ethnological Museum. It is currently exhibited in the African section dedicated to Christianity.

D.D.

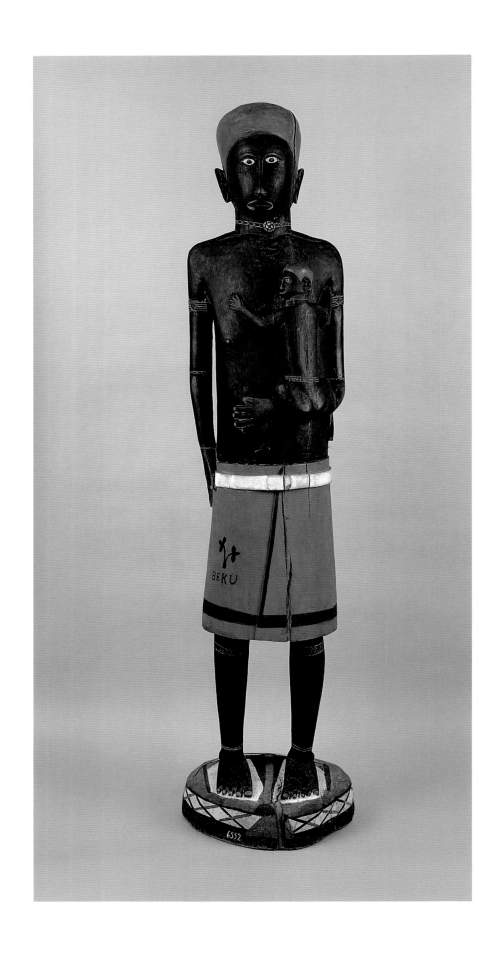

30      Guénu (Solomon Islands)
*Madonna and Child*
late 19th–early 20th century
polychromatic wood, 169.3 x 39.6 34.7 cm (66⅔ x 15⅝ x 13¹¹/₁₆ in.)
Vatican Museums, Missionary-Ethnological Museum, Inv. 6552
PROVENANCE:  Solomon Islands, Bougainville Island
LITERATURE:  Maarschalkerweerd 1937, 15–34; O'Reilly 1940, 163–198

This wooden sculpture of Mary with the Child is the work of Guénu, an artist from Bougainville Island in the Solomon Islands. It is the earliest known sculpture to depict the Christian ideal of maternity in the aesthetic and cultural vocabulary of the region. According to Patrick O'Reilly, a missionary who worked on the island in the early twentieth century, the artist Guénu believed that the Madonna had instructed him to create a statue consistent with his personal vision, without reference to the Western models present in the various chapels of the missions. The artist, who had already created a number of feminine images in the typical style of Papua New Guinea, followed a model that was familiar to him. His sculpture, however, was not well received by the local bishop, who preferred the aesthetic standards of the West.

Mary is shown standing, with the Christ Child supported on her body, His right arm reaching beneath her left arm in a local convention signifying intimacy, protection, and maternal love. The stylized depiction of the black-painted bodies of Mary and Jesus, the rendering of their faces, the short red skirt that Mary wears, and the ornaments on their bodies reflect the cultural milieu of the artist. The work was brought to Europe by O'Reilly on his return. It was donated in 1935 to the Missionary-Ethnological Museum by the religious Congregation of the Marist Brothers, to which the missionary O'Reilly once belonged, and is currently displayed in the Papua New Guinea section dedicated to Christianity.

<div align="right">D.D.</div>

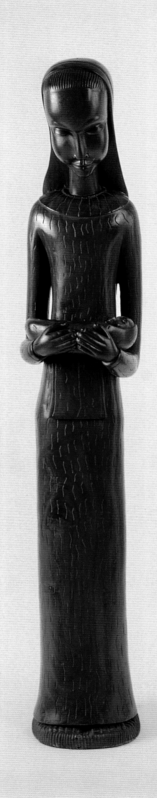

31    ADAMO KAMTE
*Madonna and Child*
1990
wood, 151.6 x 27.7 x 31.7 cm (57⅞ x 10⅞ x 12½ in.)
Vatican Museums, Missionary-Ethnological Museum, Inv. AF 8202
PROVENANCE:  Burkina Faso-Bobo Dioulasso
EXHIBITION:  Ravenna 2000

This sculpture, carved from a single cylinder of wood, depicts the Madonna standing with the Child swaddled in her arms. Its extreme verticality signifies Mary's spirituality while her absorbed contemplation of the Child speaks to her maternity. The iconography is primarily European although the work also reveals its African origins.

The tunic, which falls to Mary's feet, is marked by short, deep vertical incisions, as is the veil that partially covers her head. Mary's figure has been delicately lengthened at the hips, stressing her femininity and heightening the verticality of the work. At the same time, bent slightly forward, her face turned down, she expresses through half-closed eyes the intimacy between the Mother and Son. One notices the artist's attention to detail in the face of Mary and in that of the Child. The face of Jesus, whose figure is largely hidden by swaddling, is similar to Mary's. The curvature that characterizes the sculptural rendition of Jesus further stresses the intimacy between Mother and Child.

This work was created by the artist for Pope John Paul II in 1990, as indicated by a dedication at its base along the edge of Mary's tunic. It is now part of the Ethnological Collections of the Vatican Museums and is currently located in the African section reserved for Christianity.

D.D.

# Walking with Mary in the Third Millennium

May the unassuming Young Woman of Nazareth who, two thousand years ago,

offered to the world the Incarnate Word, lead the men and women of the new millennium toward

the One who is "the true light that enlightens every man" (John 1:9).

Pope John Paul II, *Tertio Millennio Adveniente*, 59

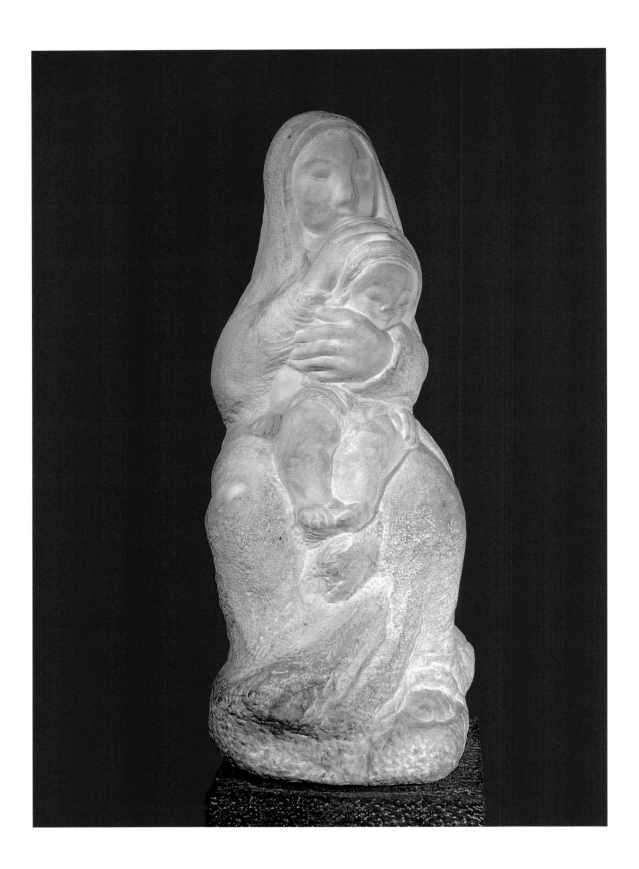

32    JOSÉ DE CREEFT (Guadalajara 1884–New York 1982)
*Sleep*
1972
marble, 32.   67.3 x 26.7 x 30.7 cm (26½ x 10½ x 12⅛ in.)
Vatican Museums, Collection of Modern Religious Art, Room XXXIII, Inv. 23153
INSCRIPTION:   Signature at bottom right
PROVENANCE:   Gift from Mr. and Mrs. R. Wunderlich
EXHIBITION:   New York 1972
LITERATURE:   Ferrazza 2000, 138; Ferrazza and Pignatti 1974, cat. 367; Fallani,
Mariani, and Mascherpa in Ferrazza and Pignatti 1974a, alph. cat.; New York 1972,
cat. 22

During his long career José de Creeft investigated the expressive qualities of his materials, exploring the tension inherent in the juxtaposition of finished and roughly worked areas. Dated 1972, this sculpture epitomizes his technique. The cape surrounding the Madonna prominently displays the traces of the chisel, while her face and hands as well as the figure of the Child are more finished for emphasis. The light shimmers on the large hands of the Madonna who, in a supremely maternal gesture, coaxes her Son to sleep with gentle strokes.

The formal solutions evident in De Creeft's sculpture, which is never perfect or proportionate, derive from his avant-garde training as well as from his conviction that the intensity and expressiveness of a work can be presented in a simple idiom. For him, spare elements communicate the essence of a topic or sacred subject.

                                                                                    M.F.

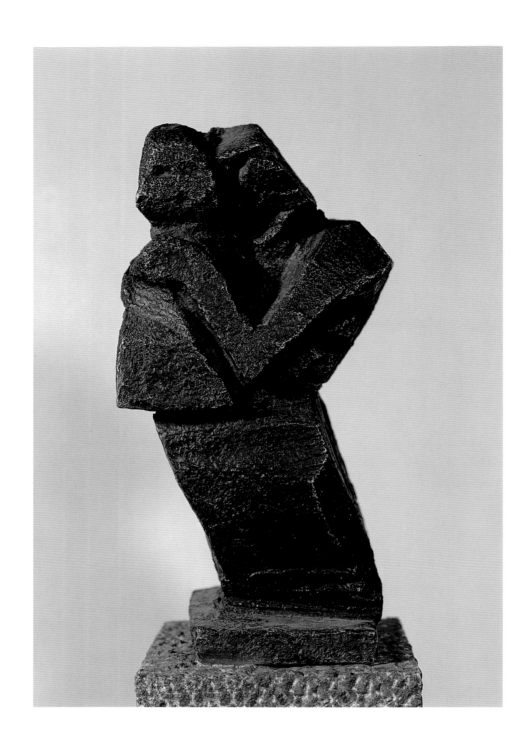

33    Auguste Chabaud (Nîmes 1882–Graveson 1955)
*Madonna and Child*
1910–1912
bronze, 22.9 x 10.9 x 9.9 cm (9 x 4⁵/₁₆ x 3⅞ in.)
Vatican Museums, Collection of Modern Religious Art, Room XXX, Inv. 23714
INSCRIPTION:  Signature on base
PROVENANCE:  Gift from Arlette Chabaud
EXHIBITIONS:  Vatican City 1980; Tokyo 1987
LITERATURE:  Ferrazza 2000, 124; Tokyo 1987, 152, cat. 82; Vatican City 1980,
cat. 14

This small sculpture was made by the Provençal artist Auguste Chabaud during the last years of his long stay in Paris. Chabaud, who had known the city early on, had moved there in 1902 and befriended many major artists of the time, including Paul Matisse, Maurice Vlaminck, Georges Braque, and Henri Laurens. His work is almost exclusively two-dimensional, including a few sculptures executed in his cubist period between about 1910 and 1914. Chabaud's interpretation of this seminal French avant-garde movement was highly original and markedly different from the solutions introduced by Pablo Picasso and Braque at the same time. As seen in the work shown here, Chabaud concentrated on a formal synthesis by combining clear, coherent forms of geometric blocks with a timeless lyricism, transmitting the essence of the work in its structure and content. The figure of the Madonna with the Child in her arms is gracefully executed through a slight inclination of the axis and a delicate union of the two figures. The sacred subject, not without references to primitive art, is modern in style, yet adheres to an iconographic tradition and conveys interest in the human dimension of its theme.

                                                                M.F.

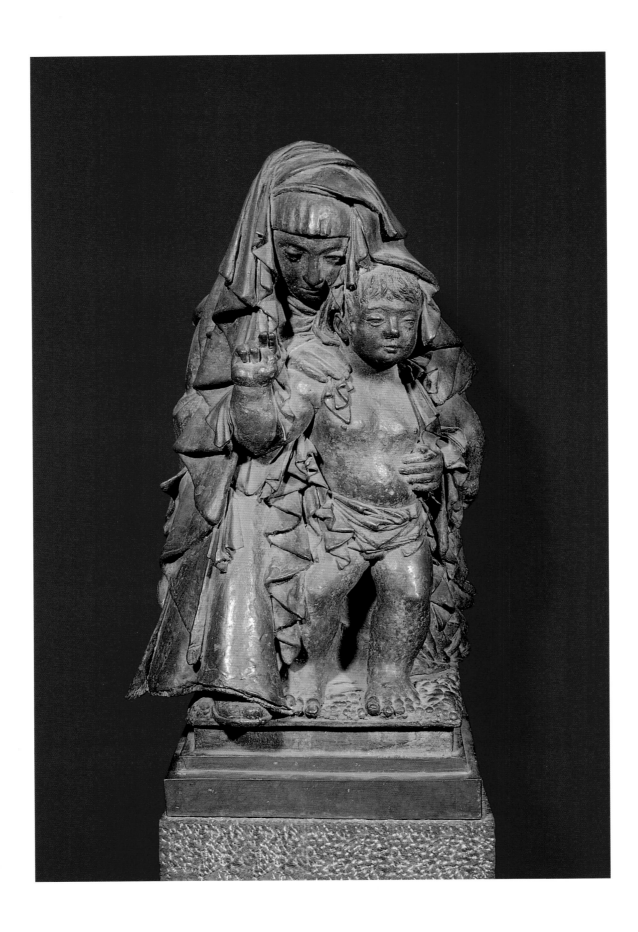

34    AMERIGO TOT (Fehevarcsurgo 1909–Rome 1984)
*Madonna of Csurgo*
1969
bronze, 64.3 x 28.8 x39.6 cm (25⁵/₁₆ x 11⁵/₁₆ x 15⅝ in.)
Vatican Museums, Collection of Modern Religious Art, Room XLII, Inv. 23610
INSCRIPTION:  Signature on back
PROVENANCE:  Gift from the artist
LITERATURE:  Ferrazza 2000, 161; Ferrazza and Pignatti 1974, cat. 440; Fallani,
Mariani, and Mascherpa in Ferrazza and Pignatti 1974a, alph. cat.

This small group was created in 1969, the year in which Amerigo Tot also executed *Homage to Karithy-Olivecrona*, an abstract sculpture. The artist's versatility in these disparate vocabularies confounded critics, but it did not contradict the spirit that had guided Tot's artistic investigations. The sculptor was trained at the Bauhaus in Dessau in the early 1930s, attending courses taught by László Moholy-Nagy and Paul Klee, and later worked in Aristide Maillol's studio in Paris. These three great masters with their divergent sculptural, pictorial, and compositional formulations collectively suggested to him the infinite possibilities open to the creative person who employs a variety of artistic and cultural sources.

   In this work, dedicated to the Madonna of his native city, Tot elaborates on the essential quality of archaic sculpture, the immediacy of popular culture, and the strength of Roman and early Renaissance art. The Madonna, crouching on the ground, seems to want to protect the Baby who is about to enter the world. The firm gaze of the small Jesus and the absorbed face of the Virgin, which recall the formal and expressive simplicity of Benedetto Antelami, evoke the destiny of salvation they are called to fulfill.

M.F.

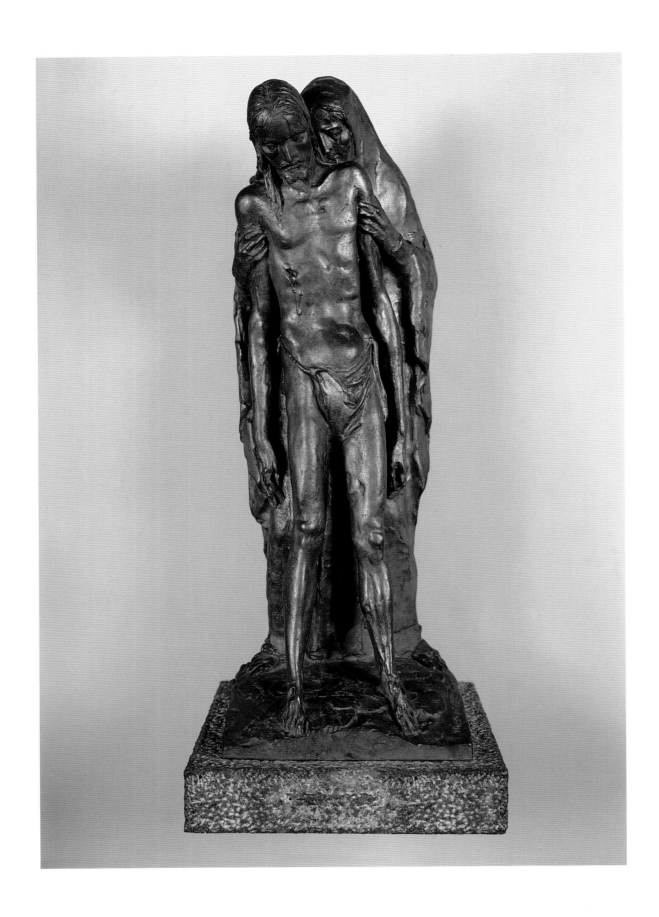

35　FRANCESCO MESSINA (Linguaglossa 1900–Milan 1995)

*Pietà*

1950

bronze, 70.3 x 23.7 x 23.7 cm (27⅝ x 9⁵/₁₆ x 9⁵/₁₆ in.)

Vatican Museums, Collection of Modern Religious Art, Room V, Inv. 23353

INSCRIPTIONS:　Signature on base, to the right

PROVENANCE:　Gift from the artist

EXHIBITION:　Assisi 1953

LITERATURE:　*Fede e Arte* 1960; Ferrazza 1992, 49–51; Ferrazza 2000, 34; Ferrazza and Pignatti 1974, cat. 64; Fallani, Mariani, and Mascherpa in Ferrazza and Pignatti 1974a, alph. cat.

In this *Pietà*, Francesco Messina does not rely upon iconography derived from the Renaissance, where the body of Christ is shown lying across the arms of His Mother. Rather, his work adopts a vertical format, with both figures upright. The Madonna, enveloped by a long cape, grasps the tortured body of the Son with both hands. His arms drop limply at His sides. As is the case in all of Messina's sculptures, the artist's attention is focused on the human aspect of the sacred story. In his works dedicated to the theme of the Passion, the sculptor stresses the pain and suffering of Christ's sacrifice for humankind.

M.F.

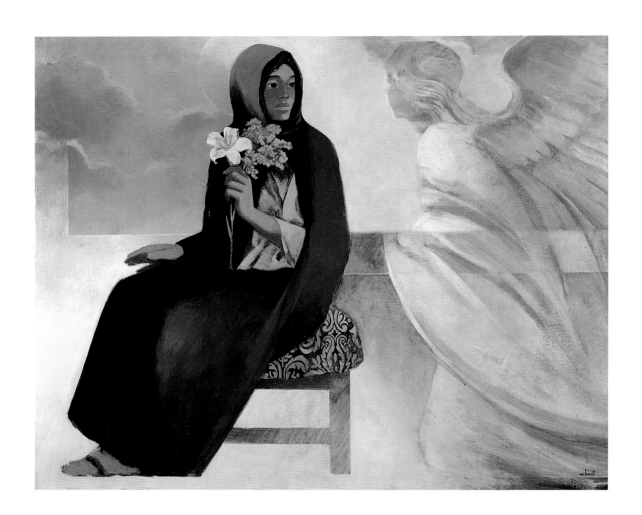

36    Mario Bardi (born Palermo 1922)
      *Annunciation*
      oil on canvas, 92.7 x 143.5 cm (36½ x 56½ in.)
      Vatican Museums, Collection of Modern Religious Art, Storage, Inv. 24819
      PROVENANCE:   Gift from Monsignor Carmelo Ferraro, Bishop of Patti

Mario Bardi chose a familiar iconography in presenting this Annunciation. However, the Archangel Gabriel is shown in monochrome tonality as if to assert his divine nature by his transparency. The very fact that this work makes use of traditional motifs, thus subjecting it to challenging comparisons, lends it a moral strength that does not succumb to mere reproduction of common motifs or folkloric naiveté. The clear, concise drawing, interpreted chromatically, is articulated with simplicity and immediacy, relating in the process the miracle of the event.

                                                                        M.F.

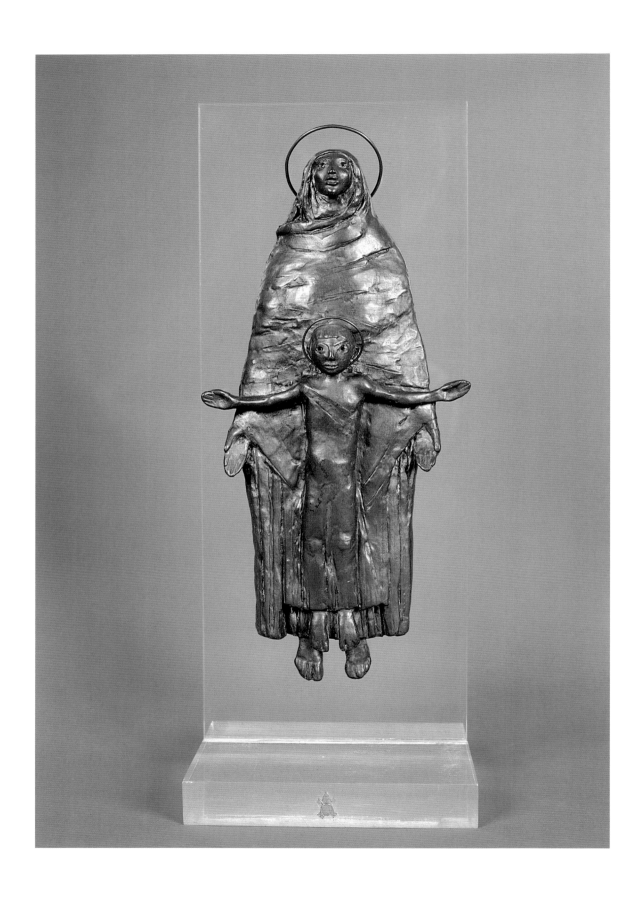

37    JACOB EPSTEIN (New York 1880 – London 1959)
*Madonna and Child*
1950
lead (issue 1/6), 34.7 x 15.4 cm (13$^{11}$/$_{16}$ x 6$^{1}$/$_{16}$ in.)
Vatican Museums, Collection of Modern Religious Art, Room VII, Inv. 23728
PROVENANCE:  Gift from The Committee of Religion and Art of America
EXHIBITIONS:  Rutherford 1967; Coral Gables 1971; Vatican City 1980; Helsinki 1982; Seoul 1984
LITERATURE:  Buckle 1963, 343, 358, cat. 534; Fallani and Ferrazza 1976, 10, 105; Ferrazza 1992, 146, fig. 6; Ferrazza 2000, 44; Levy 1981, 110–113, 113; Schinman and Schinman 1970, 84

For nearly six months, Jacob Epstein worked on a monumental sculpture for Cavendish Square in London for which this work served as a preparatory image. It is noteworthy for its stylized composition, of Byzantine origin and with distinct references to the iconography of the Madonna *Platytéra*. The figure of the Virgin stands with her arms at her sides, palms open. She seems to form a protective backdrop for the graceful body of the Child, who, with His arms extended, assumes the form of a cross. The two figures are suspended in space, almost an apparition to the faithful who approach them. There is an intense spirituality in this perfectly synthesized small piece.

The artist has used the features of his wife, Kathleen, for the image of the Madonna. Although he abandoned this model in his final version of the work, he retained the expressiveness in the faces of the Madonna and the Child. This expressiveness is a guiding principle throughout his sculptural production, which is almost exclusively dedicated to the human figure.

M.F.

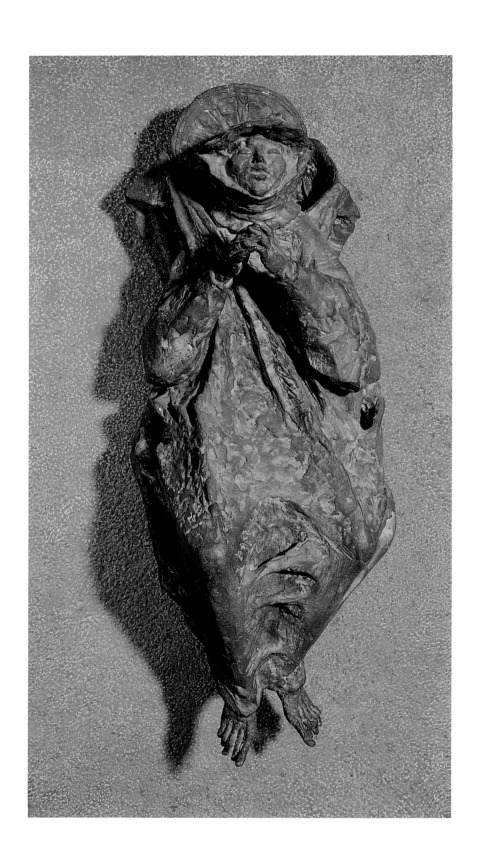

38    LUCIANO MINGUZZI (born Bologna 1911)
*Madonna*
1961
bronze with porphyry pedestal, 87.1 x 34.7 x 28.8 cm (34⁵/₁₆ x 13⁵/₈ x 11⁵/₁₆ in.)
Vatican Museums, Collection of Modern Religious Art, Storage, Inv. 23774
INSCRIPTION:  Signature on skirt, top left
PROVENANCE:  Gift from the Venerabile Fabbrica Duomo, Milan
EXHIBITION:  Vatican City 1980

In this work, the Madonna is captured by the artist at the moment of her Assumption into heaven. Her hands are joined; her face is concentrated in prayer. Yet these are not the only elements that convey the story; her stance, the garments, and the veil also illuminate, both physically and spiritually, the moment in which the miracle took place.

Minguzzi does not use traditional iconography to describe the figure of the Virgin, preferring instead a style found in the sculptures on the fifth door of the Duomo in Milan (1965). In fact, the work shown here is one of several preparatory sketches not included in the final execution.

This work encompasses elements characteristic of Minguzzi's sculptural vocabulary: spare, broken lines and a surface that reflects the range of colors created by light. The artist has undertaken religious subjects numerous times, for example in the Gate of Good and Evil for Saint Peter's Basilica in Rome (1977).

M.F.

Amato 1977
    Amato, Pietro. *Iconografia cristologica in Terra di Bari
    dall'XI al XIII secolo: Ricerca di storia, arte e spiritualità.*
    Mezzina, 1977.

Amato 1980
    Amato, Pietro. "Joseph, époux de Marie, dans l'arc
    triomphal de Sainte Marie Majeure à Rome. Étude
    iconologique," *Bullettin de l'Association Internationale
    pour l'Étude de la Mosaïque Antique (A.I.E.M.A.)* 8 (1980).

Amato 1982
    Amato, Pietro. "L'immagine medioevale della Deêsis.
    Note orientative." In *The Common Christian Roots of
    European Nations: An International Colloquium in the
    Vatican.* Florence, 1982.

Amato 1985a
    Amato, Pietro. "Arte/Iconologia." In *Nuovo dizionario
    di mariologia,* edited by S. de Fiores and S. Meo. Cinisello
    Balsamo, 1985.

Amato 1985b
    Amato, Pietro. "Per una lettura del Seicento icono-
    grafico." In *Il Seicento nell'arte e nella cultura con riferimenti
    a Mantova,* edited by S. Meo. Cinisello Balsamo, 1985.

Amato 1988a
    Amato, Pietro. *De vera effigie Mariae: Antiche icone romane.*
    Exh. cat., Santa Maria Maggiore. Rome, 1988.

Amato 1988b
    Amato, Pietro. "L'oriente cristiano." In *Imago Mariae:
    Tesori d'arte della civiltà cristiana,* edited by Pietro Amato.
    Exh. cat., Palazzo Venezia. Rome, 1988.

Amato 1988c
    Amato, Pietro. "Icona multipla." In *Imago Mariae:
    Tesori d'arte della civiltà cristiana,* edited by Pietro Amato.
    Exh. cat., Palazzo Venezia. Rome, 1988.

Amato 1990
    Amato, Pietro. "Aux origines de la Rome chrétienne:
    Les Arts au service de la Fides Romana et de la Chaire
    de Pierre." In *Trésors du Vatican: La Papauté à Paris.*
    Exh. cat., Centre Culturel du Panthéon. Paris, 1990.

Amato 1991
    Amato, Pietro. "Lorenzo d'Alessandro, La Madonna del
    Monte (a. 1491)." In *Tesori d'arte della Terra di Caldarola.*
    Rome, 1991.

Amato 1992
    Amato, Pietro. *Icone russe dal XV al XIX secolo.* Exh. cat.,
    Castello Trecentesco, Celano. Rome, 1992.

Amato 1996a
    Amato, Pietro. "Per una lettura della Madre di Dio nelle
    icone dell'Oriente cristiano." In *Maria nuovo volto.* Atti
    del Convegno "Maria icona del Vangelo della sofferenza,"
    Aug. 12–23, 1995, Fatima. Rome, 1996.

Amato 1996b
    Amato, Pietro. *Simone de Magistris "picturam et sculturam
    faciebat."* Campobasso, 1996.

Amato 1997
    Amato, Pietro. *La croce romanica di Spilamberto.* Centro
    Culturale id Torrione, Spilamberto. Mezzina, 1997.

Amato 1999
    Amato, Pietro. *Spilamberto: Capolavori di pittura nell'
    ambito estense.* Exh. cat., Chiesa di S. Andriano III papa,
    Spilamberto. Savignano, 1999.

Andaloro 2000
    Andaloro, Maria. "La figura di Maria." In *Christiana Loca,*
    edited by L. Pani Ermini. Exh. cat., San Michele. Rome,
    2000.

Ancona 1994
    *Claudio Ridolfi, un pittore veneto nelle Marche del '600.*
    Exh. cat. Ancona, 1994.

Antal 1960
    Antal, Friedrich. *La pittura fiorentina e il suo ambiente
    sociale nel Trecento e nel primo Quattrocento.* Turin, 1960.

Barbier de Montault 1867
    Barbier de Montault, Xavier. *La Bibliothèque Vaticane et
    ses annexes.* Rome, 1867.

Baussan 1932
    Baussan, Charles. *Saint Eloi.* Paris, 1932.

Bellori 1976 [1672]
    Bellori, Giovanni Pietro. *Le vite de' pittori, scultori e
    architetti moderni,* edited by E. Borea. 1672; reprint
    Turin, 1976.

Berenson 1936
    Berenson, Bernard. *Pitture italiane del Rinascimento.*
    Milan, 1936.

Bernardini 1916
    Bernardini, Giorgio. "Spigolature nel magazzeno della
    Galleria Vaticana," *Rassegna d'arte* 16 (1916).

Bernini 1985
    Bernini, Giovanni Pietro. *Giovanni Lanfranco (1582–1647).*
    Parma, 1985.
Bertini Calosso 1920
    Bertini Calosso, Achille. "Le origini della pittura del
    Quattrocento intorno a Roma," *Art Bulletin* 14, nos. 5–8
    (1920).
Bianco Fiorin 1985/1987
    Bianco Fiorin, Marisa. "Indagine su icone inedite o poco
    note presenti a Trieste," *Atti dei Civici Musei di Storia ed
    Arte di Trieste* 15. Trieste, 1985/1987.
Bianco Fiorin 1991
    Bianco Fiorin, Marisa. "Icone dei Musei Vaticani. Storia
    ed Arte di una Collezione," *Arte Cristiana* 744 (1991).
Bianco Fiorin 1995
    Bianco Fiorin, Marisa. *Icone della Pinacoteca Vaticana.*
    Coll. cat., Pinacoteca Vaticana 4. Vatican City, 1995.
*Bibliotheca Sanctorum* 1961–1970
    *Bibliotheca Sanctorum.* Istituto Giovanni XXIII nella
    Pontifica Università Lateranense. 12 vols. Rome,
    1961–1970.
Boskovits 1968a
    Boskovits, Miklós. "Sull' attività giovanile di Mariotto
    di Nardo," *Antichità Viva* 7, no. 5 (1968).
Boskovits 1968b
    Boskovits, Miklós. "Mariotto di Nardo e la formazione
    del linguaggio tardogotico a Firenze negli anni intorno
    al 1400," *Antichità Viva* 7, no. 6 (1968).
Boskovits 1975
    Boskovits, Miklós. *Pittura fiorentina alla vigilia del Rinasci-
    mento, 1370–1400.* Florence, 1975.
Botte 1966 [1936]
    Botte, B. "La Tradition apostolique de saint Hippolyte:
    Essai de reconstitution." In *Liturgiewissenschaftliche Quellen
    und Forschungen* 39. Münster, 1936; 2nd ed. 1966.
Buckle 1963
    Buckle, Richard. *Jacob Epstein, Sculptor.* Cleveland and
    London, [1963].
Buscaroli 1935
    Buscaroli, Renato. *La Pittura di Paesaggion in Italia.*
    Bologna, 1935.
Byam Shaw 1967
    Byam Shaw, James. *Paintings by Old Masters at Christ
    Church, Oxford.* London, 1967.
Calcagnini Carletti 1988
    Calcagnini Carletti, Daniele. "Nota iconografica:
    La stella e il Vaticinio del V.T. nell'iconografia funeraria
    del III e IV," *Rivista di Archeologia Cristiana* 64 (1988).
Calza 1972
    Calza, Raissa. *Iconografia romana imperiale da Carausio
    a Giuliano.* Rome, 1972.
Carignani 1990
    Carignani, Andrea. "Un ritratto femminile tardoantico
    dal Celio," *Bolletino di Archeologia* 5/6 (1990).
Carli 1960
    Carli, E. *Il Pinturicchio.* Milan, 1960.
Casale 1999
    Casale, Vittorio. "Santi Beati e Servi di Dio in immagini."
    In *Diventare Santo, Itinerari e riconoscimenti della santità tra*

*libri, documenti e immagini,* edited by Giovanni Morello,
    Ambrogio Piazzoni, and Paolo Vian. Coll. cat., Biblio-
    teca Apostolica Vaticana. Vatican City, 1999.
Cignelli 1966
    Cignelli, Lino. *Maria nuova Eva nella patristica greca
    (sec. II–V).* Assisi, 1966.
Couvreur 1967
    Couvreur, Walter. "Daniël Seghers Inventaris van door
    hem Geschilderde Bloemstukken," *Gentse Bijdragen tot
    de Kunstgeschiedenis en de Oudheidkunde* 20 (1967).
Czestochowa 1977
    Pope John Paul II. *Jasna Góra, la bellezza della Santità.*
    Paulinarium, Czestochowa, 1977.
D'Achiardi 1913
    D'Achiardi, Pietro. *Guida della Pinacoteca Vaticana.*
    Rome, 1913.
D'Achiardi 1915
    D'Achiardi, Pietro. *La nuova Pinacoteca Vaticana.*
    Bergamo, 1915.
D'Agincourt 1824–1825
    D'Agincourt, Jean-Baptiste Seroux. *Storia dell'Arte.*
    Milan, 1824–1825.
Daltrop 1988
    Daltrop, Georg. "The Vatican Collections." In *The Holy
    See: Vatican Collections,* edited by Georg Daltrop. Exh. cat.,
    Holy See Pavilion, World Expo 88. Brisbane, 1988.
De Angelis 1988
    De Angelis, Maria Antonietta. "La Madonna col
    Bambino," inv. card 40396, Vatican Museums, 1988.
De Angelis 1990
    De Angelis, Maria Antonietta. "Pinacoteca Vaticana:
    nuove attribuzioni. 'Quadri di fiori' e 'nature morte'
    del XVII e XVIII secolo," *Monumenti Musei e Gallerie
    Pontificie: Bollettino* 10 (1990).
De Bruyn 1980
    De Bruyn, Jean Pierre. "De samenwerking van Daniël
    Seghers en Erasmus II Quellinus," *Jaarboek van het
    Koninklijk Museum voor Schone Kunsten-Antwerpen* (1980).
Deichmann 1967
    Deichmann, Friedrich Wilhelm, Giuseppe Bovini,
    and Hugo Brandenburg. *Repertorium der christlich-antiken
    Sarkophage: Rom und Ostia.* Wiesbaden, 1967.
Di Stefano Manzella 1997
    Di Stefano Manzella, Ivan, ed. *Le iscrizioni dei Cristiani
    in Vaticano.* Vatican City, 1997.
Fallani and Ferrazza 1976
    Fallani, Givanni, and Mario Ferrazza, eds. *Artisti per
    l'Anno Santo 1975.* Vatican City, 1976.
*Fede e Arte* 1960
    "Opere d'arte religiosa di Francesco Messina," *Fede e Arte*
    (1960).
Ferrazza 1992
    Ferrazza, Mario. "Reparto Arte dell'Ottocento e Con-
    temporanea, Relazione 1984–1989," *Monumenti Musei
    e Gallerie Pontificie: Bollettino* 12 (1992).
Ferrazza 2000
    Ferrazza, Mario. *Collezione d'Arte Religiosa Moderna—
    Catalogo.* Vatican City, 2000.

Ferrazza and Pignatti 1974a
    Ferrazza, Mario, and Patrizia Pignatti. *L'appartamento Borgia e l'arte contemporanea in Vaticano.* Vatican City, 1974.
Ferrazza and Pignatti 1974b
    Ferrazza, Mario, and Patrizia Pignatti, eds. *Collezione Vaticana d'Arte Religiosa Moderna.* Milan, 1974.
Ferrua 1963–1964
    Ferrua, Antonio. "Note sul Museo Cristiano Lateranense," *Atti della Pontificia Accademia Romana di Archeologia, Rendiconti* 36 (1963–1964).
Ferrua 1979
    Ferrua, Antonio. "Corona di osservazioni alle iscrizioni cristiane di Roma *incertae originis,*" *Atti della Pontificia Accademia Romana di Archeologia* 3, *Memorie*, no. 8. Vatican City, 1979.
Fischer 1984
    Fischer, Angela. *Gioielli africani.* Milan, 1984.
Gandolfo 1988
    Gandolfo, Francesco. "La basilica sistina: I mosaici della navata e dell'arco trionfale." In *Santa Maria Maggiore a Roma,* edited by Carlo Pietrangeli. Florence, 1988.
Gigli 1990
    Gigli, Laura. *Guide rionali di Roma. Rione XIV. Borgo.* Rome, 1990.
Grignon de Montfort 1983
    Grignon de Montfort, Louis. *Trattato della Vera devozione a Maria.* Cinisello Balsamo, 1983.
Grimaldi 1987
    Grimaldi, Francesco. *Santa Maria Porta del Paradiso liberatrice della pestilenza.* Loreto, 1987.
Hairs 1955
    Hairs, Marie Louise. *Les peintres flamands de fleurs au XVIIe siècle.* Paris and Brussels, 1955.
Heinz-Mohr 1984 [1971]
    Heinz-Mohr, G. *Lessico di iconografia cristiana.* German ed. 1971; Milan, 1984
ICUR
    *Inscriptiones Christianae Urbis Romae.* New series, vol. 1, edited by A. Silvagni. Rome, 1922; Vols. 2–10, edited by A. Silvagni, A. Ferrua, C. Carletti, and D. Mazzoleni. Rome, 1935–1985.
Index Musei Sacri 1762
    *Index Musei Sacri Cristiani iussu SS. D. N. Clementis XIII Pont. Max. confectus die 3 Junii 1762.* Biblioteca Apostolica Vaticana, ms. Arch. Bibl. 73.
Indicazione 1857
    *Indicazione della Pinacoteca Pontificia nel Palazzo Apostolico Vaticano.* Rome, 1857.
John Paul II 1996
    John Paul II. *Dono e Mistero.* Vatican City, 1996.
Kessler 1992
    Kessler, Leslie Brown. *Lanfranco and Domenichino: The Concept of Style in the Early Development of Baroque Painting in Rome.* Ph.D. diss., University of Pennsylvania. Philadelphia, 1992.
Lainez 1979
    Lainez, Manuel Mujica, ed. *Los murales de Soldi en Santa Ana de Glew.* Buenos Aires, 1979.

Levy 1981
    Levy, Alphonse. "Modernism a Step away from Michelangelo," *ArtNews* 80, no. 8 (October 1981).
Lipinsky 1954
    Lipinsky, Angelo. "S. Eligio di Noyon," *L'orafo italiano* 8 (1954).
Lisbon 1952
    *Exposição de Arte Sacra Missionária.* Commemorative cat., Agência Genereal do Ultramar. Lisbon, 1952.
Los Angeles 1998
    *The Invisible Made Visible. Angels from the Vatican.* Exh. cat., UCLA at the Armand Hammer Museum of Art and Cultural Center, Los Angeles. Alexandria, VA, 1998.
Luciani 1996
    Luciani, Roberto, ed. "Santa Maria Maggiore a Roma," presentation by Ugo Poletti. Rome, 1996.
Maarschalkerweerd 1937
    Maarschalkerweerd, Pancrazio. "Plastiche cristiane delle terre di missione nel Pontificio Museo Missionario Etnologico," *Annali Lateranensi* 1. Vatican City, 1937.
Macé de Lépinay 1990
    Macé de Lépinay, François. "G.B. Salvi detto 'Il Sassoferrato': pittore vittima delle semplificazioni della storia?" In *G.B. Salvi: "Il Sassoferrato."* Exh. cat., Sassoferrato. Milan, 1990.
Mâle 1932
    Mâle, Émile. *L'Art Religieux après le Concile de Trente: Étude sur l'iconographie de la fin du XVIe siècle, du XVIIe, du XVIIIe siècle.* Paris, 1932.
Manila 1994
    Morello, Giovanni, ed. *2000 Years of Vatican Treasures: ". . . and They Will Come from afar."* Exh. cat., Metropolitan Museum. Manila, 1994.
Massi 1882
    Massi, Ercole. *Descrizione delle Gallerie di Pittura nel Pontificio Palazzo Vaticano.* Rome, 1882.
Meiss 1982
    Meiss, Millard. *Pittura a Firenze e Siena dopo la Morte Nera. Arte, religione e società alla metà del Trecento.* Turin, 1982.
Mellett and Camelot 1955
    Mellet, Cf. M., and Th. Camelot. *Bibliothèque augustienne* 15 (1955).
Mexico City 1993
    Morello, Giovanni, ed. *Tesoros artísticos del Vaticano: Arte y cultura de Dos Milenios.* Exh. cat., Colegio de San Ildefonso. Mexico City, 1993.
Mohl Max 1990–1997
    Mohl Max, M. *Masterpieces of the Maconde.* 3 vols. Augsburg, 1990–1997.
Montevideo 1998
    Morello, Giovanni, and Maria Antonietta De Angelis, eds. *La Fe y el Arte: Collecciòn de Obras Maestras del Vaticano.* Exh. cat., Museo Nacional de Artes Visuales. Montevideo, Uruguay, 1998.
Muñoz 1928
    Muñoz, Antonio. *I quadri bizantini della Pinacoteca Vaticana.* Rome, 1928.

New York 1972
José de Creeft: Recent Sculpture. Exh. cat., Kennedy Galleries. New York, 1972.

Nogara 1936
Nogara, Bartolomeo. "Monumenti, Musei e Gallerie Pontificie nell'Anno Accademico 1935–1936. Relazione," Atti della Pontificia Accademia Romana di Archeologia, Rendiconti 12 (1936).

Novelli 1955 [1964]
Novelli, Maria Angela. Lo Scarsellino. Bologna, 1955; reprint Milan, 1964.

O'Reilly 1940
O'Reilly, Patrick. "Description sommaire d'une collection d'objets ethnographiques de l'Île de Bougainville," Annali Lateranensi 4. Vatican City, 1940.

Pacelli 1989
Pacelli, Vincenzo. "Problemi di iconografia cristiana: il purgatorio e il suffragio." In Momenti di Storia in Irpinia attraverso trenta opere recuperate nella Diocesi di Avellino. Exh. cat., Avellino. Rome, 1989.

Paris 1964
L'Art Copte. Exh. cat., Petit Palais. Paris, 1964.

Paris 1990
Trésors du Vatican: La Papauté à Paris. Exh. cat., Centre Culturel du Panthéon. Paris, 1990.

Pastor 1908–1934
Pastor, Ludwig von. Storia dei Papi dalla fine del Medioevo. 20 vols. Rome, 1908–1934.

Pietrangeli 1982
Pietrangeli, Carlo. "La Pinacoteca Vaticana di Pio VI," Monumenti Musei e Gallerie Pontificie: Bollettino 3 (1982).

Pietrangeli 1985
Pietrangeli, Carlo. I Musei Vaticani. Rome, 1985.

Pietri 1988
Pietri, Charles. "Le origini." In Imago Mariae: Tesori d'arte della civiltà cristiana, edited by Pietro Amato. Exh. cat., Palazzo Venezia. Rome, 1988.

PL
Migne, J. P., ed. Patrologiae cursus completus seu bibliotheca universalis. Series Latina. 221 vols. Paris, 1841–1864.

Porcella 1933
Porcella, Amadore. Guida della Pinacoteca Vaticana. Vatican City, 1933.

Réau 1955–1959
Réau, Louis. Iconographie de l'Art Chrétien. 6 vols. Paris, 1955–1959.

Redig de Campos 1943
Redig de Campos, Deocletio. "Catalogo dei dipinti olandesi e fiamminghi della Pinacoteca Vaticana," Mededelingen van het Nederlandisch Instituut te Rome 22 (1943).

Ricci 1912
Ricci, C. Il Pinturicchio. Perugia, 1912.

Roberts 1938
Roberts, H. Catalogue of the Greek and Latin Papyri in the John Rylands Library. Vol. 3: Theological and Literary Texts. Manchester, 1938.

Rome 1999
Mirabilia Recepta: Le Forze dell'Ordine a difesa dei Beni Culturali. Exh. cat., Castel Sant'Angelo. Rome, 1999.

Rossi 1994
Rossi, Francesco. Il Trecento: Umbria, Marche, Italia del Nord. Coll. cat., Pinacoteca Vaticana 3. Vatican City, 1994.

Salmi 1930
Salmi, Mario. Review by Luigi Serra. "L'arte nelle Marche dalle origini cristiane alla fine del Gotico," Rivista d'Arte 12 (1930).

Salmi 1955
Salmi, Mario. "Lorenzo Ghiberti e Mariotto di Nardo," Rivista d'Arte 30 (1955).

Sbrilli 1987
Sbrilli, A. "Antonio da Alatri." In La pittura in Italia: Il Quattrocento. 2 vols. Milan, 1987.

Scarpellini 1984
Scarpellini, P. Perugia. Milan, 1984.

Schinman and Schinman 1970
Schinman, E. P., and B. A. Schinman. Jacob Epstein. Cranbury, NJ, 1970.

Spezzaferro 1993
Spezzaferro, Luigi. "La cappella Madruzzo in S. Onofrio in Gianicolo." In I Madruzzo e l'Europa, 1539–1658, I Principi-Vescovi di Trento tra Papato e Impero, edited by L. Dal Prà. Exh. cat. Trento, 1993.

Spinola 1996
Spinola, Giandomenico. Dalla Terra alle Genti. Exh. cat., Palazzo dell'Arengo, Rimini. Milan, 1996.

Spinola 1998
Spinola, Giandomenico. La Fe y el Arte. Collecciòn de obras Maestras del Vaticano. Exh. cat., Museo Nacional des Artes Visuales. Montevideo, Uruguay, 1998.

Spoleto 1989
Pittura del '600: Ricerche in Umbria. Exh. cat., Rocca Albornoziana, Spoleto. Rome, 1989.

Stratton 1994
Stratton, Susanne L. The Immaculate Conception in Spanish Art. Cambridge, 1994.

Strinati 1986
Strinati, Claudio. "Un preraffaellita del Seicento," Art e Dossier 5 (September 1986).

Tambini 1982
Tambini, Anna. Pittura dall'Alto Medioevo al Tardo Gotico nel territorio di Faenza e Forlì. Faenza, 1982.

Testini 1972
Testini, Pasquale. "Alle origini dell'iconografia di Giuseppe di Nazareth," Rivista di Archeologia Cristiana 48 (1972).

Titi 1987 [1675]
Titi, Filippo. Studio di Pittura, Scoltura, et Architettura, nelle chiese di Roma (1674–1763), edited by Bruno Contardi. 2 vols. 1675; rev. ed. Florence, 1987.

Todini 1987
Todini, Filippo. "Niccolò Alunno e la pittura folignate." In Filippo Todini and Elvio Lunghi, Niccolò di Liberatore detto l'Alunno. Foligno, 1987.

Todini 1989
    Todini, Filippo. *La pittura umbra dal Duecento al primo Cinquecento.* Milan, 1989.
Tokyo 1987
    *The Message for the Godless Age.* Exh. cat., Sogo Department Store. Tokyo, 1987.
Tokyo 1989
    *Masterpieces from the Vatican—Japan 1989.* Exh. cat., The National Museum of Western Art. Tokyo, 1989.
Vasco Rocca 1988
    Vasco Rocca, Sandro. "Il Barocco." In *Imago Mariae: Tesori d'arte della civiltà cristiana.* Exh. cat., Palazzo Venezia. Rome, 1988.
Vatican City 1980
    *Acquisizioni della Collezione Vaticana d'Arte Religiosa Moderna.* Exh. cat., Braccio di Carlo Magno. Vatican City, 1980.
Vatican City 1990
    *Diventare Santo, Itinerari e riconoscimenti della santità tra libri, documenti e immagini.* Eds. Giovanni Morello, Ambrogio Piazzoni, and Paolo Vian. Coll. cat., Biblioteca Apostolica Vaticana. Vatican City, 1990.

Vicchi 1994
    Vicchi, Roberta. In *2000 Years of Vatican Treasures,* edited by Giovanni Morello. Milan, 1994.
Vitaletti 1990
    Vitaletti, Guido. *Il Sassoferrato: Giambattista Salvi, 1609–1685.* Sassoferrato, 1990.
Voss 1924
    Voss, Hermann. *Die Malerei des Barock in Rom.* Berlin, 1924.
Waterhouse 1976
    Waterhouse, Ellis Kirkham. *Roman Baroque Painting.* Oxford, 1976.
Wazbinski 1987
    Wazbinski, Zygmunt. "Il Modus Semplice: Un dibattito sull'Ars Sacra fiorentina intorno al '600." In *Studi su Raffaello,* edited by M. Sambucco-Hamoud and M. L. Strocchi. Urbino, 1987.

Archives
    ASV      Vatican Secret Archive
    ASMV    Vatican Museum Historical Archives

# • EXHIBITIONS •

Ancona 1994
> *Claudio Ridolfi, un pittore veneto nelle Marche del '600.*
> Ancona, 1994.

Assisi 1953
> *Arte Cristiana di Messina.* Galleria della Cittadella
> Cristiana, Assisi, August 3–September 4, 1953.

Brisbane 1988
> *The Holy See: Vatican Collections.* Holy See Pavilion,
> World Expo 88, Brisbane, 1988.

Coral Gables 1971
> *Jacob Epstein: Sculpture, Watercolors and Drawings from*
> *the Collection of Edward P. Schinnon.* Lowe Art Museum,
> Coral Gables, FL, October 30–November 28, 1971.

Helsinki 1982
> *Ars Vaticana.* Ateneum, Helsinki, August 20–September
> 26, 1982.

Lisbon 1952
> *Exposição de Arte Sacra Missionária.* Agência Genereal
> do Ultramar, Lisbon, 1952.

Los Angeles 1998
> *The Invisible Made Visible. Angels from the Vatican.* UCLA
> at the Armand Hammer Museum of Art and Cultural
> Center, Los Angeles, 1998.

Manila 1994
> *2000 Years of Vatican Treasures: ". . . and They Will Come*
> *from afar."* Metropolitan Museum, Manila, November
> 1994–February 1995.

Mexico City 1993
> *Tesoros artísticos del Vaticano: Arte y cultura de Dos Milenios.*
> Colegio de San Ildefonso, Mexico City, November 16,
> 1993–February 15, 1994.

Montevideo 1998
> *La Fe y el Arte: Collección de Obras Maestras del Vaticano.*
> Museo Nacional de Artes Visuales, Montevideo,
> Uruguay, July–August 1998.

New York 1972
> *José de Creeft: Recent Sculpture.* Kennedy Galleries,
> New York, November 29, 1972–January 6, 1973.

Paris 1990
> *Trésors du Vatican: La Papauté à Paris.* Centre Culturel
> du Panthéon, Paris, 1990.

Rimini 1996
> *Dalla Terra alle Genti.* Palazzo dell'Arengo, Rimini,
> March–September 1996.

Rome 1988
> *Imago Mariae: Tesori d'arte della civiltà cristiana.*
> Palazzo Venezia, Rome, June 20–October 2, 1998.

Rome 1999
> *Mirabilia Recepta: Le Forze dell'Ordine a difesa dei Beni*
> *Culturali.* Castel Sant'Angelo, Rome, 1999.

Rutherford 1967
> Fairleigh Dickinson University, Rutherford, NJ, 1967.

Santiago 1998
> *Fe y Arte: Collecion de obras maestras del Vaticano.* Santiago,
> Chile, 1998.

Seoul 1984
> *Images of the Eternal.* National Museum of Modern Art,
> Seoul, July 21–September 14, 1984.

Tokyo 1987
> *The Message for the Godless Age.* Sogo Department Store,
> Tokyo, January 3–November 1, 1987.

Tokyo 1989
> *Masterpieces from the Vatican—Japan 1989.* The National
> Museum of Western Art, Tokyo, 1989.

Vatican City 1980
> *Acquisizioni della Collezione Vaticana d'Arte Religiosa*
> *Moderna.* Braccio di Carlo Magno, Vatican City,
> June 16–July 19, 1980.

Vatican City 1997
> *Le iscrizioni dei Cristiani in Vaticano.* Vatican Museums,
> September 1997–January 1998.

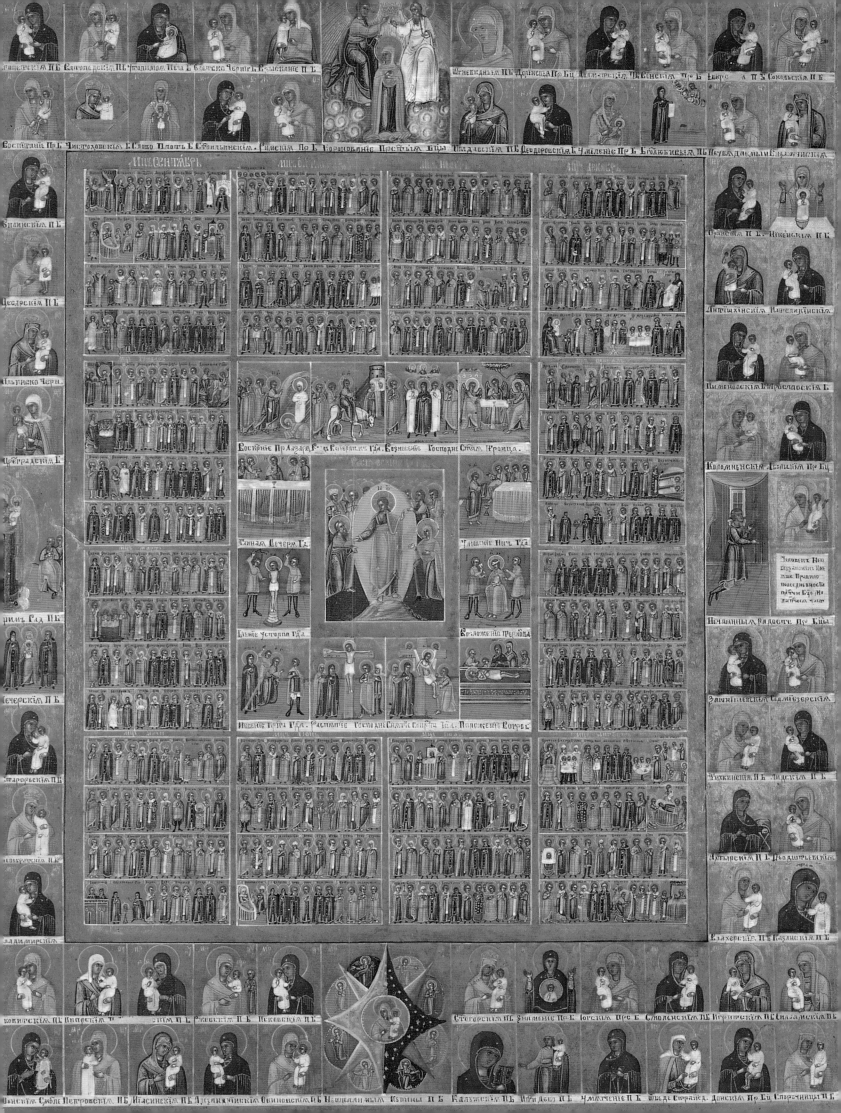

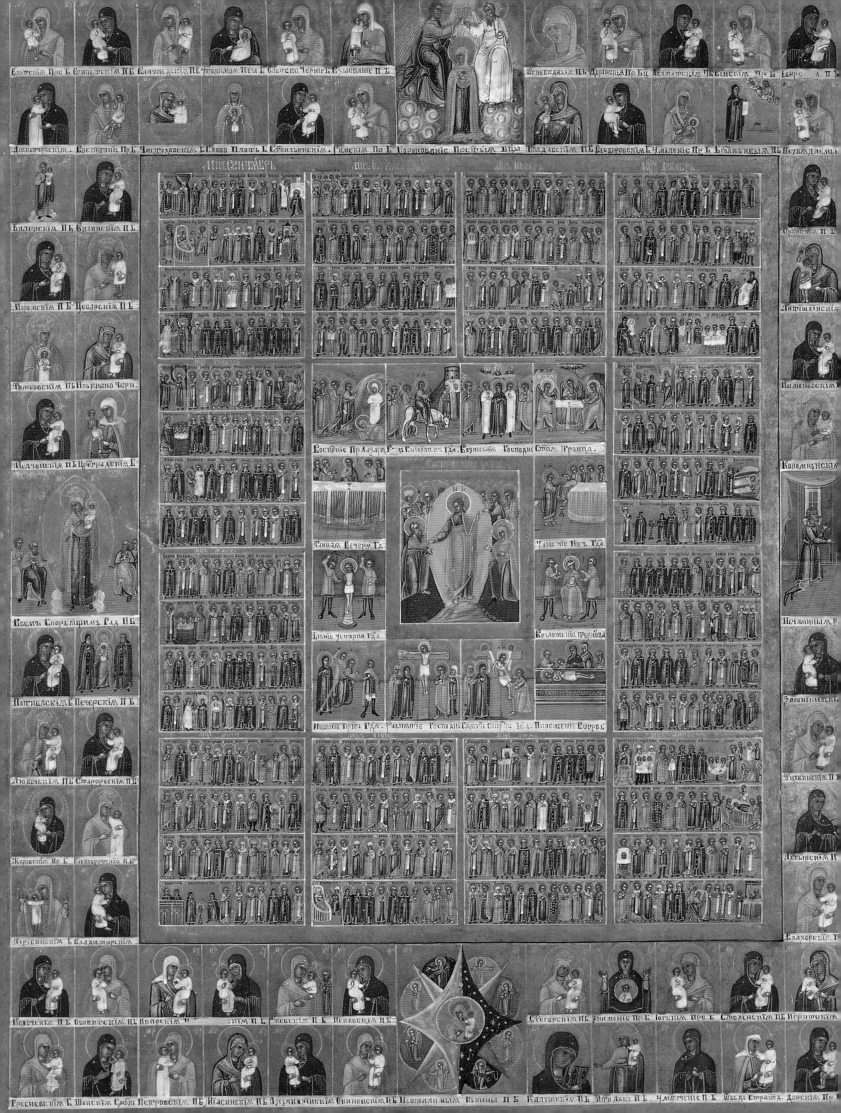